CONDITIONS HANDSOME AND UNHANDSOME

ALSO BY STANLEY CAVELL

Must We Mean What We Say? (1969; reprinted 1976)
The World Viewed (1971; enlarged edition 1979)
The Senses of Walden (1972; expanded edition 1981)
The Claim of Reason (1979)
Pursuits of Happiness (1981)
Themes Out of School (1984)
Disowning Knowledge (1987)
In Quest of the Ordinary (1988)
This New Yet Unapproachable America (1989)

CONDITIONS HANDSOME AND UNHANDSOME

The Constitution of Emersonian Perfectionism

The Carus Lectures, 1988

STANLEY CAVELL

OPEN ❈ COURT

La Salle, Illinois

Stanley Cavell teaches philosophy at Harvard University. He is the
author of *In Quest of the Ordinary, This New Yet Unapproachable
America,* and *Themes Out of School,* all published by the University of
Chicago Press.

✳

First printing 1990

Clothbound edition published by arrangement with the University of
Chicago Press.

Library of Congress Cataloging-in-Publication Data
Cavell, Stanley, 1926–
 Conditions handsome and unhandsome; the constitution of
Emersonian perfectionism/Stanley Cavell.
 p. cm.—(The Carus lectures; 1988)
 Includes bibliographical references.
 ISBN 0–8126–9149–0 (cloth)
 1. Emerson, Ralph Waldo, 1803–1882—Philosophy. 2. Emerson,
Ralph Waldo, 1803–1882—Ethics. 3. Perfection—Moral and ethical
aspects. I. Title. II. Series: Paul Carus lectures; 19th ser.
PS1642.P5C38 1990
814'.3—dc20 89–49128
 CIP

To Kurt Fischer

I take this evanescence and lubricity of all objects, which lets them slip through our fingers then when we clutch hardest, to be the most unhandsome part of our condition.

Emerson, *"Experience"*

CONTENTS

PREFACE AND ACKNOWLEDGMENTS

The numbered chapters to follow, more or less edited, here and there amplified, are the texts of my three Carus lectures, prepared at the invitation of the American Philosophical Association and presented at the annual meeting of its Pacific Division in April 1988. I was inevitably aware, as I was writing them, that certain of their topics, and moments of their form of presentation, went in various degrees against the grain of the craft of professional argumentation and presentation mostly in favor in the Association. To indicate the provenance in other institutional contexts that matter to me of certain stretches of this material, I have for the publication of these Carus lectures added three further texts: As a first appendix I reprint an address given to an academic convocation held at Iona College whose audience included the public community of which that college is a part; in a second appendix I include the, as it were, letter of introduction I wrote for my contribution (it was an early version of my first Carus lecture) to the work of a study group sponsored by the Center for Literary Studies at Hebrew University in Jerusalem; and in an extended Introduction, I adumbrate the immediate pedagogical context of the concerns of the lectures. Those concerns produced, in the fall of 1987, as their first explicit and extended manifestation, my course called Moral Perfectionism, given as one of the courses in the Moral Reasoning section of Harvard's Core Curriculum, which was in part my initial attempt to work out the implications of the realization that two of my principal preoccupations in recent years are surprisingly, and not so surprisingly, linked; specifically, that the moral outlook of Emersonian Perfectionism is the basis of the human relationship, called remarriage, engendering the narrative (and its negation) in the two genres of film I had been looking to define. The condition of this linking, for me, was the idea that the Emersonian moral outlook is the expression of a mode of thinking, counter to the mode philosophy mostly favors as reasoning, that Emerson (and that Thoreau) shares with Wittgenstein and Heidegger. This is the subject of the first lecture. Not much of this condition, and its presence in the work I had been doing on the functioning of philosophical skepticism in the

thinking of Romanticism (as recorded in the lectures collected in my
In Quest of the Ordinary), appeared explicitly in the Moral Reason-
ing course; a certain idea of what did appear there, or of the mood
that completing the course left me with—remembering it the sum-
mer after both the course and the occasion of the Carus lectures were
over—is given in the Introduction.

The Jerusalem study group I have alluded to had been formed as
the sequel to the work of a smaller group that met for the academic
year 1985–86 at the Institute for Advanced Studies at Hebrew Uni-
versity. When I joined the group in January of 1986, and until
Jacques Derrida joined it for its final month, I was its only member
who was a teacher of philosophy, and it is clear to me that in that
unique and universal and critically distressed city, in the intensity
and freedom and continuity and privilege of the group's working
discussions, as well as in the more public colloquia it held regularly,
my presentations, especially those on Emerson and on American
film, took on a new cast, a new imperative, as if needing to declare a
new world of friendships. I think of exchanges with Sanford Budick
on, as it might be, what remains of a humanistic aspiration in tex-
tual study in the aftermath of the victories of the new literary
theorizing; with Emily Budick on Emerson and the American ro-
mance tradition; with Gerald Bruns, always explicitly but not
exclusively, on Heidegger and Wittgenstein, punctuated by our
faithful, excited attendance at the fabulous Jerusalem Cinéma-
thèque; with Wolfgang Iser on the interactions and interferences
between literary and philosophical traditions and the new intru-
sions of film. It was at this group's sequel, two years later, for which
the appended cover letter was written, that it fell to Derrida to tell
me, in response to my emphasis in the first lecture on Emerson's
hand in "handsome," that he had written a text on the hand in
Heidegger ("Geschlecht II"). It would be some compensation for
this embarrassment of my ignorance were others to feel a small em-
barrassment at not having taken Emerson seriously on such a
subject.

Recalling my first months in Jerusalem, I am even more aware of
the effect of voices from that period than I was during the hurry of
preparing *In Quest of the Ordinary* for the press, versions of a
number of the lectures of which were delivered and modified in and
by Jerusalem. I think immediately of my other colleagues in the re-
search group at the Institute—Geoffrey Hartman, the late Dan

Pagis, Shlomith Rimmon-Kenan, Jon Whitman, and Shira Wolo-sky. (What we were talking about week to week is quite accurately conveyed in the proceedings of the expanded colloquium our group sponsored to mark the conclusion of its year in June 1986, edited by Sanford Budick and Wolfgang Iser and published under the title *Languages of the Unsayable*.) I think also of friends and colleagues who participated in our public lectures and discussions—Lawrence and Judy Besserman, Bill Daleski and Shirley Kaufman, Elizabeth Freund, Zvi and Malka Jagendorf, Ruth and Natan Nevo, and Leona and Zvi Toker. There, less than ever, did it seem to me possible simply to abandon or simply to stand upon professional ceremony.

The format of the Harvard core course required, each week, the reading of one of the texts listed on page 5 of the Introduction, together with the screening of a film, mainly ones drawn from the genre of remarriage comedy and from its related genre of melodrama, listed on pages 103 and 105 of Lecture 3. The complications of such a format, intellectual and logistical, are extravagant; neither the students enrolled in the course, nor I, would have made it through without the inspiring intelligence, devotion, and resourcefulness of its teaching fellows: Steven Affeldt, James Conant, Harvey Cormier, Joshua Leiderman, Rael Meyerowitz, Daniel Rosenberg, and Charles Warren. They have my gratitude and admiration. As the head section person for the course, but beyond any reasonable call of its duties, James Conant worked with me in preparing the course syllabus before going on to translate its directions and readings and screenings into fact. The most fateful of his suggestions, perhaps, was his recommending that instead of the Nietzsche text I had listed for the course (*The Genealogy of Morals*) we instead assign *Schopenhauer as Educator*, which was after all the text from which Rawls's *A Theory of Justice*—which was to play a decisive part in shaping the course—takes its Nietzsche citations. The results, as sketched in Lecture 1, which I gathered surprised Conant as much as they did me, are ones he is following up in his own study of that text. I have profited from his intelligence and friendship at each stage in seeing this work to its present state. The comments he gave me on a late draft of it he reported as in significant part the product of conversations with Steven Affeldt.

When I had drafts of the first two lectures, and found myself in need of some reassurance before going on to the third, I asked various other friends to read them. My friend and colleague Hilary

Putnam, who was my predecessor as Carus lecturer, was unforget-
tably generous, not just in the care with which he located incautious
formulations within, and unnoticed interactions between, the spe-
cific texts I had given him, but in indicating his understanding of the
particular anxiety one deals with in preparing Carus lectures. Karen
Hanson, as so often over the years, found further tangles and lapses
of tone. Burton Dreben and Juliet Floyd each raised questions most-
ly to get me to be clearer about the position I was taking toward
Rawls's work. Then soon after the lectures had been delivered Judith
Shklar gave me a wonderfully full set of reactions, about details and
about structure, did what she could to get me to say more about
Emerson's politics, and urged me to write an introduction. Certain
of these responses I put to work at once in my manuscript; others
are a painful reminder, but accompanied by a fine sense of tested
friendship, of how much work there is to do.

Before there was anything of the kind to have drafts of, I faced
the difficulties of coming late in my philosophical education, as in
other instances, to a serious reading of *A Theory of Justice*. By the
time the time came, not just the demands of the vision and the de-
tails of the book were formidable, but the intensity and vastness of
the discussion surrounding the book seemed to have occupied ter-
ritory there was no reasonable way to enter. It was Arnold Davidson
who, without underestimating the difficulties I felt, but refusing to
allow them to become decisive (out of his unswerving respect for
Rawls's work as well as out of the sense of fruitfulness, I think I may
say, he has found for his complex project of work in moments of my
own), mapped out a geography of the kinds of work Rawls's book had
effected and was affecting, gave his assessment of relative impor-
tance among the strains of that work, and listened almost daily (in
conversations uncountable except by some phone company) to my
reactions—predictable, standard, shallow, troubled, perhaps prom-
ising—during the weeks I first worked systematically through the
book. I do not expect that my responses, as recorded in the pages
that follow, have lost their eccentricity; but the extent to which they
are pertinent is significantly a function of Arnold Davidson's knowl-
edge, of the breadth of his intellectual sympathies, and of his
capacity to listen.

Two words about how I make it all right with myself that I do not
treat any of Rawls's work subsequent to the publication of *A Theory
of Justice*. First, an epochal work will take on a life of its own and

outrun its consequences, or perhaps rather hang behind them to await new developments. I assume that while the responses and discussions *A Theory of Justice* has inspired will have caused an inevitable share of restatement and accommodation and uneven developments of specific issues, the main doctrines of the book retain their original shape. I am, in any case, interested in a particular development of what I call the book's rhetorical design, primarily as that results from its continuation and modification of the idea of the social contract. Second, I mean explicitly to raise it as a question, and leave in question, whether the specific consequence of this continuation that I mainly take exception to—its placing of the idea of moral perfectionism—is, if valid, central enough to require further modification, or whether it is marginal enough not to.

My difficulties in thinking through my responses to Kripke's interpretation of Wittgenstein's *Philosophical Investigations* are different, largely, and more or less obviously, because the roles of technical subjects about which I can have no say are different. In Rawls's work, technical matters in the theory of rational choice come after, as it were, the intuitive motivation and systematic structure of the theory are in place, as forms of clarification or mathematicization of the ideas. In Kripke's *Wittgenstein on Rules and Private Language*, technical matters, so I felt, may from the beginning be lost on me. In a seminar, The Philosophy of the Ordinary, in the fall of 1986, I broached my sense at once of the nearness and the remoteness of the view taken in Kripke's book concerning Wittgenstein's ideas of privacy, rules, instruction, agreement, skepticism, and the ordinary to and from the view of them taken in my *Claim of Reason*. Many of the members, often auditors, of the seminar were graduate students who were better versed than I in the technical subjects of philosophy of mind and of philosophy of language as these dominate contemporary philosophy courses with such titles (in the Anglo-American half of the philosophical world), and who were at the same time sympathetic to, and ready to press in detail, the account of Wittgenstein's ideas of a criterion and of the ordinary presented in *The Claim of Reason*. Old quarrels concerning philosophical method were activated in this conflict between visions of the ordinary—quarrels heartening to me, pedagogically and philosophically, in demonstrating that a founding conflict has not been settled institutionally, by the taking and enforcing of sides. I had first sketched my reactions to Kripke's interpretation of the

Investigations in several lectures of my course Wittgenstein and the Ordinary, in 1984. Edward Minar was then in the grip of writing his Ph.D. dissertation on Wittgenstein's passages concerning rules, and my lectures produced exchanges between us that, while not thorough enough to satisfy either of us, amply exemplified the extraordinary difficulties in speaking of these issues without falsifying one's sense of the *Investigations*. Douglas Winblad was the teaching fellow for that course, and he too would give me reactions to formulations of mine that took me back to Wittgenstein's and to Kripke's texts. While in both classes the idea of a Wittgensteinian criterion as providing a mode of "counting" was stressed, and its relation to Kripke's account mentioned, in neither had I brought the details of my reading of Kripke's interpretation together sufficiently—as I hope the present account in Lecture 2 proves to do— for that reading to enter seriously into the problematic of counting as summarized on pages 94–95 of *The Claim of Reason* in terms of what I call "the economics of speech," and what I claim as "wording the world," and what I word as "being found worth saying"; and as invoked in the Preface to *In Quest of the Ordinary*, which cites the appearance of the Wittgensteinian idea of a criterion in my readings of moments of Emerson and of Poe and of *The Winter's Tale* (the last cited again here in Lecture 2, page 92).

Since the appearance of Heidegger in Lecture 1, and no doubt hastened by my visits to Jerusalem, and by what moved me to accept the invitations to be there, I find, as so many others in analogous ways have found, that I can no longer think about Heidegger, and in particular, for me, think more closely about his connection, through Nietzsche, with Emerson, without asking, explicitly and in detail, what the political implications are of this unsettling closeness and remoteness. The question comes to the fore in a reading I am preparing of Emerson's "Fate," an essay in effect on freedom in which Emerson is apparently all but silent on the subject of slavery. Preparing this reading has contributed to the delay in getting these Carus lectures to the publisher; it has entered into the two seminars on Moral Perfectionism I have offered since establishing the core course. Since for me the urgency of the issue of Heidegger's politics is a function of how "close" the connection of Emerson and Thoreau and Nietzsche and Heidegger are felt to be, and since the material on Emerson's "Fate" may not be published soon, I note here two further coincidences, or sites for thought, that I have not previously put

into print. Beyond the general rhyming there is between Emerson's and Heidegger's invocation of the "near" there is the more specific coincidence between Heidegger's use of "Sein bei" in Chapter 2 of *Being and Time* and Thoreau's use of "beside oneself" and of "next to us" in Chapter 5 of *Walden*. And the idea of "finding as founding" in Emerson's "Experience," as I have discussed that in *This New Yet Unapproachable America*, is evidently alignable with Heidegger's notion of *Befindlichkeit* (translated as "state-of-mind"), one of "the two constitutive ways of [Dasein's] being the 'there' [that is, being its *Da*]" (*Being and Time*, pp. 171–72). An intermediate textual step on the topic of finding (ourselves) may be found in the Preface of Nietzsche's *Genealogy of Morals*—a claim sketched on pages 24–26 of *New Yet Unapproachable America*. Is it by a metaphysical hair's breadth that Heidegger's and Emerson's visions of justice differ—that Heidegger offered his work to a final solution and that Emerson directed his work against every finality, of thought or relationship? Does the difference between embracing death and affirming life turn on subtleties of what can seem to be private readings? ("Embracing death" is an allusion to Saul Friedlander's representation of representations of Nazism in his fascinating *Reflections of Nazism: An Essay on Kitsch and Death* [Harper and Row, 1984].)

The text of Appendix A, "Hope against Hope," was written and delivered in 1985, in a different mood of the world toward a nuclear end than exists now, following the train of events of 1989 in Eastern Europe. It was hard to say what I say there, out loud then, on its occasion, which was part of the reason it felt important to say. If now its nuclear question seems unnecessary to dwell upon, perhaps one will be moved to ask whether that is the only global manifestation of ultimate urgency, and ask what it was that caused Kant and Nietzsche, who figure in my text, to consider, in prenuclear times, the end of time.

I will go on further in these prefatory words to express my sense of omission and of unphilosophical haste in the lectures to follow. So I say at once that the pain of my personal dissatisfactions is more than made up for by the pleasure in recognizing how far these defects are already being made good in the work of members of the seminars on Moral Perfectionism. I am thinking, for example, beyond James Conant's work on Nietzsche that I have mentioned, and its con-

tinuation in and from his writing on Kierkegaard and Wittgen-
stein's *Tractatus*, of Paul Franks's remarkable study of Hegel, most
immediately of his description of the introduction Hegel wrote for
the *Critical Journal* he edited with Schelling, in which Franks makes
out—on, as it were, the opposite side of German philosophy from
that represented by Nietzsche—a non-elitist perfectionism of an
Emersonian cast, associated with Hegel's account of the present,
passing historical moment of philosophy's esotericism. And I am
thinking of William Day's surprising and convincing work on im-
provisation in jazz in which he shows the, let us say, formal
intimacy of relationship demanded by improvisation to have a per-
fectionism structure. And thinking of Eli Friedlander's work on
Kant's Third Critique, in which he relates Emersonian Perfec-
tionism to Kant's discussion of genius and taste. And of Erin Kelly's
paper pressing the idea, as in my Lecture 1, of becoming ashamed of
one's shame. And of a conversation with Martin Stone on the idea
of the true self. And again, beyond these precincts, of Timothy
Gould's reflections on Kant, Wordsworth, Austin, Freud, and Der-
rida. My education, as Thoreau almost says, is sadly belated (he
says sadly neglected). I would be glad if it kept on getting itself a lot
later.

It is clear that in wishing to characterize a particular moral out-
look represented best (for me) in the writing of Emerson (and
Thoreau), I have made no systematic survey of the philosophical lit-
erature on the subject of perfectionism. But speaking of work there
is to do, I should mention two widely admired books that I am par-
ticularly aware of not having addressed, and make my excuses.
Joseph Raz, in *The Morality of Freedom*, in criticizing Rawls, fol-
lows Rawls in taking perfectionism as a teleological doctrine, and
since this is something I question from the beginning in taking ex-
ception to Rawls's characterization of the principle of perfection, it
did not seem to me that this was the context in which to measure
details of disagreement. In *The Sovereignty of Good*, Iris Murdoch
presents as a central or working case of perfectionist perception that
of a woman who comes to see her daughter-in-law in a new, more
loving light. Without denying the interest of the case, or of Mur-
doch's treatment of it, I do not see it as exemplifying what I am
calling Emersonian Perfectionism. The principle reason for this, I
think, is that I do not, from Murdoch's description, derive the sense
that in the woman's change of perception she has come to see

herself, and hence the possibilities of her world, in a transformed light. Without this sense, the case does not seem to generalize, but to be confined as one of overcoming snobbery in a particular case. This is, needless to say, morally vital, on a par with overcoming envy or (unjustified) anger or covetousness in a particular case. The peculiar importance of the vice of snobbery may lie in its representing a polar twin of envy. What Rawls calls the problem of envy plays a special role in *A Theory of Justice* because of "the fact that the inequalities sanctioned by the difference principle may be so great as to arouse envy to a socially dangerous extent" (p. 531). I imagine that these inequalities may, at an opposite distance from the equation of advantage, generate snobbery (and not just within the most advantaged). Since the (secular) perfectionist outlook I am sketching is concentrated within the position of the relatively advantaged (which I am taking to exclude the most disadvantaged and also the most advantaged), anyway those in positions for which social injustice or natural misfortune (to themselves) is not an unpostponable issue, the perfectionist may be variously subject to snobbery. But overcoming it in a particular case does not constitute a perfectionist transformation, a new attainment of the self; a passing bite of guilt might suffice.

The relative occlusion in academic moral philosophy of the dimension of the moral life spoken for in Moral Perfectionism has gone along with the dominance in moral philosophy of the struggle between teleological and deontological doctrines, represented chiefly in Utilitarianism and Kantianism. This conformation of moral philosophy has been increasingly contested, from various philosophical positions, in recent years. In addition to Murdoch's *Sovereignty of Good*, and Annette Baier's *Postures of the Mind*, cited in Lecture 3, I think of the work represented in G. E. M. Anscombe's *Ethics, Religion, and Politics*, volume 3 of her *Collected Philosophical Papers* (Minnesota, 1981); in Cora Diamond's *The Realistic Spirit* (M.I.T. Press, forthcoming); in Phillipa Foot's *Virtues and Vices* (Blackwell, 1978); in Alasdair MacIntyre's *After Virtue*, second edition (Notre Dame Press, 1984); in John McDowell's "Virtue and Reason," *The Monist*, 62, No. 3 (1979); in Bernard Williams's *Ethics and the Limits of Philosophy* (Harvard, 1985); and in Peter Winch's "Particularity and Morals," in his *Trying to Make Sense* (Blackwell, 1987). (I had forgotten that the use to which I put, as in Lecture 2 (p. 81), a paragraph from an early

essay of mine in measuring my sense of Wittgenstein's sense of, let's say, groundlessness against Kripke's sense of it, was encouraged by John McDowell's use of it, to similar effect, in "Non-Cognitivism and Rule-Following," in a section adapted from his "Virtue and Reason.") In the light of such work, the present lectures seem to me, however unpredictably, something of a continuation of the chapters in moral philosophy that constitute Part 3 of *The Claim of Reason.* Those chapters were part of the origin of the dissertation of which *The Claim of Reason* is the development, and were always meant to be continued, particularly the ideas in them of moral "conversation" and of the "position" that moral "argumentation" is meant to discover; together with ideas located in them of the systematic differentiation of morality and games from one another—where the concept, for example, of practicing a game (to be compared with the concept of a ritual or religious practice or exercise) is linked to what it means that a game is a form of *play,* and asks for assessment (however else) in an aesthetic dimension.

Restricting my attention to those in positions of relative advantage means that I am not attending to the condition of poverty, say economic victimization, nor to the condition of tyranny, political victimization. I assume that justice is bound to attend without fail to these conditions, so that if the perfectionist position I adumbrate is incompatible with this attention of and to justice, the position is morally worthless. To some, Emerson and Thoreau seem morally vulnerable just here, preaching poverty from a position of advantage; anyway, scorning those (as in a moment of the opening chapter of *Walden*) who would excuse themselves from "adventuring on life now" by claiming that they haven't the *means.* I have responded to this critical, not to say desperate, issue, beyond moments in Lecture 1, specifically as it presents itself in a famously outrageous passage in Emerson's "Self-Reliance," in my talk "Hope against Hope," appended to these lectures. I add, for future assessment, the thought that in Emerson's and Thoreau's America the standing social threat to the just life was not the existence and imagination of intractable poverty, and not general political tyranny, but the existence of chattel slavery.

The moral vulnerability of Emerson's and Thoreau's impatience may be described as a temptation to meta-snobbery, snobbery over not being a snob (like pride in transcending pride), an apparent effort to exempt oneself from the condition of morality (the divided

human condition) by surpassing it. But sainthood and angels no more overthrow morality than monstrousness or devils do. To think otherwise is under parody in Kleist's *The Marquise of O____*, one cause of its appearance in Lecture 3. This difficult tale, especially its parodic, ironic use of beauty to veil ugliness, and courtesy to mask violence, suggests a tone I do not suppose I will ever quite capture in Kleist's writing. I do mention in passing, in Lecture 3, its parody of romance, which suggests its terrible desire for romance, in gesture and in genre, and I cite Kleist's legendary response to reading Kant's persisting—it can seem ultimate—skepticism. I propose the irony of Kleist's tale as a continuation of his response to Kant, a further (self-)parody, anticipating Emerson's response to skepticism, in what Emerson figures as the human romance with the world, as in "Experience": "Thus inevitably does the universe wear our color"; and "Patience, patience. . . . There is victory yet for all justice; and the true romance which the world exists to realize, will be the transformation of genius into practical power." The universe as wearing our color suggests, as in the context of the tournament, that we are in the position of the feminine; the world as doing the realizing suggests that it is in the masculine; then we, in the world, are in both. It is as if Kleist will neither accept nor refuse the Emersonian vision, an excruciating one for those who can call for it but who cannot imagine themselves shaking their memories and starting again; call them Europeans.

Further ideas, whose omission in what follows I hope can also be taken as promises of continuation, indicate how under-analyzed or under-described I have left Emerson's conception of the self, especially as epitomized in his attributing to it (as I read him) predicates that are paired as the self's always having been attained and its always having to be attained. This double picture, or picture of doubleness, suggests rather opposite pictures of cases in which the idea of self-transformation is impertinent. One impertinence is represented in the figure of Billy Budd, whose purity seems not to be thinkable as attained and attainable, but only as given, hence whose integrity (a condition of which seems to be its existence in human isolation, essentially incommunicado) can only be preserved; hence, if attacked (and it will be attacked), or invaded, preserved violently. Another impertinence, or refusal of transformation, now in the face not of individual attack but of social cataclysm, and requiring all the oppositional (exemplifying) energy

of perfectionist perception, is suggested in descriptions that Hannah
Arendt awards to Karl Jaspers:

> But what is so magnificent about Jaspers is that he renews himself
> because he remains unchanged. . . .
> . . . It was self-evident that he would remain firm in the midst of
> catastrophe. . . . It meant a confidence that needed no confirmation,
> an assurance that in times in which everything could happen one
> thing could not happen. What Jaspers represented then, when he was
> entirely alone, was not Germany but what was left of *humanitas* in
> Germany. . . . The *humanitas* whose existence he guaranteed grew
> from the native region of his thought, and this region was never un-
> populated. What distinguishes Jaspers is that he is more at home in
> this region of reason and freedom, . . . than others who . . . cannot
> endure living constantly in it. . . . Well, freedom is more than inde-
> pendence, and it remained for Jaspers to develop out of independence
> the rational consciousness of freedom in which man experiences him-
> self as given to himself. . . . He need only dream himself, as it were,
> back into his personal origins and then out again into the breadth of
> humanity to convince himself that even in isolation he does not rep-
> resent a private opinion, but a different, still hidden public view—a
> "footpath," as Kant put it, "which someday no doubt will widen out
> into a great highway." (*Men in Dark Times*, pp. 78, 76, 77)

So I am restricting my attention not alone to individuals who are
more than least advantaged and less than most advantaged, but also
to social conditions that escape the extremes of chaos or of tyranny.
I will come to call these conditions those of good enough justice.

Of course I asked John Rawls, and of course, collegially, he agreed, to
read a late draft of Lectures 1 and 3. In the two long and full conver-
sations we devoted to them, the topic that most interested both of us
was whether *A Theory of Justice* denies anything I say, whether it
doesn't leave room for the emphases I place on things. If I am right
that the project of Emersonian Perfectionism demands no privileged
share of liberty and of the basic goods, Rawlsian justice should hold
no brief against it. As for this perfectionism's claim to speak for a
human life requiring no special, unequally distributed, gifts of
nature, however important that may be to some perfectionism's pic-
ture of itself, faith in it need not, I think, be of any particular interest
to the rule of justice, since it is equally important to this perfec-
tionism's picture of itself that it does not seek to impose itself by
power but recommends itself in its powerlessness. The constraint it

seeks to its standard (this echoes a phrase of Emerson's that I come back to) is understood as the self's coming to itself, or to its next self. —But if it is this easy for a perfectionism to accommodate itself to *A Theory of Justice*, why has Rawls bothered carefully to rule out the extreme form of the doctrine, associated by him with the name of Nietzsche, which on its face fails to get started in a (democratic) theory of justice?

There are, I think, various answers to this question. I have sometimes found myself speculating about why Rawls is not concerned rather to rule out, for example, instead of Nietzsche, the lesser figure, though in the English-speaking world hardly less influential, of George Bernard Shaw, oddly influenced by Nietzsche, and representative of the impressive perfectionist strain in Victorian socialism, which contains such names as William Morris, John Ruskin, and in the background Carlyle, Emerson's correspondent. A wayward speculation I realize, but prompted by the fact that Rawls's account of the perfectionist call for culture is quite counter to Nietzsche's struggles in Germany but quite consonant with Shaw's in England, as for example with Shaw's Professor Higgins in *Pygmalion*. Rawls formulates the principle of perfection as "directing society to arrange institutions and to define the duties and obligations of individuals so as to maximize the achievements of human excellence in art, science, and culture" (*A Theory of Justice*, p. 325). Shaw's Higgins, toward the end of his play, says to Eliza, "If you can't stand the coldness of my sort of life, and the strain of it, go back to the gutter. . . . Oh it's a fine life, the life of the gutter. . . . Not like Science and Literature and Classical Music and Philosophy and Art." Shaw and his strain of socialist thinkers do not regard the aspiration to culture to be incompatible with economic and political equality; I suppose on the contrary. Their arguments may not bear up. But the issue as it concerns the figure of Nietzsche in *A Theory of Justice* seems to be less over arguments than over aspirations, over what we have to seek arguments for.

But in the present moment, the approach I take to the question why Rawls has bothered to rule out the form of perfectionism associated with the name of Nietzsche is along different lines. Any perfectionism—democratic or aristocratic, secular or religious, philosophical or debased—will claim to have found a way of life from whose perspective all other ways of life are judged as wanting. Now Rawls directs the full force of justice against any proposed

principle of justice that wishes to favor, that is to say, to empower, one way of life over another (that is to say, where each way of life meets the two principles of justice chosen in the original position). I have denied that Emersonian Perfectionism seeks such favor. Moreover, this perfectionism directs its judgment not, as other perfectionisms may, at the resultant tolerance by justice of, let us say, vulgarity (it may be called obscenity, or unnaturalness, or superstition, or irreverence); it directs its judgment rather against the point at which justice takes up its sword, the point at which the ideal theory of justice (which is the part of the theory of justice A Theory of Justice is principally concerned to work out) is brought to "judge existing institutions" (cp. p. 246), that is, is used to judge the degree of partiality of their compliance with "the principles that characterize a well-ordered society under favorable circumstances" (p. 245). Rawls goes on to say that "[t]he measure of departures from the ideal is left importantly to intuition" (p. 246). What else is left? I find that the idea here of "left importantly to intuition" is ambiguous as between meaning that people on the whole do not go to the trouble to check their intuitions in these cases (check their intuitions against principles—we will come to this in a moment) and meaning that there is in principle little in the way of such checking that can be done in these cases. And it seems to me that this ambiguity may encourage Rawls's claim that a rational plan of life is one that can be lived "above reproach." It is this claim, above all I think, that my understanding of Emersonian Perfectionism contests, and it is the position of this contestation that, before all, I do not see that Rawls has left room for; it seems to me that he must deny it. This will come up variously, in the Introduction and in Lecture 3 particularly; but it may help to say something further about it at once. (It may, I recognize, not help everyone. If a reader finds himself or herself getting slowed down here uninterestingly, my advice is to move on to the Introduction and come back here another time.)

The idea of what citizens in different social positions "can say to one another" about the justice of their differences is fundamental to the persuasiveness and the originality of Rawls's moral theorizing. I speak of this idea, threading through A Theory of Justice, as the conversation of justice. But I leave this title ambiguous as between the conversation eventual citizens must have in arriving at principled judgments about the justice or fairness of the original position in which the principles of justice are chosen, and the conversations ac-

tual citizens must have in settling judgments about the degree of embodiment of those principles in the actual society, or system of institutions, of which they are part. To note this ambiguity now might help clarify my sense of the ambiguity in Rawls's formulation of what is "left importantly to intuition." When the conversation of justice is directed to the constitution of the original position, and intuition is checked by principles, the conversation of justice comes to an end in a state of reflective equilibrium. To prove that at any time within the circumstances of justice (see *A Theory of Justice*, section 22) there is an optimal resolution to this conversation (a set of principles whose choice will receive optimal agreement) is one of Rawls's notable achievements. There is, so far as I can see, no such proof to be expected that the conversation of justice has an optimal, or any, resolution, when it is directed to the constitution of our actual set of institutions. It seems to me that Rawls is taking encouragement from the proof concerning the resolution for the original position, to regard "above reproach" as a rational response to the question of affirming a plan of life in our actual society. Whereas this bottom line is not a response but a refusal of further conversation. Sometimes the invitation to such a conversation must be refused. When, in effect, at the denouement of *A Doll's House*, as considered in Lecture 3, Nora's husband, Torvald, claims that he is beyond reproach, that Nora has no claim against him, or against the institutions of their society, he is closing a door to which Nora's ensuing, more explicit, closing of a door is the mirroring answer. The ambiguity in "left to intuition" conceals the assumption, or picture, or premiss, I think, that intuition can only be checked, or rationalized, or brought into reflective equilibrium, by principles.

Let us sketch how the appeal to intuition in measuring departures from the ideal (p. 246) differs from the appeal to intuition in arriving at reflective equilibrium (pp. 19–20). In the latter case, our "judgments of the basic structure of society," which are to be matched with the principles of justice, are, before that matching, made "intuitively, and we can note whether applying these principles would lead us to make the same judgments . . . in which we have the greatest confidence [for example, that religious intolerance and racial discrimination are unjust]; or whether, in cases where our present judgments are in doubt and given with hesitation [for example, as to what is the correct distribution of wealth and authority], these principles offer a resolution which we can affirm on reflection"

(pp. 19, 20). ("I assume that eventually we shall find a description of the initial situation that both expresses reasonable conditions and yields principles which match our considered judgments duly pruned and adjusted. This state of affairs I refer to as reflective equilibrium" (p. 20).) But the matching of principles with considered judgments yielding reflective equilibrium does not describe the process of bringing a present perception (say, of a constitution of intolerable inequality or discrimination) under what Kant describes in the *Critique of Judgment* as reflective judgment. In the former case intuition is left behind; in the latter case intuition is left in place. In both cases there is, it seems to me, an idea or picture of matching in play. In arriving at reflective equilibrium the picture is that judgment finds its derivation in a principle, something more universal, rational, objective, say a standard, from which it achieves justification or grounding (though the principle will typically undergo challenge and modification by the intuitive force of judgment in order to fit itself for this role). In reflective judgment, rather, the idea is of the expression of a conviction whose grounding remains subjective—say myself—but which expects or claims justification from the (universal) concurrence of other subjectivities, on reflection; call this the acknowledgment of matching. For aesthetic judgment this claim is, as Kant famously formulates the matter, to be speaking with a universal voice. For moral judgment we might formulate the matter as the claim to be listening to the universal voice (the moral law, which commands respect). (That justice is blind—eyes covered to accidents of social position and natural fortune—is expressed in Rawls's image of the veil of ignorance. In my referring to justice's sword, I was assuming [with Rawls] that this cover is in a sense never abandoned, but also that, even with sword raised, justice is not deaf to calls upon its name. The issue then is how it must respond to this call, perhaps by reaffirming that its scales are fair, or by rejudging, recounting, the weights in them.)

It is, I surmise, because a moral judgment of a state of affairs (not [yet] issuing in a judgment as to the action imperative in the face of this state) has a perceptual dimension and assesses pleasure and pain, and because it is informed by sensibilities in various stages of perceptiveness or impressionability, that moral judgment is sometimes held to have an aesthetic dimension. Perfectionists, judging the world and themselves in it, may seem to dwell in this dimension or realm. Rawls has shown why this dimension must not affect the

moral necessity of reflective equilibrium (the fact of matching be-
tween judgments and principles) expressed in the joint choice in the
original position of the principles of justice. But this should not
compromise the moral necessity of reflective judgment (the demand
for and exposure to, the matching of one's judgment by the judg-
ment of others) in measuring the degree of one's life's, hence of
one's society's, departures from compliance with those principles.

"Of one's life's, hence of one's society's." This "hence" is mov-
ing terribly fast. It contains the idea that measuring the degree of
one's society's distance from strict compliance with the principles of
justice is a function of taking the measure of one's sense of compro-
mise with injustice, or rather with imperfect justice, in one's life
within actual institutions. This does not rule out the possibility of
attributing the departure of one's life from one's plan of life as a case
of akrasia (or say neurosis); it rather makes this possibility part of
the intuition concerning the historical state of things, part of the
judgment whether the conduct of one's life need be, given the way
the world is, so far less than it might be. Of course the clause "given
the way the world is" may be taken as exactly irrelevant in the per-
fectionist dimension to the measurement of the conduct of one's
life, say the state of one's soul. This irrelevance of the world (as it is)
was of the starkest significance to Wittgenstein at the time of the
making of the *Tractatus*, before and after the First World War, as it
was to other European thinkers and artists in this period. I think
Philosophical Investigations may be seen not as a repudiation of this
sense of the irrelevance of the world, but as a further way of re-
sponding to the, let's say, absolute responsibility of the self to
itself—not now as the fixed keeping of its counsel of silence in and
about what cannot be asserted or explained ("said"), but through the
endless specification, by exemplification, in the world (of and with
others) of when words are called for and when there are no words.
Call this the absolute responsibility of the self to make itself intel-
ligible, without falsifying itself (say by overstepping the limited
ways in which it can express itself—but since these are the human
repertory of ways of expression, how can we humans "overstep"
them, how can we so much as try to, what drives us to excess, some-
thing extreme or something central in the human?). This way of
picturing the turn from the *Tractatus* to the *Investigations* (as one
pivoting on ideas of responsibility of the self to itself, by way of oth-
ers, so by way of being other to itself) does not repudiate the

religious dimension of Wittgenstein's teaching, since this turn may
be understood as a turn within that dimension. What stands out,
rather, to my mind, in this way of expressing the turn, is the impor-
tance, the incessance, of skepticism in the *Investigations*, its
becoming part of the textuality of this philosophizing, the shadow
of this writing's address, in every word, to the ordinary (actual or
eventual). Leading words back to their everyday use (one of the
Investigations's signature descriptions of itself that will reappear
variously in the lectures to follow) is both in practice and in myth an
expression of the self's answerability, questionability, to and by it-
self. ("Absolute responsibility of the self to make itself intelligible"
is not, I trust, to be dismissed as unrealistic by interpreting it meta-
physically, as if it said "responsibility of the self to make itself
absolutely intelligible," which is presumably an empty counsel,
hence tempting. The absolute responsibility may be perfectly dis-
charged, in a given case, by a willingness to stammer, as prophets,
for example, will, as in "The American Scholar": "Long must . . .
[the scholar] stammer in his speech. . . . For the ease and pleasure
of treading the old road, accepting the fashions, the education, the
religion of society, he takes the cross of making his own, and, of
course, the self-accusation . . . in the way of the self-relying and
self-directed." Alternatively, the deprivation of standing ways and
means, or position, in which to meet this responsibility, the respon-
siveness of one's partiality, expressed perhaps in showing the self's
enraged irresponsibility for the world as it is—hence the absolute
injustice of being denied a self, the bearing of one partiality among
others, so the fate to scream for and from the exposed human condi-
tion—may sound like the Queen of the Night. [This thought of *The
Magic Flute* is a preliminary, admiring response during a first read-
ing of Catherine Clément's recently translated *Opera, or the
Undoing of Women.*])

In both moral and aesthetic judgment we may find ourselves iso-
lated from and by others (Kant's "footpath" may not [now, ever]
widen out). And while it can seem that we can afford quite easily to
get along without aesthetic companionship, perfectionists will wish
to show how fateful that isolation can be. Such considerations might
move us to ask afresh what the relation is between the realm of the
aesthetic and the fact of art. The answer seems no more obvious
than what the fact of art is. Or I might say: The relation of the aes-
thetic to the fact of art is no clearer than its relation to the fact of
philosophy.

I understand the intersection of the aesthetic and the moral to be expressed in Emerson's sentence (as often with his sentences, not especially remarkable, yet eminently remarkable) from "Self-Reliance": "You are constrained to accept his [namely, the true man's] standard." This will come back. I take it for a moment now as a touchstone, or say fair warning, of the sort of interpretative demand I place on certain texts that other philosophical temperaments will deplore or will not give recognition as philosophy. Would it help for me simply to assert that a perfectionist relation to a text (words ordered by another) is an emblem of the relation perfectionism seeks from another, as if there is no respite from attention to the course of one's life? Is this morality? (Compare *A Theory of Justice*, page 50: "If we should be able to characterize one (educated) person's sense of justice, we would have a good beginning toward a theory of justice. We may suppose that everyone has in himself the whole form of a moral conception. So for the purposes of this book, the views of the reader and the author are the only ones that count.") Emerson's sentence just cited is an Emersonian rethinking—in Lecture 1 I characterize Emersonian thinking in general as a kind of rethinking—of two fundamental concepts of Kant's *Foundations of the Metaphysics of Morals:* Emerson's "standard" alludes to Kant's two "standpoints," the ability to take which, to take both, defines the human; and "constraint" alludes to Kant's defining of the moral (hence human) realm as characterized by a constraint expressed by an "ought." (I assert these connections thus starkly, not because on another occasion I could not list plenty of preparatory connections between "Self-Reliance" and Kant's *Foundations,* but rather precisely to indicate that there is no pure or necessary philosophical preparation for the connections, none that would show Emerson's allusions, granted that they are at work, to be philosophical rather than literary, or serious rather than parodic, or polemical rather than ironic. I might say that the question whether morality has a foundation in reason is given the following slant of answer in Emerson: Perfectionism has its foundation in rethinking.) In Emerson's teaching—in which the moral is not a separate realm or a separate branch of philosophical study, but one in which each assertion is a moral act (intrusive or not, magnanimous or not, heartfelt or not, kind or cutting, faithful or treacherous, promising cheer or chagrin, acknowledging or denying)—constraint names, in the place of the Kantian "ought," a form of attraction, the relation to the friend; and judgment is backed not by a standard (a moral law, a principle of

justice) but fronted by the character of the judger. Whether judg-
ment expressing a call for change, entered without the imperative
"ought" and in the absence of a (nonsubjective) standard, can count
as moral will depend on what changes one regards as morally
brought on. A call for change will not be expressed as a particular
imperative when what is problematic in your life (as of now) is not
the fact that between alternative courses of action the right has be-
come hard to find, but that in the course of your life you have lost
your way.

That what is then required is a turn, or return (to, of, from the
self)—Dante provides a constant guide for this journey, up to a
point; Emerson characterizes the juncture as our thoughts return-
ing to us, by way of a guide—and that this is philosophy's, or
thinking's, business, is registered from Plato to Wittgenstein and
Heidegger as philosophy's proceeding by (a methodical) remember-
ing. Memory is the access to that knowledge that constitutes the call
for a change expressed as a (re)turn. Emerson's "Experience," as
taken on in my "Finding as Founding," is essentially a working out
of the violence of the image of change, of the taking of a spiritual
step, as it were, as a series of rememberings, say disfragmentings,
reconstitutions of the members of, and of membership in, one's
stranded state. (I deliberately shade this description, in its placing of
the word "state," to bring out the allegory of the social by the indi-
vidual soul, hence to register that from the first Emerson takes up,
by reversing, Plato's allegory of the soul by the social.) If I were still
composing the ensuing Introduction, "Staying the Course," I
might, in drawing up a list of features of Plato's *Republic* as candi-
dates for constructing a thematics of perfectionism (pp. 6–7), as a
further nomination try to discern the Platonic idea of knowledge as
memory and vision in the figure of the sun as representing the at-
tractiveness of the Good, and as something implied in our first
glimmers of our actual condition. (Or I might move to Wagner's
Ring, in which a story keeps being recalled and retold as if its signifi-
cance is bound to be forgotten, and in which the motivation to
perfection—one set of its conditions—is the need to undo the curse
of fathers as gods [and vice versa].)

What makes change (supposing it is possible) hard; why does it
suggest violence? Why, asked otherwise, is perfectionism (appar-
ently) rare? How may a perfectionist who insists that the outlook is
not essentially elitist, that it requires (and deserves) no special share

of social goods or of biological endowment, account for the apparent fact that so few people choose to live it, but instead apparently choose lives of what Thoreau calls quiet desperation, what Emerson calls silent melancholy? Why is this perpetual pain preferred to the pain of turning? Perfectionism's tuition of this intuition will tend to portray its vision of social as well as of individual misery less in terms of poverty than in terms of imprisonment, or voicelessness. If politically the vision can serve to discount the systematic fact of poverty, might it not as well serve to reveal poverty as social violence?

The idea of a knowledge that brings about, or constitutes, the change of turning invites a further word cautioning against, in what follows, attaching any fixed, metaphysical interpretation of the idea of a self in my understanding of Emersonian Perfectionism—the idea of it as always attained and always unattained. That idea of the self must be such that it can contain, let us say, an intuition of partial compliance with its idea of itself, hence of distance from itself, space for consciousness of itself, or of consciousness denied. The companion concept of society is such that partial compliance with its principles of justice is not necessarily a distancing of oneself from it, but may present itself as a sense of compromise by it or conspiracy with it. (This needs work: compromise and conspiracy have analogues as well for the relation of the self to itself. Silent melancholy may be taken as a sense of political depression.)

Attention to the aesthetic aspect of (moral) judgment suggests a way of accounting for my speaking of Perfectionism not as a competing moral theory (say requiring a principle of justice or ordering of principles different from the proposals of Rawls) but as emphasizing a dimension of the moral life any theory of it may wish to accommodate. Any theory must, I suppose, regard the moral creature as one that demands and recognizes the intelligibility of others to himself or herself, and of himself or herself to others; so moral conduct can be said to be based on reason, and philosophers will sometimes gloss this as the idea that moral conduct is subject to questions whose answers take the form of giving reasons. Moral Perfectionism's contribution to thinking about the moral necessity of making oneself intelligible (one's actions, one's sufferings, one's position) is, I think it can be said, its emphasis before all on becoming intelligible to oneself, as if the threat to one's moral coherence comes most insistently from that quarter, from one's sense of obscurity to oneself, as if we are subject to demands we cannot

formulate, leaving us unjustified, as if our lives condemn themselves. Perfectionism's emphasis on culture or cultivation is, to my mind, to be understood in connection with this search for intelligibility, or say this search for direction in what seems a scene of moral chaos, the scene of the dark place in which one has lost one's way. Here also is the importance to perfectionism of the friend, the figure, let us say, whose conviction in one's moral intelligibility draws one to discover it, to find words and deeds in which to express it, in which to enter the conversation of justice. With respect to the issue whether virtue is knowledge, whether virtue can be taught, whether to know the way is to take the way, perfectionism's obsession with education expresses its focus on finding one's way rather than on getting oneself or another to take the way.

The idea of the conversation of justice was developed initially, as said, to mark an essential and recurrent moment in *A Theory of Justice*; but it is meant also to allude to everything from the too-familiar fact that Plato's founding *Republic*, discussing justice, is written as (reported) dialogue, as if declaring that philosophical prose founds itself as a conversation of justice; to the exchanges in such works as Ibsen's *A Doll House* and in those of the films I adduced in staying the Moral Perfectionism course, in which conversations continued or broken constitute or dissolve a relationship as a marriage, and in which this relationship bears the weight of friendship, which Aristotle says "would seem to hold cities together."

And now, thinking of the painful omissions in the lectures to follow, I note, together with the connection between the conversation of justice and the moral demand (or demand of sanity) for intelligibility, the idea of expressing one's (human, moral, rational) nature. It is a test Rawls invites of his theory that it provide "better than any other theory known to us . . . a mode of expression for what we want to affirm" (p. 452). (Here is a reason for understanding the writing in *A Theory of Justice* to be meant as *part* of the conversation of justice [mostly its ideal part], to enter into that kind of civic, or pre-civic, relation with each of its readers.) The idea of expression as a moral test harks back to Kant's idea of acting from the moral law as "[giving] expression to [our true] nature" "as free and equal rational beings" (*A Theory of Justice*, pp. 253, 252). Impressed by this importance of giving expression as rendering

intelligible in *A Theory of Justice*, I hear throughout that book an attention to images and to, let us say, allegory otherwise easy to pass by. So I place greater literary significance, I guess I have to say, than other philosophers will find appropriate on Rawls's directions for reading his work, as in such a passage as this:

> Each aspect of the contractual situation can be given supporting grounds. Thus what we shall do is to collect into one conception a number of conditions on principles that we are ready upon due consideration to recognize as reasonable. These constraints express what we are prepared to regard as limits on fair terms of social cooperation. One way to look at the idea of the original position, therefore, is to see it as an expository device which sums up the meaning of these conditions and helps us to extract their consequences. On the other hand, this conception is also an intuitive notion that suggests its own elaboration, so that led on by it we are drawn to define more clearly the standpoint from which we can best interpret moral relations. We need a conception that enables us to envision our objective from afar: the intuitive notion of the original position is to do this for us.

It is from such passages, together with Rawls's unfailing attention, in relating his systematizing intuitively to ideas associated with the myth of the original contract, that I have derived encouragement in reconceiving, or re-expressing, intuitive responses of mine to ideas of the contract, of the state of nature to which it opposes itself, of consent, of the conversation moral relationship exacts or constrains us to, of cooperation as conformity—encouragement to suppose that my somewhat contesting expressions, however sketchy, are (their failings aside) not opposed to a certain spirit in the writing of *A Theory of Justice*.

The idea of expressing our nature enters into Rawls's answer to a criticism leveled against Kant by Henry Sidgwick to the effect that "on Kant's view the lives of the saint and the scoundrel are equally the outcome of a free choice (on the part of the noumenal self) and equally the subject of causal laws (as a phenomenal self)" (*A Theory of Justice*, p. 254). Rawls admits this "defect" in Kant and believes it is "made good . . . by the conception of the original position," taken as "the point of view from which noumenal selves see the world," and conceiving noumenal selves as having freedom over their choice of principles "but [as also having] a desire to express their nature as rational and equal members of the intelligible realm" (p. 255). But doesn't this assume a limitation in the kinds of scoun-

drel (or saint) there may be, in particular that there are none touched with the satanic, with an intolerance precisely for membership, for reciprocity in the intelligible, or any other, realm? (*The Marquise of O*____ may be seen as an anxious denial of, hence familiarity with, the possibility of such a figure.)

Such a thought is, I think, invited by the idea of a noumenal self as one's "true self" (pp. 254, 255) and of this entity as having desires and requiring expression. This fantasy of a noumenal self as one's true self seems to me rather to be a certain expression or interpretation of the fantasy of selflessness (Kant's holy will; Bankei's Unborn (cited on page 5)); the idea would be that the end of all attainable selves is the absence of self, of partiality. Emerson variously denies this possibility ("Around every circle another can be drawn," from "Circles"), but it seems that all he is entitled (philosophically) to deny is that such a state can be *attained* (by a self, whose next attainment is always a self). Presumably a religious perfectionism may find that things can happen otherwise. The idea of the self as on (or lost with respect to) a path, as a direction to a fixed goal, needs its own study. I suppose selflessness may be figured as itself a goal or else as constituted by goallessness (satirizable as idleness). Emerson's thought of endless, discontinuous encirclings, or, as elsewhere, as steps up or down, does not imply a single, or any, direction, hence, in one sense, no path (plottable from outside the journey). (From "Self-Reliance": "If I am the Devil's child, I will live then from the Devil." The idea is that attempting not to live so would not protect the world from the fact of you, probably on the contrary. And surely not to live, turn, against your attained makes you more subject—conforming—to the devil of others.)

While the idea of the noumenal plays a role in what I understand as Emersonian Perfection (as when in "Experience" Emerson breaks into his thoughts by saying "I know that the world I converse with in the city and in the farms, is not the world I *think*"), and is related to an idea expressed as being true (or false) to oneself, I assume no role for the idea of a true (or a false) self. Such an idea seems rather something imposed from outside oneself, as from another who has a use for oneself on condition that one is beyond desire, beyond change; which surely does not deny that such another might be oneself. Nor, in a similar domain, will I appeal in what follows to an idea of a duty to oneself, which, whatever it means, is not to be weighed in the balance against a duty to others. I can no more neu-

tralize a promise (to another) by what I call keeping a promise to
myself than I can neutralize a debt by using money or time or atten-
tion I owe you to pay for, or to do, something I owe myself—unless,
perhaps, I think of myself as entitled to a deeper complication of
debt with you. "Duty to myself," put otherwise, should not be used
to flinch from a moral and intellectual crisis of following—without
moral lunacy—what morally (on a major view of the moral) is no
more considerable than whim (the assertion of my sensuous nature,
here opposed as a whole to my intelligible nature) as the basis for
breaking with a promise.

A reading of Bernard Williams's "Persons, Character, and Mo-
rality" (collected in his *Moral Luck*) prompts me, or permits me—
brought again to recognize my under-description or under-analysis
of Emerson's conception of the self—to say another word in antici-
pation of the idea, companion to the idea of the attainable self, of the
"next" self. The knowledge Emerson expresses of the non-identity
of the world he converses with and the world he thinks is an ex-
pression of what I called a while ago his picture of the doubleness of
the self. This expression of doubleness, part of Emerson's continu-
ing interpretation of Kant's interpretation of the human as the
capacity to take "two standpoints" toward itself, can, I hope, serve to
show that the idea of what I will be calling the "next" (or "further")
self survives the arguments Williams, in the essay just cited, brings
against Derek Parfit's proposals concerning "future" or "successive"
selves in his "Later Selves and Moral Principles" (in A. Montifiore
[ed.], *Philosophy and Personal Relations*). A principal issue con-
cerns the imagining of the relation of past and future selves,
whether a relation between things so conceived can express what
Williams formulates as "the peculiar unity of one person's life."
The idea of "nextness" has the idea of futurity in it, but it is meant
to register the spatial as well as the temporal suggestion (meta-
phor?) in being next (to). So one may find a way to say that the next
self is (already) present. (As an attainably better [state of the] world
is present in it.) If we ask, Present to what?, I think we may find
ourselves answering, To itself. Some philosophers will take this as
clear enough warning not to pursue the idea further. But for me its
speaking of the reflexiveness of the self registers a fact of selfhood,
of the human, for which I assume any view of the self will have, or
want, an account. The doubleness in Kant's two standpoints, or two
worlds, that the human takes upon itself, or lives in, is, I think,

understandable as a projection of reflexiveness. The intelligible
world would be the scene of human activeness, the sensuous world
that of human passiveness. Then Kant's moral imperative, his
"ought," which the doubleness of human habitation is meant to ex-
plain, or picture, is also an explanation, or shows the place for one,
of the self's identity, that it is the *same* self that is active and passive
(if the one who knows and the one who is known were not one [one
what?], what would self-knowledge be [of]?). My reading of Emer-
son takes him, however else, as looking everywhere to inherit
Kant's insight without his architectonic (he isn't the only one); to
account, for example, for "constraint" without the conditions of the
imperative "ought" and so without Kant's fixed differences between
the intelligible and the sensuous realms, between the imposition of
the categories and the reception of their intuitions—departures
from Kant that will require Emerson to find freedom and knowledge
as much in the passive (patience, passion) as in the active dimen-
sions of selfhood.

Returning for a moment to the question how one might take on
the picture of the scoundrel (say in asking whether he or she may
find their natures expressed in unshared and unshareable principles,
or in asking whether the unjust can be happy), I add that a role for it
in perfectionism lies in asking how the demand of one's human
nature for expression demands the granting of this human demand
to others and in showing that at some stage the scoundrel, opting
out of membership in the intelligible realm, must seek to deprive
others of expression, of their voice in choosing the principles, or say
ideas, of their lives. This further interpretation of self-obscurity, of
the demand for intelligibility, of the desire for the expression of
one's human nature, in terms of the (re)claiming of one's voice, is
registered, as I read *A Doll's House* in Lecture 3, in Ibsen's staging
the moral stakes as one of Nora's finding her voice. Torvald says to
her, of her, characteristically, "A songbird must have a clear voice to
sing with"—the sort of words in which he has managed, for the
eight years of their marriage, to control her voice, dictate what it
may utter and the manner in which it may utter it.

Becoming intelligible to oneself may accordingly present itself as
discovering which among the voices contending to express your
nature are ones for you to own here, now. (The contention among
voices may shift without settling once and for all. If voice is a predicate
of a self, then the contention of voices suggests that, while a self

has a world, the peculiar unity of the world of a self may express itself as a dissonance, a scene, say, of abdication, division, banishment, war, imprisonment.) Emerson's state of conformity is to be related to Kant's state of conformity to the moral law, as opposed to acting for the sake of the law, which Emerson's idea interprets, I believe with full awareness. To one in the state Emerson names self-reliance, every word urged from one in the state of conformity causes chagrin, violates the expression of our nature by pressing upon us an empty voice, hence would deprive us of participation in the conversation of justice. This emptiness is something, it seems to me, Marx is fantasizing when he speaks near the end of his *Critique of Hegel's Philosophy of Right: Introduction* of "a social group that is the dissolution of all social groups, of a sphere that has a universal character because of its universal sufferings and lays claim to no particular right, because it is the object of no particular injustice but of injustice in general. This class can no longer lay claim to a historical status, but only to a human one." John Stuart Mill is giving voice to this emptiness in the passage from *On Liberty*, quoted at the end of my Lecture 1, which describes our times as an epoch in which "from the highest class down to the lowest," everyone, in exercising their tastes and deciding upon a course of conduct, thinks first of conformity; "until by dint of not following their own nature, they have no nature to follow."

Deprivation of a voice in the conversation of justice is not the work here of the scoundrel (so I am not as keen as others seem to be to let the worth of moral theory depend on its being able to (re)convince a convinced scoundrel; I am rather more worried over the clarification of the grounds on which the scoundrel may and must be discounted); deprivation here is the work of the moral consensus itself, spoken for by the respectable Torvalds of the world (in us). If the reservations and reinterpretations I express and propose in my intermittent readings of certain passages of *A Theory of Justice* ever arrive at anything other than local supplementations or extensions of those passages, and uncover a disagreement with that work whose line of resolution is not clear, it must concern this matter, as come upon differently earlier, of how and where the conversation of justice stops. Earlier the moment of the failure of conversation presented itself as a refusal of conversation; here it presents itself rather as a denial that conversation has been offered. ("It seems reasonable to suppose that the parties in the original position are equal"

(*A Theory of Justice*, p. 19). But what if there is a cry of justice that expresses a sense not of having *lost* out in an unequal yet fair struggle, but of having from the start been *left* out. Is such an intuition false to the myth of the original contract?) When Rawls says "Those who express resentment must be prepared to show why certain institutions are unjust or how others have injured them" (p. 533), he seems to be denying precisely the competence of expressions claiming a suffering that is (in Marx's words, but without Marx's differentiation of classes) "the object of no particular injustice but of injustice in general," or of expressions attesting (in Mills' idea, but without Mill's indifference to classes, or say social "positions") that the mass of the individual members of society have been deprived of a voice in their histories. My discussion of Nora's case in Lecture 3 serves to test this denial.

These notes of my sense of omissions in the texts of these Carus lectures are not meant to express regret over some systematic lack of completeness in them. It goes without saying that they are sketches. And the temptation to go on with them begins to seem a ruse to distract from my anxiety that I have not made a sound or interesting enough departure to give the issues further room for thought. So I reaffirm the lectures' announced aim of bringing certain figures and texts and topics back, and together, to the fuller attention of the institution of philosophy, both to those who stake their residence within its circle and to those whose circles, like it or not, intersect philosophy's.

I conclude these notes having just concluded offering the Moral Reasoning core course on Moral Perfectionism for the second time. This time around James Conant gave six of the lectures, and Steven Affeldt took on, faultlessly, the endlessly surprising complexities of the position of this course's head section person. Again Daniel Rosenberg and Charles Warren held sections for the course, now joined by Nancy Bauer, Eli Friedlander, and Arata Hamawaki. And again all of us met together at least once a week to discuss the intellectual and pedagogical aspirations and consequences of this effort. These discussions would deepen my sense of omission or limitation, but at the same time my sense of hope, as I had to recognize, and to try to mark for another day, new paths of promise my courses of lectures, for the course, and for the Carus occasion, did not find their way to take.

The bibliography for this book, compiled so resourcefully by William Bristow, differs in various respects from a listing, in the most authoritative editions, of works cited in the text: it takes care to cite works in the editions from which they are quoted (thereby obviating the need for footnote references); it undertakes to include works merely alluded to or simply listed; and, where sensible, gives editions that are more likely than others to be readily available. This plan goes with my fantasy that this book, in seeking its readers, must find various destinations; and that an accidental reader may at any time, and from any level or direction in his or her getting an education, be moved to follow out parts of the book's background or follow on leads from its sidelights.

Thanks are owed, and I know I speak for the whole staff of teachers involved in the Moral Perfectionism course, to Harvard's Core Curriculum office, particularly to Dean Susan Lewis, for cooperation in meeting the extraordinary logistical demands of the course; and to the curator of the Harvard Film Archive, my friend Vlada Petric, and to his assistants Roberta Murphy and, this year, James Lane, for accommodating the screening, and, on cassettes, the individual reviewing of more than a dozen films by several hundred students.

Not untypically, in the economy of absences and presences that goes into the writing I do, my family shares the immediate cost of the absences; among whatever pleasures, I know Cathleen and Benjamin and David also share that of dedicating this book to Kurt Fischer.

I end with grateful thoughts of the succession of days in Portland on which the Carus lectures were delivered, and of the gracious introductions to each of them by, respectively, Joel Feinberg, Julius Moravcsik, and John O'Connor.

Brookline
June 1990

INTRODUCTION
Staying the Course

Is Moral Perfectionism inherently elitist? Some idea of being true to oneself—or to the humanity in oneself, or of the soul as on a journey (upward or onward) that begins by finding oneself lost to the world, and requires a refusal of society, perhaps above all of democratic, leveling society, in the name of something often called culture—is familiar from Plato's *Republic* to works so different from one another as Heidegger's *Being and Time* and G. B. Shaw's *Pygmalion*. What the question means, and what I will mean in proposing that there is a perfectionism that happily consents to democracy, and whose criticism it is the honor of democracy not only to tolerate but to honor, called for by the democratic aspiration, it is a principal task of these Carus Lectures to clarify.

Because I have for some years seemed to myself to know, against the untiring public denials of the fact, that Emerson is a thinker with the accuracy and consequentiality one expects of the major mind, one worth following with that attention necessary to decipher one's own, I have found myself under increasing pressure to understand what makes the fact incredible, and not just to current academic philosophical and literary sensibilities. An obvious cause is Emerson's manner of writing, to justify which as philosophy would seem to require both justifying it as (the expression of) a mode of thinking and explaining why what it accomplishes is not to be accomplished in more canonical forms of argumentation. Beyond or behind this source of incredibility, or let me say resistance, another resistance has unscreened itself as separately thematizable, that Emerson's prose is in service of, or formed (however else) in view of, a moral outlook that has largely lived in the disfavor of academic moral philosophy, when, that is, that philosophy has taken notice of it at all. In the history of modern moral philosophy, a development that has been fairly orderly along a course set by the writings of Hume and of Kant, the reigning theories in contention, with exceptions perhaps more numerous and persuasive in recent decades than in the past, have been those of Utilitarianism (the favored teleological theory, founding itself on a concept of the good) and Kantianism (the favored deontological theory, founding itself on an independent

1

concept of the right). From the perspective of these theories, Moral Perfectionism, seeming to found itself, let us say, on a concept of truth to oneself, may appear not to have arrived at the idea, or to disdain it, of other persons as counting in moral judgment with the same weight as oneself, hence to lack the concept of morality altogether.

Perfectionism, as I think of it, is not a competing theory of the moral life, but something like a dimension or tradition of the moral life that spans the course of Western thought and concerns what used to be called the state of one's soul, a dimension that places tremendous burdens on personal relationships and on the possibility or necessity of the transforming of oneself and of one's society— strains of which run from Plato and Aristotle to Emerson and Nietzsche, and pass through moments of opposites such as Kant and Mill, include such various figures as Kleist and Ibsen and Matthew Arnold and Oscar Wilde and Bernard Shaw, and end at my doorstep with Heidegger and Wittgenstein. (That Heidegger and Wittgenstein are instances of what I see as perfectionism is more important in my motivation to begin thinking through the subject—particularly, of course, given the course of Heidegger's biography—than their appearances in what follows here will make clear. In the case of Heidegger I take for granted that his emphasis in *Being and Time* on "authenticity" and his protesting that his writing is not to be comprehended within the separate discourse of ethics, intuitively attest to his belonging to the subject of perfectionism. How useful the subject will prove to be in coming to terms with Heidegger's history remains to be seen. In the case of Wittgenstein what I say here leaves his relation to perfectionism quite indirect, so I mention that I am extending the view of his *Investigations* that I propose in "Declining Decline: Wittgenstein as a Philosopher of Culture.")

Even before going on, in a moment, to amplify and specify perfectionist texts, the absence of women's names on this list of names might, should, at once raise the question, Where is the voice of the woman in this view of things: nowhere or everywhere? My intellectual access to this question lies most immediately or systematically in the thinking I have done about film, where certain comedies (remarriage comedies) exemplify relationships that make moral sense—to the extent that they are credibly happy—not in terms of Utilitarian or of Kantian lines of thought, but in terms, I am learning to say, of Emersonian Perfectionism. Certain melodramas

derived from these comedies, or from which the comedies derive, accordingly exemplify relationships, and the end of them, that negate moral sense. Both genres essentially concern the status of the woman's voice, say her consent.

Since Emerson's thinking and Emerson's perfectionism are companion matters, I broach each of them as halves of my first lecture, and then in the second lecture I elaborate the thinking half by taking up the instance of Kripke's discussion of Wittgenstein's ideas of rules and privacy, and in the third lecture I elaborate the perfectionist half by taking up instances of its appearance in examples from film and from theater. The question of perfectionism needs initially more discussion since it goes counter to the particular account of perfectionism to be found in John Rawls's A Theory of Justice, which has, more than any other book of the past two decades, established the horizon of moral philosophy for the Anglo-American version or tradition of philosophy (at least). My admiration for Rawls's work is, among other reasons, for its accomplishment in establishing a systematic framework for a criticism of constitutional democracy from within. Is there a more serious and pressing political issue than the articulation of such a criticism? What I have to say concerning the issue in these lectures builds from my sense of rightness and relief in Rawls's having articulated a concept of justice accounting for the intuition that a democracy must know itself to maintain a state of (because human, imperfect, but), let me say, good enough justice. Apart from this state there are perfectionisms, but their role cannot, by hypothesis, be that of criticizing democracy from within.

My direct quarrel with A Theory of Justice concerns its implied dismissal of what I am calling Emersonian Perfectionism as inherently undemocratic, or elitist, whereas I find Emerson's version of perfectionism to be essential to the criticism of democracy from within. It should follow from this that Emersonian Perfectionism does not imply perfectibility—nothing in Emerson is more constant than his scorn of the idea that any given state of what he calls the self is the last. Yet I keep the old-fashioned word "perfection" in play for a number of reasons. An important reason, for me, is to register Emerson's sense—and Freud's, not to mention Plato's—that each state of the self is, so to speak, final: each state constitutes a world (a circle, Emerson says) and it is one each one also desires (barring inner or outer catastrophes). On such a picture of the self one could say both that significance is always deferred and equally that it is never

deferred (there is no later circle until it is *drawn*). The section on perfectionism in *A Theory of Justice* (sec. 50) takes Nietzsche as epitomizing what Rawls calls the strong version of perfectionism; Rawls then dismisses the view as a serious contender in the arena of a democratic theory of justice on the basis, as I spell out in some detail in the first lecture, of what I find to be a misreading, or over-fixed reading, of a set of Nietzschean sentences. My particular fascination with this dismissal is that the passage from Nietzsche is a virtual transcription of Emersonian passages, so that at a certain juncture of Rawls's book there occurs a continuation of American philosophy's repeated dismissal, I sometimes say repression, of the thought of Emerson. To what extent is this gesture necessary to philosophy?

A definition of what I mean by perfectionism, Emersonian or otherwise, is not in view in what follows. Not only have I no complete list of necessary and sufficient conditions for using the term, but I have no theory in which a definition of perfectionism would play a useful role. I emphasize accordingly that an open-ended thematics, let me call it, of perfectionism, which I shall adumbrate in a moment, is not to my mind a mere or poor substitute for some imaginary, essential definition of the idea that transcends the project of reading and thematization I am undertaking here. This project, in its possible continuations, itself expresses the interest I have in the idea. That there is no closed list of features that constitute perfectionism follows from conceiving of perfectionism as an outlook or dimension of thought embodied and developed in a set of texts spanning the range of Western culture, a conception that is odd in linking texts that may otherwise not be thought of together and open in two directions: as to whether a text belongs in the set and what feature or features in the text constitute its belonging.

Suppose that there is an outlook intuitively sketched out (sometimes negatively) in some imaginary interplay among the following texts. (I ask almost nothing from the idea of this interplay. It is not meant to do more than momentarily activate the fantasy, perhaps it vanishes early, that there is a place in the mind where the good books are in conversation, among themselves and with other sources of thought and pleasure; what they often talk about, in my hearing, is how they can be, or sound, so much better than the people who compose them, and why, in their goodness, they are not more

powerful.) I begin by specifying texts, most of which are mentioned or alluded to in the pages to follow: Plato's *Republic*, Aristotle's *Nichomachean Ethics*, the Gospel according to St. Matthew, Augustine's *Confessions*, Shakespeare's *Hamlet* and *Coriolanus* and *The Tempest*, Pascal's *Pensées*, Kant's *Foundations of the Metaphysics of Morals*, Friedrich Schlegel's *Athenaeum Fragments* and "On Incomprehensibility," Kleist's *The Marquise of O——*, Mill's *On Liberty* and *On the Subjection of Women*, Ibsen's *Hedda Gabler* and *A Doll's House*, Matthew Arnold's *Culture and Anarchy* and "Dover Beach," Emerson's "The American Scholar" and "Self-Reliance" and "Experience," Nietzsche's third *Untimely Meditation* entitled *Schopenhauer as Educator*, Marx's *Introduction to the Critique of Hegel's Philosophy of Right*, Thoreau's *Walden*, the critical writings of Oscar Wilde, certainly including his review of a book about Confucius, Freud's *The Interpretation of Dreams, Civilization and Its Discontents*, and "Delusions and Dreams in Jensen's *Gradiva*," Shaw's *Pygmalion*, W. C. Williams, *Selected Essays*, John Dewey's *Experience and Nature*, Heidegger's *Being and Time*, and "On the Origin of the Work of Art," and *What is Called Thinking?*, Wittgenstein's *Philosophical Investigations*, Beckett's *Endgame*, and (the film) *The Philadelphia Story*. Others might have been mentioned here, most of which appear in related writings of mine: Ovid's *Metamorphoses*, Dante's *Divine Comedy*, Montaigne's *Essays*, Spinoza's *Ethics*, Milton's *Paradise Lost*, Moliere's *Misanthrope*, *The Unborn: The Life and Teaching of Zen Master Bankei*, Schiller's *On the Aesthetic Education of Man*, Rousseau's *The Reveries of a Solitary Walker*, Goethe's *Faust* and *Wilhelm Meister*, Hegel's *Phenomenology of Spirit*, Wordsworth's *Prelude*, Coleridge's *Biographia Literaria*, Kierkegaard's *Repetition* and *Concluding Unscientific Postscript*, Whitman's *Leaves of Grass*, Melville's *Pierre*, Dickens's *Hard Times* and *Great Expectations*, Pater's *The Renaissance*, Dostoevsky's *The Idiot*, Twain's *Huckleberry Finn*, William James's *Varieties of Religious Experience*, Henry James's "The Beast in the Jungle," Veblen's *Theory of the Leisure Class*, D. H. Lawrence's *Women in Love*, and (the film) *Now Voyager*.

Why bother making explicit what is for the most part so deliberately obvious a list, particularly when sometimes only a fragment of these works may be pertinent to the issue of perfectionism? I want, of course, at once for it to call to mind a fraction of the play of voices

left out ("forgotten?") in characteristic philosophical discussions about how we might live, voices that will enter other conversations, more urgent ones to my mind, about how we do live. Then is philosophy's omitting of texts a sign of the fragility of their interplay? On the contrary, it seems to me, to the extent it is something like forgetting, a sign of how massive the resistance to it is. And while I mean the lists to contest the sense of arbitrainess or exclusiveness in the perfectionist's characteristic call for a conversion to "culture," I merely indicate, mostly by the inclusion of two films, that the door is open to works of so-called popular culture; I am playing it safe, or obvious, interested in asking philosophers whether they imagine that they are able to speak more authoritatively for the uncultivated than (other) works of high culture do. The presence or absence of any text on the list is open to argument—or say subject to the continuing conversation of the texts—none is safe because sacred, others must, if the conversation is to continue, have a hearing. The process of listing is less like hedging a word with a definition for a theoretical purpose than it is like opening a genre for definition. (In the background here are various efforts of mine, for example in the Introduction to *This New Yet Unapproachable America*, to characterize philosophy's anxiety about reading, expressed in its wish either to read everything or to read nothing. In the background too is a wish for an homage to Emerson's characteristic gesture of listing our models, the meaning of whose "greatness" is not to be taken for granted in Emersonian Perfectionism, precisely the contrary. In an old culture a list of obvious books might seem pretentious or ridiculous—like a gentleman's calling himself a gentleman. In a new culture it should be a reminder not so much of the sublimity of the human—Whitman's perception is not so much of the *works* of humankind—as of the humanness of the sublime.)

Given that a work is accepted as definitive for perfectionism, the issue of the features it contributes to the concept of perfectionism, or confirms, or modifies, also remains open. Take, for example, Plato's *Republic*. Obvious candidate features are its ideas of (1) a mode of conversation, (2) between (older and younger) friends, (3) one of whom is intellectually authoritative because (4) his life is somehow exemplary or representative of a life the other(s) are attracted to, and (5) in the attraction of which the self recognizes itself as enchained, fixated, and (6) feels itself removed from reality, whereupon (7) the self finds that it can turn (convert, revolutionize

itself) and (8) a process of education is undertaken, in part through (9) a discussion of education, in which (10) each self is drawn on a journey of ascent to (11) a further state of that self, where (12) the higher is determined not by natural talent but by seeking to know what you are made of and cultivating the thing you are meant to do; it is a transformation of the self which finds expression in (13) the imagination of a transformation of society into (14) something like an aristocracy where (15) what is best for society is a model for and is modeled on what is best for the individual soul, a best arrived at in (16) the view of a new reality, a realm beyond, the true world, that of the Good, sustainer of (17) the good city, of Utopia. The soul's exploration by (imitating, participating in) Socrates' imitation (narration) of philosophical exchange (18) produces an imagination of the devolution of society and rebukes the institutions of current societies in terms of (19) what they regard as the necessities of life, or economy, and (20) what they conceive marriage to be good for (21) in relation to sexuality and to bearing children, the next generation; and (22) rebukes society's indiscriminate satisfactions in debased forms of culture, to begin with, (23) forms of debased philosophy; arriving at the knowledge that (24) the philosophical life is the most just and happy human life, knowledge whose demonstration depends on seeing, something precisely antithetical to academic philosophy, that (25) morality is not the subject of a separate philosophical study or field, separate from an imagination of the good city in which morality imposes itself; (26) the alternative is moralism; so that (27) the burdens placed on writing in composing this conversation may be said to be the achieving of an expression public enough to show its disdain for, its refusal to participate fully in, the shameful state of current society, or rather to participate by showing society its shame, and at the same time the achieving of a promise of expression that can attract the good stranger to enter the precincts of its city of words, and accordingly (28) philosophical writing, say the field of prose, enters into competition with the field of poetry, not—though it feels otherwise—to banish all poetry from the just city but to claim for itself the privilege of the work poetry does in making things happen to the soul, so far as that work has its rights.

Socrates speaks of his ideal state as "our city of words" at the end of book 9 of the *Republic*, and the question may well arise as to whether this city should appear as a further feature of perfectionist

writing generally. Is this description of the city as words merely an artifact of the medium of Plato's philosophizing in the form of dialogue, calling special attention to the distance between our ability to inspire one another with dreams of a world of goodness and our (in)ability as citizens "to realize that world," as Emerson puts it at the close of "Experience"?

But suppose the noting of "our city" is a standing gesture toward the reader, or overhearer, to enter into the discussion, to determine his or her own position with respect to what is said—assenting, puzzled, bullied, granting for the sake of argument, and so on. Then the city has, in each such case of reading, one more member than the members depicted in a Platonic (or Wittgensteinian, or Emersonian) dialogue. (That Emerson's prose exists as a kind of conversation with itself, as a dialogue, is a burden of my first essay on that prose, "Thinking of Emerson.") And while Socrates goes on to say that "it makes no difference whether it [the ideal city, of words] exists anywhere or will exist," the reader's participation roots the idea that the Utopian vision participating in this presented city of words is one I am—or I am invited to be—already, reading, participating in. This implies that I am already participating in that transformation of myself of which the transformed city, the good city, is the expression. As Thoreau sees the matter in the fifth chapter ("Solitude") of *Walden*, a grand world of laws is working itself out *next* to ours, as if ours is flush with it. Then it may be a feature of any perfectionist work that it sets up this relation to its reader's world. What is next to me is, among other things, what I listen to, perhaps before me, for example, reading Thoreau's text, *Walden*; it is nearer than Walden may be, ever, and presents an attraction to its reader to find a Walden by not knowing in advance where it is and what it looks like. And what is next to me may be that any or all of this is dead.

Emerson discusses and depicts relations of his writing to its reading in countless ways, surely no fewer than Thoreau's ways, for example in such a remark as this: "So all that is said of the wise man by stoic or oriental or modern essayist, describes to each man his own idea, describes his unattained but attainable self" ("History," para. 5). It is Emerson's way to mean by "idea" here both our idea of the wise and our idea that it applies to us, neither of which we, before his words, may have known we harbored. I take for granted that Emerson is identifying himself as "the modern essayist," hence

that he is claiming to be a path to one's unattained self. I will call it
the next self, as claiming that Emerson is invoking what Thoreau
invokes, a few paragraphs after his passage about what we are next
to, in his observation that "with thinking we may be beside our-
selves in a sane sense," thus identifying thinking as a kind of
ecstasy. The implication is that the self is such that it is always be-
side itself, only mostly in an insane sense. (Thinking does not start
from scratch; it, as it were, sides against and with the self there is,
and so constitutes it. The question is, What must that be in order to
be sided, to be capable of asides, to require parentheses?) Thoreau's
interpretation of nextness contains a parody of what detractors of
Transcendentalism understand its interest to amount to in a world
beyond this one, an afterworld, available for the musing. (Some-
thing of the sort is parodied along the same lines in the third section
of the first part of *Zarathustra*, in Nietzsche's punning title *Von den
Hinterweltlern*, meaning afterworldsmen, sounding like back-
woodsmen, suggesting that only hicks believe there is some other
place.) What is in Thoreauvian nextness to us is part of this world, a
way of being in it, a curb of it we forever chafe against.

I might at once declare that the path from the *Republic*'s picture
of the soul's journey (perfectible to the pitch of philosophy by only a
few, forming an aristocratic class) to the democratic need for perfec-
tion, is a path from the idea of there being one (call him Socrates)
who represents for each of us the height of the journey, to the idea of
each of us being representative for each of us—an idea that is a
threat as much as an opportunity. Emerson's study is of this (demo-
cratic, universal) representativeness—it comes up in my first
lecture under the head of "standing for" ("I stand here for human-
ity")—as a relation we bear at once to others and to ourselves: if we
were not representative of what we might be (or what we were, in
some Platonic or Wordsworthian past of our lives), we would not
recognize ourselves presented in one another's possibilities; we
would have no "potential." But there is little point in such a declara-
tion now since, to begin with, we do not know whether the distance
between, for example, Plato and Emerson, or between any minds
finding themselves in one another, is well thought of as a path. The
distance is measured by the difference between Plato's progress of
conversation in the form of argumentative exchange and dialectical
progression eventuating in the stratum of mythology, and Emer-
son's preparation of the "American Scholar" for a long period of

stammering, poverty, and solitude eventuating perhaps in a text in which "we recognize our own rejected thoughts . . . come back to us with a certain alienated majesty" (words from the opening paragraph of "Self-Reliance" that will recur in the lectures to follow).

I will be speaking in the first lecture of Emerson's manner of thinking as characterized by what he calls transfiguration, which I take there as transfigurations of Kantian terms, a process whose extent is barely suggested; and already now, before the beginning, we see that we must think of the transfiguration in Emerson's prose of an unknown number of Platonic terms and images: for example, of chains (Emerson speaks of clapping ourselves into prison, from shamefully being ashamed of the eyes of others); of a sense of unreality (Emerson in effect claims that we do not exist, we are afraid to say "I am," and so haunt the world); of what the soul's "attraction" is to its journey (Kant reads it as an imperative, expressed by an "ought," a point of decisive difference in Emerson); of how to picture what constitutes such journeying (Emerson's word for it is taking steps, say walking, a kind of success(ion), in which the direction is not up but on, and in which the goal is decided not by anything picturable as the sun, by nothing beyond the way of the journey itself—this is the subject of Emerson's "Experience" as seen in my "Finding as Founding"); and of how Emerson sees "culture" (in his "Circles": "A new degree of culture would instantly revolutionize the entire system of human pursuits," quoted by Nietzsche near the close of *Schopenhauer as Educator*). Emerson is not suggesting that we add more books and concerts and galleries to our lives, nor speaking of any thing open only to persons possessing certain gifts or talents unequally distributed across the general population, nor of an extra degree of work asking to be rewarded for its public benefits, but of an attitude to our pursuits that is precisely unimposable and unrewardable, one that we would all instantly see the worth of could we but turn, revolutionize ourselves. Emerson's problem of representativeness, or exemplification ("imitation"), or perfection, thus begins earlier than Plato's, both in lacking a sun and in having no standing representative of the path to it. Emerson elects himself to be our representative man (anyone is entitled, and no one is, to stand for this election) and he warns that we have to— that we do—elect our (private) representative(s). In a sense his teaching is that we are to see beyond representativeness, or rather see it as a process of individuation. His praise of "the infinitude of

the private man" (from the *Journals*, April 1840, as quoted in *Selections*, ed. Whicher, p. 139) is not a praise of any existing man or men but an announcement of the process of individuation (an interpretation of perfectionism) before which there are no individuals, hence no humanity, hence no society. When in the seventh paragraph of "Self-Reliance" Emerson remarks of his sometimes succumbing to calls for philanthropy, "It is a wicked dollar, which by and by I shall have the manhood to withhold," we need not, we should not, take him to imagine himself as achieving a further state of humanity in himself alone.

These experiments with or transfigurations of the terms "representation" and "election" in Emerson's teaching suggest the reason he characteristically speaks of "my constitution," meaning for him simultaneously the condition of his body, his personal health (a figure for the body or system of his prose), and more particularly his writing (or amending) of the nation's constitution. The idea of his constitution accordingly encodes and transfigures Plato's picture of justice in the state as justice in the soul writ large. Such is philosophical writing, or authorship, early and late. Not, of course, always or everywhere. It may be, perhaps it should be, over; that too is an Emersonian question.

What exemplification (or "imitation") is in *The Republic* is a more famous, no doubt in part a more metaphysical, instance of the questions raised in Emersonian representativeness. (Emerson's transfiguration of illustrativeness into illustriousness is the region of his view of representativeness that I emphasize in my first lecture.) But the question or questions are no more important in the ancient economy of perfectionism than they are in the modern. Emerson's incessant attention to representation, to his own presentation of himself, of his authorship, of his constitution of words, together with his reader, as one another's illustrious other, might serve to caution against the impression of Plato's theory of art and poetry as something in which Plato's authorship is only inadvertently or unconsciously implicated. As if our superior perspective on Plato's artfulness permits us to place it better than he. As if the "banishing" of "poetry" from his republic—but not from his *Republic*, the city of words, the one of philosophical participation or exemplification—meant that Plato mistakenly took himself to have put behind him, outside his work, the problematic of originality, imitation, and corruption in conducting the life of philosophy, rather

than philosophically to have staked out the problematic, to be staking it out, with or without the reader's responsiveness to it, election of it, there.

In my way of reading Emerson, his passage naming the unattained but attainable self suggests two ways of reading (reading him, to begin with), in one of which we are brought to recognize our own idea in his text (reading with our unattained self), in the other not (reading with our attained self, appreciating our given opinions, learning nothing new). To recognize the unattained self is, I gather, a step in attaining it. (Such reading is given a fuller description in my first lecture.) I do not read Emerson as saying (I assume this is my unattained self asserting itself) that there is one unattained/attainable self we repetitively never arrive at, but rather that "having" "a" self is a process of moving to, and from, nexts. It is, using a romantic term, the "work" of (Emerson's) writing to present nextness, a city of words to participate in. A further implication, hinted at a moment ago in passing, is that our position is always (already) that of an attained self; we are from the beginning, that is from the time we can be described as having a self, a next, knotted. An Emersonian sally at this idea is to say that we are (our thinking is) partial. (This idea will come back to stay in the first lecture.) That the self is always attained, as well as *to be* attained, creates the problem in Emerson's concept of self-reliance—he insists on it, though not in the following terms exactly—that unless you manage the reliance of the attained on the unattained/attainable (that is, unless you side that way), you are left in precisely the negation of the position he calls for, left in conformity. That one way or the other a side of the self is in negation—either the attainable negates the attained or vice versa—is the implication I drew earlier in saying that *each* state of the self is final, one we have desired, in this sense perfect, kept, however painful, in perfect place by us. In this dire sense, as said—but only in this sense—Perfectionism implies Perfectibility. (If Heidegger's distinction between the ontological and the ontic shows the pervasive draw or claim of one upon the other, so for instance shows how it happens that "Authentic Being-One's-Self . . . is . . . an existentiell modification of the 'they'—of the 'they' as an essential existentiale," [*Being and Time*, p. 168], then Emerson's idea of the unattained but attainable self may be thought of as replacing Heidegger's distinction, or vice versa.)

But again here the question may arise: Even if the intuitions I have been thematizing are true of *something*, why do I call it perfectionism, incurring or toying with metaphysical suggestions I say I want no part of? Most significant is the suggestion of a state, the same for all, at which the self is to arrive, a fixed place at which it is destined to come home to itself. Is it worth this risk of suggestion to be able to say, as if blocking the metaphysical with a paradox, that each state of the self is final? Why not call the view Attainabilism or the Ethics of Representation or of Excellence or of Virtue? I might answer this by saying that it is a mission of Emersonian Perfectionism precisely to struggle against false or debased perfectionisms and that it is a sufficient reason to keep the name Perfectionism to mark this mission. This is part of Emersonian Perfectionism's struggle against the moralistic, here the form of moralism that fixates on the presence of ideals in one's culture and promotes them to distract one from the presence of otherwise intolerable injustice. (Ideological criticism is a form, accordingly, of antimoralism; too often, in my experience, it is an unphilosophical form, one with an insufficiently ideological form of ideology, which is to say, an insufficient study of (its own) ideas.) The other pressing form of moralism for Emersonianism is the enforcement of morality, or a moral code, by immoral means, represented in the theocratic state, but still present in reforming states (as at the best they are).

It is to John Dewey's eternal credit to have combated, unrelentingly, both forms of moralism, the idealistic and the unreforming—if, as it strikes me, with inadequate philosophical and literary means. On such an occasion as the Carus lectures, prompting for me old memories, I remember, when first beginning to read what other people called philosophy, my growing feeling about Dewey's work, as I went through what seemed countless of his books, that Dewey was remembering something philosophy should be, but that the world he was responding to and responding from missed the worlds I seemed mostly to live in, missing the heights of modernism in the arts, the depths of psychoanalytic discovery, the ravages of the century's politics, the wild intelligence of American popular culture. Above all, missing the question, and the irony in philosophy's questioning, whether philosophy, however reconstructed, was any longer possible, and necessary, in this world. Positivism's answer, the reigning answer in the professional philosophy of the America in which I was beginning to read philosophy, shared pragmatism's

lack of irony in raising the question of philosophy—in the idea that philosophy is to be brought to an end by philosophy, which in a sense is all that can preserve philosophy; and in the fact that the major modern philosophers, from Descartes and Locke and Hume to Nietzsche and Heidegger and Wittgenstein, have wished to overcome philosophy philosophically. (The irony of self-overcoming, call it the irony of "having" a self, say an identity, being the one you are rather than another, with its overcomings, is enacted in philosophy, no less perfectly when philosophy claims to be final and to be possessed by an individual.) But then positivism harbored no particular longing for a cultural or intellectual role for philosophy apart from its relation to logic and science.

I could not trust my reactions very far, and I could do nothing whatever sensible about them; but it seemed to me that the young teachers I was close to in those years, Henry Aiken, Abraham Kaplan, Morton White, all of whom took Dewey seriously, felt the lack of his work's power as well as the importance of its claims for philosophy—and, I trust, felt the thrill of certain moments of Dewey's writing. It was not until the force of Wittgenstein's *Philosophical Investigations* came over me, in my own reluctant beginnings as a teacher of philosophy, that I found the details of the philosophizing I seemed to imagine must exist, a beginning, deferred inventory of what I felt missing in Dewey, whose signature concepts are, to my ear, characteristically eclipsed by their very similarity to, yet incommensurability with, Wittgenstein's problematizings of "privacy," "thinking," "knowledge," "use," "practice," "context," "language," and "philosophy." And in coming to Heidegger's work a few years later, recognizing further items and transfigurations of the inventory I fancied for philosophy, leading or encouraging me to Emerson and to Shakespeare and what not, I would from time to time remember and cite a moment from Dewey that seemed part of what was moving me, but I was not moved to look again at what Dewey had actually said. When in the past decade Richard Rorty's *Philosophy and the Mirror of Nature* and *Consequences of Pragmatism* appeared, not even this work, which, among other matters, more than any other forced a reassessment of Dewey's contribution to our intellectual life, has enabled me to find my way back to Dewey's writing. I think the reason, if there is a reason, has to do with the fact that Rorty's placement of Dewey in the company of Wittgenstein and of Heidegger, whose voices have seemed to me to

eclipse Dewey's, has been achieved, so I might put the matter, at the expense of giving up the question of the question of philosophy, of what it is, if anything, that calls for philosophy now, in favor of an idea that we are, or should be, past interest in the distinctions between philosophy and other modes of thought or of the presentation of thought. (An expense too high for me; for Rorty a gift.) Nevertheless, I am aware that it is because of my encounters with Rorty's work that I am moved now to go a little beyond the invocations of Dewey that have entered my writing from the earliest of the work I have published that I still use (in the essay "Must We Mean What We Say?", where the reference in note 31 to "American pragmatism" pretty much means Dewey) and for a moment to place my sense of what I found and what I missed in Dewey as that bears on what I have been saying about Emerson and perfectionism.

I found myself just now thinking of Dewey in connection with his tireless combating of two forms of moralism. So important is the feature of antimoralism that this alone constitutes Dewey as some sort of perfectionist—though surely not an Emersonian one. Tocqueville captures the sense of Deweyan perfectionism (in pt. 1, chap. 18 of *Democracy in America*): "[The Americans] have all a lively faith in the perfectibility of man, they judge that the diffusion of knowledge must necessarily be advantageous, and the consequences of ignorance fatal; they all consider society as a body in a state of improvement, humanity as a changing scene, in which nothing is, or ought to be, permanent; and they admit that what appears to them today to be good, may be superseded by something better tomorrow." Taken one way this description can almost seem to fit Emerson as well as Dewey. To see how close and far they are to and from one another, consider just the difference in what each will call "knowledge" and "ignorance" and how each pictures this "difference." For Dewey, representing the international view, knowledge is given in science and in the prescientific practices of the everyday, that is, the learning of problem solving. For Emerson, the success of science is as much a problem for thought as, say, the failure of religion is. Again these words might be true, in a different spirit, of Dewey as well. Then it may help to say: for Dewey the relation between science and technology is unproblematic, even definitive, whereas for Emerson the power manifested in technology and its attendant concepts of intelligence and power and change and improvement are in contest with the work, and the

concept of the work, of realizing the world each human is empowered to think. For an Emersonian, the Deweyan is apt to seem an enlightened child, toying with the means of destruction, stinting the means of instruction, of provoking the self to work; for the Deweyan the Emersonian is apt to look, at best, like a Deweyan. (In part Dewey's fine essay on Emerson reads this way; but in part it also reads like a poignant wish to find something in Emerson's achievement that he could put to use in his own work.) For Dewey the texture of the philosophical text barely exists, except as superstition and resistance to social change. For Emerson it is a question whether the problem sufficiently exists for philosophy, both the urgency of the need for transformative social change and the resistance to internal change, to transformative nextness. That we must have both is a sufficient reason for my siding with the endangered Emersonian.

False or debased perfectionisms seem everywhere these days, from bestselling books with titles like *Love Yourself* to the television advertisement on behalf of Army recruitment with the slogan, "Be all that you can be." Someone is apt to find these slogans difficult to tell from a remark of Emerson's in which he lists, among the "few great points" whose recurrence is "the secret of culture," what he words as "courage to be what we are." (This is from the concluding paragraph of "Considerations by the Way." Nietzsche gives *Ecce Homo* the subtitle: *How One Becomes What One Is.*) Then let us note, anticipating a cardinal theme of the lectures to follow, that Emersonian Perfectionism requires that we become ashamed in a particular way of ourselves, of our present stance, and that the Emersonian Nietzsche requires, as a sign of consecration to the next self, that we hate ourselves, as it were impersonally (bored with ourselves might be enough to say); and that in the television promise to be all you can be, the offer is to *tell* you what all you can be, most importantly, a mercenary. (I do not deny that it is better than certain alternatives.) Whatever the confusions in store for philosophical and moral thinking, ought we to let the fact of debased or parodistic versions of a possibility deprive us of the good of the possibility? The inevitability of debased claims to Christianity, or to philosophy, or to democracy, are, so one might put it, not the defeat, not even the bane, of the existence of the genuine article, but part of its inescapable circumstance and motivation. So that the mission of Perfectionism generally, in a world of false (and false calls for) democracy, is the discovery of the possibility of democracy, which to

exist has recurrently to be (re)discovered (as with philosophy, and religion, and, I have to add, psychoanalysis). A difference between the Emersonian and the Nietzschean versions of perfectionism is the Emersonian's implied claim that the possibility of discovery exists, is in a certain effect, here, where there is good enough justice to work from. So the question becomes: Where is here?

Discouragement by the success of moralizing and debased perfectionism creates, in good enough hearts, a familiar, even common, cynicism. I think of a moment in Howard Hawks's film *His Girl Friday* in which one reporter reads aloud to the gathering of fellow reporters in the press room the beginning of a story left unfinished in a typewriter by the one woman reporter in the group (played by Rosalind Russell) after she has left the room to accompany and comfort a (another) victimized woman. It is a moment given revelatory status, the fast-talking, all-knowing reporters depicted as communally stilled in the presence of genuine sentiment genuinely recorded. The one who breaks that mood is marked by that fact as a spiritual outsider. What he says to break the communal is, "I don't think it's ethical to read somebody else's work." And he is answered, "Where do you get that ethics stuff? You're the only one who'll swipe any of it." It is a complex moment. That the outsider is narratively set apart by cliché homosexual signs of difference is no doubt part of Hawks's tough-guy posture and worldview; if so, Hawks tenderly contests it by the communal spokesman's implied confession that he (they) not only would not but cannot steal the woman's access to the realities of sentiment her writing has recorded. Their toughness cannot afford it. Complexities aside, this perception of the communal as spoiled by the moralistic is a perfectionist moment, underscored when the woman's "editor" (played by Cary Grant) notes the rumors of a new mayor cleaning up the city of "New York"; evidently, for them, a Utopian vision. The cynical rebuke of hypocrisy, in a scene of democratic corruption, forms a counterpart—about as remote as the dimensions of Western theater permit, yet continuous—with Socrates' speculation, in the city of words passage, that the good city exists always as a model to the good soul, and his claim that the philosopher will participate in the public affairs of only that city, toward which his interlocutor seems to express some reservation. Of course the claim to be willing to participate in a city if, but only if, it is good, is a convenient story for a bunch of born outsiders, say like these reporters, to tell themselves. It has its convenience for intellectuals generally. The point of

the moment for me, Socratic and Hawksian, is its glimpse of perfectionist aspiration as calling on, or remembering, the wish for participation in the city, as if its moral task is to show the ground on which to withstand its invitation to cynicism. Perfectionism is the dimension of moral thought directed less to restraining the bad than to releasing the good, as from a despair of good (of good and bad in each of us). If there is a perfectionism not only compatible with democracy but necessary to it, it lies not in excusing democracy for its inevitable failures, or looking to rise above them, but in teaching how to respond to those failures, and to one's compromise by them, otherwise than by excuse or withdrawal. To teach this is an essential task in Rawls's criticism of democracy from within. My sense of affinity, yet within it an unease, with *A Theory of Justice*, turns on the content of this teaching, epitomized by Rawls's injunction to the democrat to find a way of life that is "above reproach" (p. 422). My unease here is roughly the sense that looking for such a life is not enough to contain the sense of compromise done to my life by the society to which I give my consent (I assume that living "above reproach" is meant to do this, and that the life looked for is not like the one Thoreau found). To make clearer my unease here is a guiding motive of the third lecture.

The connection between the perfectionism I seek and false perfectionisms, in an environment of political rift, is memorialized forever in Polonius's "To thine own self be true," which has become all but uncitable as its vulgarizing of good advice is vulgarly cited as good advice. But even here, or here concentrated, there is a despairing and a hopeful way to respond: you can hear in it redemptive words reduced to serving a server, used by a man lost to experience, spoiled by his voice, or nonvoice; or you can hear in the words the sound of the good heart making a momentary, flickering way back, perhaps called back by the man's taking leave of his son, reminded of his own youth, even into this cave of convention. If Hamlet's perfectionism is driven mad by such impurity and irony, we had better not identify too closely with him. Polonius's appearance reminds me to mention that the address to culture that Emerson and Nietzsche call for is not one of consuming it but of discovering it, its reality. To assert the good of consuming culture, in general, as it stands, would be for them as philistine as to question, in general, the good of producing it.

The founding irony of perfectionism, expressed in Socrates'

claim about the philosopher as prepared to take part in the public affairs of that city only, that is, in the ideal city of words, wherever that happens to be, is enacted in *Walden*, where the writer, basically alone, conducts himself as though he is founding and conducting the economy, at once the private and the public affairs, of his city, perhaps laying it up as a model in heaven, his conduct "to serve a parable-maker one day" (chap. 7, "The Bean Field"), I imagine a day on which his conduct and his writing are the same. It would be the day of perfectionist or Emersonian authorship. Emerson states the irony toward the end of "Experience": "I know that the world I converse with in the farm and in the city is not the world I *think*." In the first of the lectures to follow I shall also find this an epitome of Kant's two worlds to which we have human passage in our ability to take "two standpoints." Emerson's invoking the world he thinks is at once to declare what I am marking as the perfectionist's address to Utopia as to something somehow here, whose entrance is next to us, hence persistently just missed, just passed, just curbed, and so to declare that the world in question inspires or requires a particular mode of thinking. It is a mode, or moment, I associate in the first lecture with the later Heidegger; here in passing, after adducing an underlying passage from Kant, I want to indicate its association with the later Wittgenstein.

The association with Wittgenstein will depend on accepting what he calls "bringing words back from their metaphysical to their everyday use" as a mode of thinking—evidently a counter-mode, or a mode with a counter-incentive, to the thinking that denies the philosophical fatefulness of the everyday. Here again, in characterizing Emersonian Perfectionism, I find it as an inflection—not exactly an interpretation—of Kant. From the *Foundations of the Metaphysics of Morals:*

> Yet how pure reason, without any other incentives, wherever they may be derived, can by itself be practical, . . . without any material (object) of the will in which we might in advance take some interest, can itself furnish an incentive and produce an interest which would be called purely moral; or, in other words, how pure reason can be practical—to explain this, all human reason is wholly incompetent. . . .
>
> This intelligible world signifies only a something which remains when I have excluded from the determining grounds of my will everything belonging to the world of sense in order to withhold the principle of motives from the field of sensibility. . . . An incentive

must here be wholly absent unless this idea of an intelligible world
itself be the incentive or that in which reason primarily takes an in-
terest. But to make this conceivable is precisely the problem we
cannot solve. (pp. 81–82, 462–63)

It sounds as if Kant is confusing, or rather somehow identifying,
an incentive *of* pure reason, with which reason could provide the
will, with an incentive *to* reason, an interest with which the will
could provide reason. But suppose that the intelligible world is "the
city of words," say Utopia; and suppose that the world of that city is
not a "something" that is "outside" (i.e., "beyond" "the world of
sense"—what is the process Kant figures as taking a standpoint?),
but is, as it says, "no place," which perhaps suggests no place *else*,
but this place transfigured. (*Walden* is the instance I know best, this
pure pool of words, which not everyone sees, but anyone might see,
at Walden Pond, and hence where not?) Then all that thinking needs
to be an incentive for is thinking itself, in particular for stopping to
think (say not for action but for passion), as if to let our needs recog-
nize what they need. This is a reasonable sense of intelligence—not
the sense of applying it but that of receiving it. The incentive to the
world I think is . . . the world. Reason does not need to make any-
thing happen; as romantics like Friedrich Schlegel, Emerson, and
Heidegger like, more or less, to put it, what happens in the world (as
with poetry) is always happening. (Something of the sort is what
Dewey senses in his insistence that art could not make happen with
experience what it makes happen, unless it were already happening,
as it were, inartistically. But then there are no *means* for making it
happen.) You cannot bring Utopia about. Nor can you hope for it.
You can only enter it. (If you cannot imagine entering it, then either
you think that the world you think must look very different from
the world you converse with, or else you find that the world you con-
verse with lacks good enough justice. In this way the imaginability
of Utopia as modification of the present forms a criterion of the pres-
ence of good enough justice. I should perhaps add that my remark
about Utopia as something not to be hoped for is a response not
alone to what I know [I know it is not enough] of the thought of
Ernst Bloch but to one of Kant's guiding questions: "What may I
hope for?" In basing religion on morality, whatever its gains, Kant's
price is to leave religion with its corner on hope, hence as something
whose object is elsewhere, something theology may well itself wish
to contest—but why without the help of philosophy?)

If what Wittgenstein means by "bringing words back" represents thinking, it bears a relation to words and the world different from that in, say, Dewey's application of intelligence to the world; it may seem its opposite. I have emphasized its opposite sound by contrasting intelligent action with stopping to think. Dewey's picture of thinking as moving in action from a problematic situation to its solution, as by the removal of an obstacle, more or less difficult to recognize as such, by the least costly means, is, of course, one picture of intelligence. Intelligence is to overcome inner or outer stupidity, prejudice, ignorance, ideological fixation. Intelligence has its beauties. Wittgenstein's picture of thinking is rather one of moving from being lost to oneself to finding one's way, a circumstance of spiritual disorder, a defeat not to be solved but to be undone. It has its necessities. Not whether it is good to have the Enlightenment is our problem, but whether we can survive its solutions. Dewey's repeated forcing of his attentions on me has also, I think, to do with having recently and repeatedly heard Wittgenstein's view of language described as pragmatism, one whose certainty between words and world is based on action, as opposed to, I guess, something mental. Such a view seems confirmed by Wittgenstein's saying, "If I have exhausted the justifications I have reached bedrock, and my spade is turned. Then I am inclined so say: 'This is simply what I do'" (*Investigations*, §217). But this is an expression less of action than of passion, or of impotency expressed as potency. To see this, ask yourself what "this" refers to. (This moment of the *Investigations* is one of the principal exhibits in the case I present in my second lecture "against" certain passages in Kripke's *Wittgenstein: Rules and Private Language*.)

Wittgenstein's return of words to their everyday use may be said to return words to the actual language of life in a life momentarily freed of an illusion; Emerson's return of words may be said to return them to the life of language, to language and life transfigured, as an eventual everyday. A measure of their differences, within practices and attitudes that link thinking to an entrustment of ordinary words—and at the same time a measure of their joint differences from other philosophers, particularly it seems to me from a conventionalist view of Wittgenstein, I believe the most widely shared view—may be marked by a sentence describing the poet from Emerson's essay "The Poet" (poets are figures included under Emerson's category of the American Scholar, as are philosophers, should there be any), that both depicts and expresses his attitude:

"In every word he speaks he rides on them as the horses of thought." It is the sort of outbreak that seems to explain straight off why Emerson is the writer about whom it is *characteristically* insisted, continuing in the 1980s as in the 1840s, by admirers as much as by detractors, that he is not a philosopher, accompanied (proven?) by the repetitive finding of his prose to be a fog (sometimes intensified as metaphysical) or a mist (sometimes tempered as golden). The mystery is that anyone would, under that description of his prose, take the trouble to deny that he is a philosopher.

What does speaking of words as horses rule out? Apart from other animals, it rules out, or differs from, for example, speaking of words as tools or saying that they are the bearers of meanings. The metaphorical halt allows the suggestion that there is no answer of the sort philosophers might expect to questions of the form, "If words aren't tools or bearers of meaning, what *are* they? What *do* they bear?" But why deflect the question with the invocation of horses? Given that the idea of "every word" is not a generalization but bespeaks an attitude toward words as such, toward the fact of language, the horse suggests that we are in an attitude or posture of a certain grant of authority, such as humans may claim, over a realm of life not our own (ours to own), in view of some ground to cover or field to take. That words are under a *certain* control, one that requires that they obey as well as that they be obeyed, is captured in Wittgenstein's idea that in his philosophizing words are seen to be away and as having to be returned home (to their *Heimat*). What he says is not quite that "what we do is to bring words back," but more strictly that we *lead* them (*führen die Wörter*)—from metaphysical to everyday; suggesting that their getting back, whatever that is, is something they must do under their own power, if not quite, or always, under their own direction. The idea of authority here comes up for me no doubt for perhaps independent reasons, both from the drift of recent literary theory, especially deconstruction, in which the authority of the literary seems at once to be denounced and apotheosized, as well as from the way I have read Wittgenstein's portrait of skepticism, as the site in which we abdicate such responsibility as we have over words, unleashing them from our criteria, as if toward the world—unleashing our voices from them—coming to feel that our criteria limit rather than constitute our access to the world.

In taking issue in my second lecture with Kripke's account, or ne-

glect, of Wittgenstein's sense of criteria, I sketch two ideas concerning the ground of the attitude toward words just now attributed to Emerson and to Wittgenstein—an investment or entrustment of ordinary words worked out to a certain extent with respect to Emerson in the first lecture—that prepare what I call, in continuing my reading of certain strands of A Theory of Justice in the third lecture, the idea of "the conversation of justice." The two preparatory ideas are that of "the argument of the ordinary," which I say is conducted in Philosophical Investigations, and that of "the scene of instruction," which also runs through the Investigations and whose manifestation, as said, in the section picturing my spade being turned allows a clear single site at which the all but nonexistent yet all but all-pervasive difference between Kripke's account of Wittgenstein and mine can come forth and conflict. The sort of "preparation" I have in mind cannot make much sense before the ideas are developed a bit, but since the relation among the ideas seems to me the threshold before which these lectures stop, something whose crossing it is one of their aims to motivate, I want to give some suggestion of what is to be crossed to.

Before doing so, it will help to remark that for Dewey the philosophical appeal of the ordinary is present but intermittent, as when he relates esteeming to estimating or relates objects to what it is that objects, or mind to minding; for positivists the appeal is philosophically anathema, and sometimes ordinary language as such, as we encounter it—I hope we all know the purity of the mood—offends the intellect. Kripke's case is, so far as I know, unique: he, to my mind correctly, takes the Investigations as in struggle with skepticism throughout and, as I put the matter, never to repudiate the skeptical possibility; but he then avoids the seriousness of Wittgenstein's investment in the ordinary so completely that Wittgenstein's sense of the skeptical is itself avoided, namely as a perspective that interprets itself in contrast with, in a paradoxical relationship to, the ordinary. On Kripke's view Wittgenstein makes a skeptical discovery for which he supplies (what Kripke styles) a skeptical solution. For me Wittgenstein discovers the threat or the temptation of skepticism in such a way that efforts to solve it continue its work of denial. The question is what the denial is of. Sometimes I say it is of finitude, sometimes of the human. These are hardly final responses. It should help to ask what Wittgensteinian criteria are designed to do and why philosophers have typically taken them as

designed to solve the question whether we can know that there is a world and others in it, that is, to answer the question of skepticism (and this should include Kripke's version of skepticism, beginning with the question whether I can know, be certain, that I mean one thing rather than another). What the schematism of criteria shows, instead, according to the reading of the *Investigations* on this point presented in my *Claim of Reason*, is why we wish to, and how we can, repudiate the knowledge our criteria provide, that is to say, how we can be tempted to skepticism, what its possibility is. Kripke's concentration on rules and his postponement of, and casualness about, the role of criteria in establishing the basis, hence the nature, of the "agreement"—whatever necessity in agreement human beings have—apart from which there is no common world of things and others, takes away, to my way of thinking, the *Investigations'* originality. Rules are not a (skeptical) solution to the problem of meaning (call it, for Wittgenstein, the question of what a word is); apart from a certain appeal to rules (the kind I believe Kripke makes for Wittgenstein, but which I believe Wittgenstein precisely repudiates) there would be no skeptical crisis of meaning (of the kind Kripke develops).

I was speaking of the relation of three ideas whose specific preparation begins explicitly in the second lecture: the argument of the ordinary; the scene of instruction; and the conversation of justice. Each is a function of taking oneself as representative of certain facts or conditions of what I might call philosophical life: that to appeal to ordinary language is not only to be able to communicate with other humans but is to exemplify the language so that others (a new generation of the culture) may learn it of you, may come to say what you say; and that this scene (of instruction) shadows the encounters of peers; and that to the extent that a philosophical argument is understandable as an argument over what, if anything, language tells of the world (the form in which skepticism presents its temptation in the *Investigations*, in which thinking presents itself in Heidegger's *What is Called Thinking?*), the argument cannot and must not have a victor, that skepticism is neither true nor false but a standing human threat to the human; that this absence of the victor is to help articulate the fact that, in a democracy embodying good enough justice, the conversation over how good its justice is must take place and must also not have a victor, that this is not because agreement can or should always be reached, but because disagreement, and sep-

arateness of position, is to be allowed its satisfactions, reached and expressed in particular ways. In the encounter of philosophy it is as important to keep still as to speak, to refuse sides, to wait; in an encounter over justice, there are sides, or positions, and while there may in the moment be nothing to do, and nothing further to say, there is still something to show: say consent or dissent. Responsibility remains a task of responsiveness.

I shall in effect be saying that the moral perfectionism I am most interested in exemplifies and studies this responsiveness. A way of describing Rawls's achievement is to say that it makes perspicuous how the justice of justice can be assessed. This is possible because, in Rawls's interpretation of social contract theory, the original position in which the contract is consented to is open to the present. Rawls conceives the original position as an interpretation of what in social contract mythology, or fantasy, is the state of nature. Its access to the present accordingly, that is mythically, permits the question: Is (this) society worth its burdens, over those of the burdens of consignment to nature? And Rawls's theory of justice is, pertinently, the provision of tests of institutions according to this ability to mitigate those burdens—those both of the natural and of the social orders (the fortune of talents, the inheritance or luck of position). Mitigation thus conceived as part of justice (as opposed to conceiving it, say, as philanthropy) is essential to democracy. The issue of Emersonian Perfection is whether something else is not also essential, implied by the power to, in a sense the necessity to, choose one's life, in particular, as Rawls movingly pictures the matter, to "[share] one another's fate" (*A Theory of Justice*, p. 102). The "something else" is the idea of the cultivation of a new mode of human being, of being human, where the idea is not that this comes later than justice but that it is essential in pursuing the justice of sharing one another's fate without reducing that fate, as it were, to mitigation.

It would at a stroke undermine perfectionism's claim to the moral attention of democracy if (where) the cultivation perfectionism seeks is a product of talent, distributed as unevenly as any other biological emphasis. But it is a serious misunderstanding of Emerson, as of Nietzsche, to construe their call for culture as a scouting for talent, something they on the whole distrust. What Emerson appeals to, or would awaken, he calls genius. Of course this might morally be even more deplorable, since on a familiar view of genius,

genius is rarer than talent. But this calculation is the reverse of Emerson's, for whom genius—call it, in Emerson's retransfiguration of the idea, the capacity for self-reliance—is universally distributed, as universally, at any rate, as the capacity to think. Then what is the particular moral question about it? If the cultivation of (one's) genius requires and demands no unjust share of social goods, what is the issue? But what if the moral enforcements of Utilitarian interests and Kantian obligations precisely counter this cultivation; and what if this cultivation is necessary to what justifies a society in reform, for which tradition is no longer authoritative— as necessary to its sense of responsiveness to the conflict of interests and of obligations as justice itself. Emersonian Perfectionism can be taken as the paradoxical task of secularizing the question of the profit in gaining the whole world and losing one's soul. Paradoxical because the losing, hence finding, of, let us say, one's self, must proceed without the option of forgoing this world for another place, and without a given discourse in which to think about what is one's "own" self. The moral question of Emersonian Perfectionism does not arise because this quest requires a greater share of goods than other ways of life, but because the right to *this* way, to the demand for one's own experience (as Emerson sometimes casts the matter) keeps getting lost, as if the threat of this life to other lives lies elsewhere than in (though it may be projected as) demands for unfair material advantages. It is axiomatic in Emersonian Perfectionism that, as in the second paragraph of Emerson's "The Poet," "The young man reveres men of genius, because, to speak truly, they are more himself than he is." It is *this* "more" that it is, for some reason, threatening to claim. And unless the axiom were true generally, why would the materially successful feel rebuked by (Emerson says we are shamed, not simply guilty, in the face of) the materially unsuccessful? (Not, on the whole, of course, sufficiently or efficiently rebuked.) Emersonian Perfectionism is not primarily a claim as to the right to goods (let alone the right to more goods than others) but primarily as to the claim, or the good, of freedom. Perfectionism's contribution to the idea of the liberation of human kind is perhaps to be located in the question as to, let's say, the origin of liberty, whether it can be granted or only, after it is taken, acknowledged. (The latter is what is counted on in the opening of the Declaration of Independence.) This question is apt to figure the issue of my liberty as a matter of my voice. Where a reforming society is characterized

by enough goods and enough similarity of need and of vulnerability so that what Rawls names "the circumstances of justice" are realized (as in *A Theory of Justice*, sec. 22), liberty has no economy; I mean it is not subject to the questions of scarcity, productiveness, fair distribution, and so forth, that goods are. To say that my liberty may be limited by the liberty of others is a way of saying that liberty is not to be limited by, for example, taste or opinion. But the formulation encourages an idea that there is a stock of liberty available to a given group and that my claiming an amount of it deprives someone else of that amount; as if the moral issue of liberty is to economize it rather than to exercise it, which may increase it all around. That liberty is limited by the conditions necessary for the institution and preservation of the social order (to say nothing of what is necessary for the institution and preservation of the order of my character) is no doubt true. But what the content of that order is to be is something into which my voice is to enter. The issue of consent becomes the issue of whether the voice I lend in recognizing a society as mine, as speaking for me, is my voice, my own. If this is perfectionism's issue, it should indicate why perfectionist claims must enter into the conversation of justice.

Assessing the burdens of the social order as compared with those of the state of nature was seen by classical social contract theorists as weighing the "advantages" of society as compared with those of nature. This is so important a matter that for Hume it obviates the need for the intellectual burden of a social contract: advantage is enough to explain one's willingness for society; fortunately, since that is all there is to do the explaining. The problem with the general advantage of society over nature as a term of social criticism is that it is too powerful—the general advantage of society is likely to seem so obvious that it tells chiefly against tyranny, where society itself becomes a populated state of nature. There is a sharing of one another's fate, obviously sometimes pertinent, as on a picture of a threatened raft—or a ship as small as that at the beginning of *The Tempest*—where each soul present is either to do his part to save all or to stand aside as irrelevant, as all may presently become. But the idea of consent, requesting my voice, transforms the picture of survival. It asks me to make my society mine, one in which I am spoken for, where my voice may be raised in assessing the present state of society against a further or next state of society. Call the former (society vs. nature) absolute advantage, the latter (society vs. the

next state of society) relative advantage. In criticizing my society for its relative disadvantages I am in effect criticizing myself.

This is a way of formulating the idea that freedom is obeying the law we give to ourselves, which is to say: freedom is autonomy. Formulating this idea rather from the side of what I say (authorizing the law) than from the side of what I listen to (obey, subject to the law) is meant to bring forward the way a compromised state of society, since it is mine, compromises me. This idea is essential to my understanding of Emersonian Perfectionism, that is, a perfectionism understood not only to be compatible with democracy, but its prize. The idea is that the mode of character formed under the invitation to the next self, entering the next state of society, is one capable of withstanding the inevitable compromise of democracy without cynicism, and it is the way that reaffirms not only consent to a given society but reaffirms the idea of consent as a responsiveness to society, an extension of the consent that founds it. This idea takes the public pursuit of happiness, an attestation of the society as a site of this pursuit in the presence of its unexplained misery, as a test of the goodness enough of its justice. The suffering compromises my happiness, but it does not falsify it nor its show of consent.

To a certain cast of European mind this is apt to sound like an enforced obligation to happiness hardly a step away from enforced consent, the negation of consent; for such a mind America remains, if not exactly an object of amusement, a site of mystery. Emerson is examining American shows of happiness in such a passage, from "Self-Reliance," as this: "A man must consider what a blindman's-buff is this game of conformity. . . . It makes [most men] not false in a few particulars, authors of a few lies, but false in all particulars . . . every word they say chagrins us. . . . There is a mortifying experience in particular, which does not fail to wreak itself also in the general history; I mean the foolish face of praise, the forced smile which we put on in company where we do not feel at ease in answer to conversation which does not interest us." (p. 151) Emerson's urgency in detailing the forced false smile of conformity is that as a vessel of the democratic idea, inevitably consulting himself on the state of his consent, he must find the true smile on the face— where else?—of the true man, one he is attracted to as the representative man, the human being who is the sign of what it is to be human, who asks for the new construction of the human dispensa-

tion. In the third lecture we shall hear John Milton analogize, in his treatise on divorce, the "honest peace and just contentment" of a reformed state not to the authority of the (male) head of a family but to the happiness of a good or legitimate marriage, which he characterizes as the participation in a "meet and happy conversation." To figure that my voice is called for in the social formation is to figure both that I participate in a structure that produces unaccountable misery and that my participation is to be expressed as happiness, even Emersonian joy. Call this the paradox of (continued) consent (to what Milton calls a "reformed" state, which I understand as the commitment of democracy in general against political privilege).

To assess the force of this paradox requires assessing the alternative mode of responsiveness to good enough justice, noted earlier, that is one of Rawls's most admirable contributions to the study of justice—his description of the good democrat as managing to live a life "above reproach." Important as this possibility will be, in defensibly just circumstances, to preserving one's sanity, it is, in the application Rawls gives it, as an answer to the present cry of justice, unavailable. My systematic argument, such as it is, for this unavailability, in the third lecture, as opposed to my somewhat more elaborated account in that lecture of the case of Nora in *A Doll's House*, concerns the nature of promising, and is so briefly presented as to amount to a bare suggestion. But Rawls's proposal is, I believe, the cause of the elegaicism, concentrated in but not confined to his final paragraph ("to see clearly and to act with grace and self-command"), a particularly admired moment, I believe, of the book's rhetorical design. That mood is the contrary of Emerson's widely, perennially criticized mood of cheer, or joy. Taking Emerson's mood as the expression of (perfectionist) participation in democracy, I naturally feel obliged to defend it, or determine its defensibility, as the solution of the paradox of consent. That mood is the particular business of the little address "Hope against Hope," which I have added as an Appendix to these Carus lectures.

Writing from within a society characterized—it is a mark of my consent to say so—by good enough justice, I take it for granted that there are more people in this society advantaged by it than disadvantaged by it; and in a country as fantastically wealthy as the United States is, great numbers of people are greatly advantaged. In speaking of consent as expressed by (pursuits of) happiness, I am

speaking directly of this numerical majority, mottled by so many other differences, deeper if not more important differences. I am not, that is, assuming that I speak here directly to or for the disadvantaged, the oppressed, whose happiness is, or should be, a mystery and an object of longing to the more or less unjustly advantaged. Apart from saints, and setting aside the consent of the greatly advantaged to take care of itself, I assume that the consent of the relatively advantaged does *not* take care of itself, but that, as comes out especially in the third lecture, it is subject to an oppressive helplessness—I have described its signs as a sense of compromise and of cynicism—Emerson calls it being ashamed—that distorts or blocks their participation in the conversation of justice. They may, for example, call for civility where there is no civility. In my ignorance, sometimes hard to tell from the world's ignorance, and in the recent intellectual fascination with Nazism, and the Jewish sense of continued abandonment and isolation in the face and aftermath of Nazism, and in the worldwide intensification of fundamentalism, together with a worldwide revulsion from it, I feel subject to—not increasingly, perhaps, but particularly unprotected against—fantasias of perplexity containing images of what Plato meant in stating democracy's devolution into tyranny; of accounts of the intellectual withdrawals in Weimar; of memories of a generation of students rebuking their parents for handing on to them advantages they found they could not accept, an undismissible source of criticism whose legacy of pain we continue in the presence of. I conjecture that it is the presence of this pain that accounts for, for example, the recent extraordinary success of Allan Bloom's *The Closing of the American Mind*, which repeatedly identifies American students of the 1960s with the Hitler Youth. Sour ugliness in response to bitter ugliness, it expresses that shame of association democracy uses as the coin of social control in place, so far as it can, of the threat of its police powers. (Unlike other cultural conservatives, or say antimodernists, Bloom extraordinarily maintains a conviction in human perfectibility by means of education. But he is surely right to insist on the peculiar importance to a democracy of its means and system of education.) Shame manifests the cost as well as the opportunity in each of us as the representative of each. It is why shame, in Emerson's discourse—his contradiction of joy—is the natural or inevitable enemy of the attainable self, the treasure of perfectionism for democracy. It is the power to take one's liberty; hence the power to recognize the rights of this power in others.

As representative we are educations for one another. An early lesson of democracy is that one is not to legislate his or her tastes or opinions, but only the good of all. Its consequent lesson is that this early lesson is not just one among the lessons of democracy: any may have to bear the burden of showing that a certainty of moral position may be based merely on taste or opinion—not inevitably, but in a given case. A philosopher will naturally think that the other has to be argued out of his position, which is apt to seem hopeless. But suppose the issue is not to win an argument (that may come late in the day) but to manifest for the other another way. (The "degree" Emerson speaks of in prophesying the revolutionary effect of a "new degree of culture" is not necessarily of a higher intensity, but of a shift in direction, as slight as a degree of the compass, but down the road making all the difference in the world.) The trial may end soon, your spade turned. But that is not, for perfectionism, the end of the confrontation, since its point was not argument. (Let us hope there is no law against your cultivating with your spade just there.) It becomes the perfectionist moment, where one begins showing how to manage individuation, its economy, the power that goes into passiveness. How dare one? Thoreau goes along with the idea that he is boasting. In a democracy the speaking of public thoughts is apt to seem, in its open possibility, the easiest way to speak; for Emerson it is the most necessary and the hardest. The distinction between private and public, subjective and objective, a feast for metaphysical and moral dispute, becomes the daily fare of democracy.

Understanding Emersonian Perfectionism as an interpretation of Rousseau's and Kant's idea of freedom as autonomy means understanding it as questioning what or who the self is that commands and obeys itself and what an obedience consists in that is inseparable from mastery. Rousseau's criticism of society in these terms is that we are not expressed in the laws we give ourselves, that the public does not exist, that the social will is partial (conspiratorial). Kant's hypothetical criticism takes the form of asking whether our obedience is partial, that is heteronomous, taken on the part of incentives not internal to the law. Emerson's turn is to make my partiality itself the sign and incentive of my siding with the next or further self, which means siding against my attained perfection (or conformity), sidings which require the recognition of an other—the acknowledgment of a relationship—in which this sign is manifest. Emerson does not much attempt to depict such a relationship (film may call it marriage, philosophers have usually called it friendship),

but the sense I seek to clarify is that Emerson offers his writing as representing this other for his reader. So that Plato's pressures on writing, his so-called literary powers, are confirmed as internal to the task of presenting the soul's journey; as if this cannot be presented without calling for it, and vice versa. It is why the moral force of perfectionism does not collect in judgments but is at stake in every word, as if every word that does not cheer us chagrins us. (This is not, I hope, to be taken as a moralistic criticism of academic prose for not being what it is not. It is to raise again the question whether the soul's journey is any part of a university's business, hence to what extent, if it is an essential part of philosophy's business, philosophy is left out of the university. Where would it not be left out?)

Plato asks whether the unjust can be happy. In these encouragingly ancient terms, Emerson, on my view, asks whether the democrat must be happy—in the face, as happiness must always be found in the face, of imperfect justice. Happiness is not defined by Emerson, for example as certain routes of pleasure or of beauty or as satisfactory work, deep as these discoveries are. Philosophers have tried to specify the basis of friendship. If one thinks, adapting a rhetorical discovery of Kant's, of perfectionist friendship as the finding of mutual happiness without a concept, then to articulate its basis may be said to be a recurrent point of the conversation that constitutes the friendship.

1 AVERSIVE THINKING
Emersonian Representations in Heidegger and Nietzsche

In taking the perspective of the Carus Lectures as an opportunity to recommend Emerson, despite all, to the closer attention of the American philosophical community, I hope I may be trusted to recognize how generally impertinent his teachings, in style and in material, can sound to philosophical ears—including still, from time to time, despite all, my own. But what else should one expect? My recommendation is bound to be based—unless it is to multiply impertinence—on something as yet unfamiliar in Emerson, as if I am claiming him to remain a stranger. In that case to soften his strangeness would be pointless—which is no excuse, I do realize, for hardening it. About my own sound it may help to say that while I may often leave ideas in what seems a more literary state, sometimes in a more psychoanalytic state, than a philosopher might wish—that is, that a philosopher might prefer a further philosophical derivation of the ideas—I mean to leave everything I will say, or have, I guess, ever said, as in a sense provisional, the sense that it is to be gone on from. If to a further derivation in philosophical form, so much the better; but I would not lose the intuitions in the meantime—among them the intuition that philosophy should sometimes distrust its defenses of philosophical form.

It is common knowledge that Emerson's "The American Scholar" is a call for Man Thinking, something Emerson contrasts with thinking in "the divided or social state," thinking, let us say, as a specialty. I do not know of any commentary on this text that finds Emerson to be *thinking* about the idea of thinking. Uniformly, rather, it seems to be taken that he and his readers understand well enough what it is he is calling for, that it is something like thinking with the whole man; and I suppose this can be taken so for granted because there has been, since Emerson's time, or the time he speaks for, a widespread dissatisfaction with thinking as represented in Western philosophy since the Enlightenment, a dissatisfaction vaguely and often impatiently associated, I believe, with an idea of romanticism. And of course there has been, in turn, a reactive impatience with this dissatisfaction. Emerson is, in his way, locating himself within this struggle when he calls upon American thinkers

33

to rely on and to cheer themselves: "For this self-trust, the reason is deeper than can be fathomed—darker than can be enlightened" ("The American Scholar," p. 75). As if he anticipates that a reader might suppose him accordingly to be opposed to the Enlightenment, he will famously also say, "I ask not for the great, the remote, the romantic; . . . I embrace the common, I sit at the feet of the familiar, the low," a claim I have taken as underwriting ordinary language philosophy's devotion to the ordinary, surely one inheritance of the Enlightenment.

Existentialism—in the years in which it seemed that every mode of thinking antagonistic to analytical philosophy was called Existentialism—was famous for some such dissatisfaction with philosophical reason, expressed, for example, by Karl Jaspers in his book on Nietzsche, originally published in 1935:

> That the source of philosophical knowledge is not to be found in thinking about mere objects or in investigating mere facts but rather in *the unity of thought and life,* so that thinking grows out of the provocation and agitation of the whole man—all this constitutes for Nietzsche's self-consciousness the real character of his truth: "I have always composed my writings with my whole body and life"; "All truths are bloody truths to me." (Jaspers, *Nietzsche,* p. 386)

("Cut these sentences and they bleed.") Philosophy, as institutionalized in the English-speaking world, has not much felt attacked by nor vulnerable to such criticism, partly because the style and animus of the criticism is so foreign as to suggest simply other subjects, but partly, and sufficiently, because surely since Frege and the early Russell, analytical philosophy can see what thinking is, or should be, namely reasoning, expressed in a certain style of argumentation.

In taking on Emerson's view of thinking I will not be interested to advocate his view over, nor much to characterize it against, views more familiar to us (say a view of reason as rationality) but rather to ask attention to an attitude toward or investment in words that Emerson's view seems to depend upon, an attitude allegorical of an investment in our lives that I believe those trained in professional philosophy are trained to disapprove of. The disapproval of the attitude interests me as much as the attitude itself. If, as professional philosophers, we were asked whether philosophizing demands of us anything we would think of as a style of writing, our answer, I guess, would waver, perhaps because our philosophical motivation

in writing is less to defend a style than to repress style or allow it only in ornamental doses. In speaking of disapproval, accordingly, I am not raising a question of taste, of something merely not for us, but a question of intellectual seriousness and illicitness. However glad we may be to think of ourselves as intellectually fastidious, I do not suppose we relish the idea of ourselves as intellectual police.

I should perhaps confess that an ulterior stake of mine in speaking of Emerson's attitude to words is that—to begin specifying a suggestion already made—I find J. L. Austin and the later Wittgenstein to participate in a region of the attitude, the region that places an investment in the words of a natural language so heavy as to seem quite antithetical to sensible philosophizing. It was half a lifetime ago that I began writing philosophy by preparing a paper ("Must We Mean What We Say?") for this division of our philosophy association defending J. L. Austin's practice with ordinary language against criticisms of it articulated by Benson Mates, criticisms notably of Austin's apparently insufficient empirical basis for his claims to know what we say and mean when. I did not really answer Mates's criticisms because I could not account for that investment in the ordinary. I still cannot. This failure pairs with my inability to answer Barry Stroud's question to me twenty years later, at another Association meeting, about whether my *Claim of Reason* didn't amount to a claim to find a general solution to skepticism. I wanted to answer by saying that by the end of the first two parts of that book I had convinced myself not only that there is no such solution, that to think otherwise is skepticism's own self-interpretation, but that it seemed to me, on the contrary, work for an ambitious philosophy to attempt to keep philosophy open to the threat or temptation to skepticism. This left me what I named as Nowhere, and it led me, in the fourth part of my book, to particular territories customarily associated with literature—especially to aspects of Shakespearean and of certain romantic texts—in which I seemed to find comic and tragic and lyric obsessions with the ordinary that were the equivalent of something (not everything) philosophy knows as skepticism. Emerson became more and more prominent an inhabitant of these regions. His investment in the ordinary is so constant and so explicit that, perhaps because of the very strangeness and extravagance of his manner, it may indicate afresh why a philosopher interested in the manner might spend a reasonable lifetime looking for an account of it.

The first half of this lecture takes its bearing from pertinences Emerson's American Scholar address bears to Heidegger's sequence of lectures translated as *What Is Called Thinking?* (all citations of Heidegger are from this text); the second half continues the discussion broached in my Introduction of that moral perfectionism for which Emerson's writing is definitive, particularly in connection with its dominating influence on, among others, Nietzsche.

Emerson's sense of thinking is, generally, of a double process, or a single process with two names: transfiguration and conversion. For instance (still in "The American Scholar"), "A strange process, . . . this by which experience is converted into thought, as a mulberry leaf is converted into satin. The manufacture goes forward at all hours" (p. 70). And again:

> The actions and events of our childhood and youth are now matters of calmest observation. . . . Not so with our recent actions,—with the business which we now have in hand. Our affections as yet circulate through it. . . . The new deed . . . remains for a time immersed in our unconscious life. In some contemplative hour it detaches itself . . . to become a thought of the mind. Instantly it is raised, transfigured; the corruptible has put on incorruption. (pp. 70–71)

Transfiguration is to be taken as a rhetorical operation, Emerson's figure for a figure of speech—not necessarily for what rhetoricians name a known figure of speech, but for whatever it is that he will name the conversion of words. In "Self-Reliance" he calls the process that of passing from Intuition to Tuition, so it is fitting that those who find Emerson incapable of thought style him a philosopher of Intuition, occluding the teacher of Tuition. Tuition is what Emerson's writing presents itself to be throughout; hence, of course, to be articulating Intuition. It is when Emerson thinks of thinking, or conversion, as oppositional, or critical, that he calls it aversion. This bears relation not alone to Emerson's continuous critique of religion but to Kant's speaking of Reason, in his always astonishing "Conjectural Beginning of Human History," as requiring and enabling "violence" (to the voice of nature) and "refusal" (to desire), refusal being a "feat which brought about the passage from merely sensual to spiritual attractions," uncovering "the first hint at the development of man as a moral being" (pp. 56–57). And Emerson's aversion bears relation to Heidegger's discussion of why thinking in his investigation of it "is from the start tuned in a negative key." (*What is Called Thinking?* p. 29)

Accordingly, a guiding thought in directing myself to Emerson's way of thinking is his outcry in the sixth paragraph of "Self-Reliance": "The virtue in most request is conformity. Self-reliance is its aversion." I gather him there to be characterizing his writing, hence to mean that he writes in aversion to society's demand for conformity, specifically that his writing expresses his self-consciousness, his thinking as the imperative to an incessant conversion or refiguration of society's incessant demands for his consent—his conforming himself—to its doings; and at the same time to mean that his writing must accordingly be the object of aversion to society's consciousness, to what it might read in him. His imperative is registered in the outcry a few paragraphs later, "Every word they say chagrins us." Emerson is not, then, as the context might imply, expressing merely his general disappointment at some failure in the capacity of language to represent the world but also expressing, at the same time, his response to a general attitude toward words that is causing his all but complete sense of intellectual isolation. It is his perfectionism's cue.

The isolation is enacted in "The American Scholar," whose occasion is enviably if not frighteningly distinctive. Whoever Emerson invokes as belonging to the class of scholars that commencement day at Harvard in the summer of 1837—himself, his audience (whether as poets, preachers, or philosophers)—the principal fact about the class is that it is empty, the American Scholar does not exist. Then who is Emerson? Suppose we say that what motivates Emerson's thinking, or what causes this call for the American Scholar, is Emerson's vision of our not yet thinking. Is this plain fact of American history—that we are, we still find ourselves, looking for the commencement of our own culture—worth setting beside the intricate formulation whose recurrences generate Heidegger's *What Is Called Thinking?*: "Most thought-provoking in our thought-provoking time is that we are still not thinking" (p. 6). (*Das Bedenklichste in unserer bedenklichen Zeit ist, dass wir noch nicht denken.*) It probably does not matter that the translation cannot capture the direct force in the relation of *bedenklich* to *denken* and the senses of *bedenklich* as doubtful, serious, risky, scrupulous—it would mean capturing the idea of the thing most critically provoking in our riskily provocative time to be that we are still not really provoked, that nothing serious matters to us, or nothing seriously, that our thoughts are unscrupulous, private. (Emerson's remark in his "Divinity School Address" echoes for me: "Truly speaking, it is

not instruction, but provocation, that I can receive from another soul." What translation will capture the idea of provocation here as calling forth, challenging?) Nor hence capture the surrealistic inversion of the Cartesian thought that if I am thinking then I cannot be thinking that perhaps I do not think. In Heidegger, if I am thinking then precisely I must be thinking that I am (still) not thinking. I say the translation may not matter because one who is not inclined, as I am, at least intermittently to take Heidegger's text as a masterpiece of philosophy will not be encouraged—on the contrary—to place confidence in a mode of argumentation which invests itself in what is apt to seem at best the child's play of language and at worst the wild variation and excesses of linguistic form that have always interfered with rationality. For someone who has not experienced this play in Heidegger, or in Emerson, the extent of it can from time to time appear as a kind of philosophical folly.

I summarize two instances from the essay "Experience" to suggest the kind of practice that has convinced me that Emerson's thought is, on a certain way of turning it, a direct anticipation of Heidegger's. Emerson writes: "I take this evanescence and lubricity of all objects, which lets them slip through our fingers then when we clutch hardest, to be the most unhandsome part of our condition." You may either dismiss, or savor, the relation between the clutching fingers and the hand in handsome as a developed taste for linguistic oddity, or you might further relate it to Emerson's recurring interest in the hand (as in speaking of what is at hand, by which, whatever else he means, he means the writing taking shape under his hand and now in ours) and thence to Heidegger's sudden remark, "Thinking is a handicraft," by which he means both that thinking requires training and makes something happen, but equally that it makes something happen in a particular way since the hand is a uniquely human possession: "The hand is infinitely different from all grasping organs—paws, claws, fangs" (Heidegger, 16). (It matters to me in various ways to recall a seminar of C. I. Lewis's on "The Nature of the Right," given at Harvard in the academic year 1951–52—the year Heidegger delivered the lectures constituting *What Is Called Thinking?*—in which Lewis emphasized the hand as a trait of the human, the tool-using trait, hence one establishing a human relation to the world, a realm of practice that expands the reaches of the self. The idea seemed to me in my greenness not to get very far, but it evidently left me with various

impressions, among others one of intellectual isolation. Lewis's material was published posthumously under the title, "The Individual and the Social Order.") Emerson's image of clutching and Heidegger's of grasping, emblematize their interpretation of Western conceptualizing as a kind of sublimized violence. (Heidegger's word is *greifen*; it is readily translatable as "clutching.") Heidegger is famous here for his thematization of this violence as expressed in the world dominion of technology, but Emerson is no less explicit about it as a mode of thinking. The overcoming of this conceptualizing will require the achievement of a form of knowledge both Emerson and Heidegger call reception, alluding to the Kantian idea that knowledge is active, and sensuous intuition alone passive or receptive. (Overcoming Kant's idea of thinking as conceptualizing—say analyzing and synthesizing concepts—is coded into Emerson's idea that our most unhandsome part belongs to our condition. I have argued elsewhere (in "Emerson, Coleridge, Kant") that Emerson is transfiguring Kant's key term "condition" so that it speaks not alone of deducing twelve categories of the understanding but of deriving—say schematizing—every word in which we speak together (speaking together is what the word condition says); so that the conditions or terms of every term in our language stand to be derived philosophically, deduced.)

Now reception, or something received, if it is welcome, implies thanks, and Heidegger, in passages as if designed to divide readers into those thrilled and those offended, harps on the derivation of the word thinking from a root for thanking and interprets this particularly as giving thanks for the gift of thinking, which is what should become of philosophy. Does it take this thematization to direct attention to one of Emerson's throwaway sentences that, as can be said of essentially every Emersonian sentence, can be taken as the topic of the essay in which it finds itself, in this case "Experience"?: "I am thankful for small mercies." To see that this describes the thinking that goes on in an Emersonian sentence you would have to see the joking tautology in linking his thankfulness with a *mercy*, that is to say a *merci*; and to recognize "small mercy" as designating the small son whose death is announced at the beginning of "Experience," an announcement every critic of the essay comments on, a child never named in the essay but whose death and birth constitute the lines of the father's investigation of experience—and it is the philosopher's term "experience" Emerson is (also) exploring, as in

Kant and in Hume—an effort to counteract the role of experience as removing us from, instead of securing us to, the world. The idea, again argued elsewhere (in "Finding as Founding"), is that Emerson's essay "Experience" enacts the father's giving birth to Waldo—the son that bears Emerson's name for himself, hence declares this birth (as of himself) as his work of writing generally, or generously. The clearer the intricacies become of the identification of the child Waldo with the world as such, the deeper one's wonder that Emerson could bring himself to voice it socially, to subject himself either to not being understood or to being understood—yet another wonder about intellectual isolation. I am for myself convinced that Emerson knew that such devices as the pun on "thankful" and "mercy" were offensive to philosophical reason. So the question is why he felt himself bound to give offense. (An opening and recurrent target of Dewey's *Experience and Nature* is thinkers who take experience to "veil and screen" us from nature. Its dissonance with Emerson is interesting in view of Dewey's being the major American philosopher who, without reservation, declared Emerson to be a philosopher—without evidently finding any use for him. For Dewey the philosophical interpretation of experience was cause for taking up scientific measures against old dualisms, refusing separation. For Emerson the philosophical interpretation of experience makes it a cause for mourning, assigning to philosophy the work of accepting the separation of the world, as of a child.)

It is in Nietzsche, wherever else, that some explanation must be sought for the inner connection between a writer (such as Heidegger) who calls for thinking knowing the completed presence of European philosophy or, say, facing its aftermath, as if needing to disinherit it, and a writer (such as Emerson) who calls for thinking not knowing whether the absence of the philosophical edifice for America means that it is too late for a certain form of thinking here or whether his errand just is to inherit remains of the edifice. Nietzsche is the pivot because of his early and late devotion to Emerson's writing together with his decisive presence in Heidegger's *What Is Called Thinking?* But no matter how often this connection of Nietzsche to Emerson is stated, no matter how obvious to anyone who cares to verify it, it stays incredible, it is always in a forgotten state. This interests me almost as much as the connection itself does, since the incredibility must be grounded in a fixed conviction that Emerson is not a philosopher, that he cannot be up to the pitch of

reason in European philosophy. The conviction is variously useful to American as well as to European philosophers as well as to literary theorists. When one mind finds itself or loses itself in another, time and place seem to fall away—not as if history is transcended but as if it has not begun.

The reverse of the unhandsome in our condition, of Emerson's clutching, and Heidegger's grasping—call the reverse the handsome part—is what Emerson calls being drawn and what Heidegger calls getting in the draw, or the draft, of thinking. Emerson speaks of this in saying that thinking is partial, Heidegger in speaking of thinking as something toward which the human is inclined. Heidegger's opening paragraphs work inclination into a set of inflections on *mögen, vermögen,* and *Möglichkeit:* inclination, capability, and possibility. Emerson's "partiality" of thinking is, or accounts for, the inflections of partial as "not whole," together with partial as "favoring or biassed toward" something or someone. Here is Emerson weaving some of this together:

> Character is higher than intellect. Thinking is the function. Living is the functionary. . . . A great soul will be strong to live, as well as strong to think. Does he lack organ or medium to impart his truths? He can still fall back on this elemental force of living them. This is a total act. Thinking is a partial act. Let the grandeur of justice shine in his affairs. Let the beauty of affection cheer his lowly roof. Those "far from fame," who dwell and act with him, will feel the force of his constitution. ("The American Scholar," p. 72)

("Affairs," "lowly roof," and "constitution," are each names Emerson is giving to functions of his writings.) A number of clichés, or moments of myth, are synthesized here, opening with a kind of denial that virtue is knowledge, continuing with the existentialist tag that living is not thinking, picking up a romantic sound ("lowly roof") to note that strong thoughts are imparted otherwise than in educated or expert forms, and hitting on the term "partial" to epitomize what he calls at the beginning of his address "the old fable" "that the gods, in the beginning, divided Man into men, as the hand was divided into fingers, the better to answer its end" (thus implying that Man has an end, but that to say so requires a myth).

When Emerson goes on to claim to have "shown the ground of his hope in adverting to the doctrine that man is one" (p. 75), the apparent slightness of this, even piousness, in turning toward a doc-

trine, as if his hopes are well known, and well worn, may help disguise the enormity of the essay's immediate claim for its practice, that is, for its manner of writing. The passage (citing thinking as partial) proposes nothing *more*—say something total—for thinking to be; it declares that *living* is total, and if the living is strong it shows its ground, which is not to say that it is *more* than thinking, as if thinking might leave it out. Thinking *is*—at its most complete, as it were—a partial act; if it lacks something, leaves something out, it is its own partiality, what Kant calls (and Freud more or less calls) its incentive and interest (*Triebfeder*).

Since the lives of this people, Emerson's people, do not yet contain thinking, he cannot, or will not, sharing this life, quite claim to be thinking. But he makes a prior claim, the enormous one I just alluded to, namely to be providing this incentive of thinking, laying the conditions for thinking, becoming its "source," calling for it, attracting it to its partiality, by what he calls living his thoughts, which is pertinent to us so far as his writing is this life; which means, so far as "the grandeur of justice shine(s)" in the writing and "affection cheer(s)" it. Then this lowly roof, in which the anonymous will dwell with him, will provide them with the force of his constitution—there is no further fact, or no other way, of adopting it. (To follow out the idea of Emerson as (re)writing the constitution of the nation, or amending it, in the system of his prose, is a tale I do not get to here.) This provisionality of his writing—envisioning its adoption, awaiting its appropriation in certain ways (it cannot *make* this happen, work as it may)—is the importance of his having said, or implied, that since in the business we now have in hand, through which our affections as yet circulate, we do not know it, it is not yet transfigured, but remains in "our unconscious life," the corruptible has not yet put on incorruption. But what is this corruptible life, this pretransfigurative existence of his prose, unconscious of itself, unconscious to us? It is, on the line I am taking, one in which Tuition is to find its Intuition, or in which Emerson's thinking finds its "material" (as psychoanalysis puts it). In the opening two paragraphs of "The American Scholar" it "accepts" its topics in hope, and understands hope as a sign, in particular of "an indestructible instinct," yet an instinct that thinking must realize as "something else." I suppose this to mean that thinking is replacing, by transfiguring, instinct (as Nietzsche and as Freud again will say).

The opening reluctance and indefiniteness of Emerson's defini-

tion of his topic in "The American Scholar," his notation of this anniversary event as the "sign of the survival of the love of letters amongst a people too busy to give to letters any more" (than love and hope and instinct), suggest to me that Emerson means that his topics are our everyday letters and words, as signs of our instincts; they are to become thought. Then thinking is a kind of reading. But thought about what? Reading for what?

Sign suggests representation. How can "The American Scholar" represent the incentive of thinking—constitute a sign of its event—without at the same time presenting thinking, showing it? If thinking were solving problems, the incentive would be the problems or could be attached to the solutions. But Emerson's crack about our being "too busy to give to letters any more" exactly suggests that we are precisely busy solving things. When he opens by defining the anniversary on which he is speaking as one of hope and perhaps not enough of labor, he means of course that our labors (including those of what *we* call thinking) are largely devoted elsewhere than to letters—which is what everyone who cared was saying in explanation of the failure of America to found its own letters, its own writing, and its own art. But Emerson also means that founding letters demands its own labor and that we do not know what this (other) labor (the one that produces letters) is, that it is also a mode of thinking. Labor—as a characterization of thinking—suggests brooding. An interplay between laboring as reproductive and as productive (say as the feminine and the masculine in human thought) suggests Emerson's relentlessness concerning the interplay of the active and the receptive, or passive, in our relating to the world. (Thinking as melancholy reproduction characterizes Hamlet.) The other labor of thinking—devoted to letters—is, accordingly, one that requires a break with what we know as thinking. (Wittgenstein says our investigation has to be turned around; Heidegger says we have to take a step back from our thinking.) The incentive to this other mode will presumably consist in recognizing that we are not engaged in it, not doing something we nevertheless recognize a love for, an instinct for. Then Emerson's task is to show to that desire its satisfaction, which is to say: This writing must illustrate thinking. This means at the least that it must contain thought about what illustration is, what an example is.

In "The American Scholar" Emerson's transfiguration of illustration is his use of the word "illustrious." For example: "[The

scholar] is one who raises himself from private considerations ["innermost" he sometimes says] and breathes and lives on public ["outermost"] and illustrious thoughts" (p. 73). In Emerson's way of talking, this is a kind of tautology. It is a favorite idea of Emerson's that the passage from private to public ideas is something open to each individual, as if there is in the intellectual life the equivalent of the Moral Law in the moral life, an imperative to objectivity. In "Self-Reliance" he imagines a man who is able to reachieve a certain perspective that society talks us (almost all of us) out of, as one whose opinions would be "seen to be not private but necessary" (p. 149), and in "The American Scholar" he phrases what he will call the ground of his hope that man is one by saying "the deeper [the scholar] dives into his privatest, secretest presentiment, to his wonder he finds this is the most acceptable, most public, and universally true" (p. 74). The contrast to the superfically private, which the *most* private can reach, Emerson characterizes sometimes as necessary, sometimes as universal, thus exactly according to the characteristics Kant assigns to the a priori. I suppose Emerson knows this. But why would Emerson speak of illustrating the a priori conditions of thinking as illustrious? Surely for no reason separate from the fact that the illustration of thinking as attaining to the necessary and universal illustrates the conditions shared by humanity as such; such thoughts are illustrious exactly because they are completely unexceptional, in this way representative.

This thought produces some of Emerson's most urgent rhetoric, some of the most famous. In the opening paragraph of "Self-Reliance": "To believe your own thought, to believe that what is true for you in your private heart is true for all men,—that is genius." "In every work of genius we recognize our own rejected thoughts; they come back to us with a certain alienated majesty." Self-evidently no one is in a position to know more about this than any other, hence in no position to *tell* anyone of it, to offer information concerning it (this is the Ancient Mariner's mistake, and his curse). So pretty clearly Emerson is not talking about science and mathematics. Then what is he talking about? Whatever it is, he properly— conveniently, you might think—describes himself as *showing* his ground. But if his ground, or anyone's, will prove to be unexceptional (except for the endlessly specifiable fact that it is one's own life on that ground), why the tone of moral urgency in showing it, declaring it? Is thinking—something to be called thinking—some-

thing whose partiality or incentive is essentially moral and perhaps political?

Let us confirm Emerson's transfiguration of the illustrative in its other occurrence in "The American Scholar": "The private life of one man shall be a more illustrious monarchy, more formidable to its enemy, more sweet and serene in its influence to its friend, than any kingdom in history" (p. 76). The idea is that the illustrious is not, or shall not be, merely a particular result of monarchy but monarchy's universal cause, and the paradox alerts us to consider that while of course monarchy is derived as the rule of one (for whoever is still interested in that possibility) it may also come to be seen to speak of the *beginning or origin* of one, of what Emerson calls "one man," the thing two sentences earlier he had called "the upbuilding of a man," that is, of his famous "individual." (Hence the paradox of a private life as an illustrious monarchy is to be paired with the argument, as between Jefferson and Adams, of the natural aristocrat. Both knew that *that* was a paradoxical idea—as if democracy has its own paradox to match that of the philosopher king. The Adams-Jefferson exchange is invoked in a complementary context in my *Pursuits of Happiness*, p. 155.) When this process of upbuilding, or origination, is achieved, then, as the final sentence of "The American Scholar" puts it, "A nation of men will for the first time exist"—or as Marx put the thought half a dozen years after Emerson's address, human history will begin. For Emerson you could say both that this requires a constitution of the public and at the same time an institution of the private, a new obligation to think for ourselves, to make ourselves intelligible, in every word. What goes on inside us now is merely obedience to the law and the voices of others—the business Emerson calls conformity, a rewriting of what Kant calls heteronomy. That no thought is our own is what Emerson signals by interpreting the opening fable of his essay, concerning the gods' original division of Man into men, to mean that "Man is thus metamorphosed into a thing" (p. 64). That we are already (always already) metamorphosed sets, I suppose, the possibility and necessity of our transfiguration. Then what were we before we were metamorphosed? (Emerson speaks not only of our conversion, which is to say, rebirth; he also says that we are unborn. This is worth brooding over.)

If we are things, we do not belong to Kant's Realm of Ends, we do not regard ourselves as human, with human others. For Kant the

Realm of Ends might be seen as the realization of the eventual human city. As for Kant, for Emerson this vision is an inception of the moral life. What is the entrance to the city?

Here we cross to the second part of this lecture, to follow out a little the questionable tone of moral urgency in Emerson's descriptions of thinking. My thought is that a certain relation to words (as an allegory of my relation to my life) is inseparable from a certain moral-like relation to thinking, and that the morality and the thinking that are inseparable are of specific strains—the morality is neither teleological (basing itself on a conception of the good to be maximized in society) nor deontological (basing itself on an independent conception of the right), and the thinking is some as yet unknown distance from what we think of as reasoning. An obvious moral interpretation of the image of figuring from the innermost to the outermost is that of moral perfectionism (on a current understanding) at its most objectionable, the desire to impose the maximization of one's most private conception of good on all others, regardless of their talents or tastes or visions of the good.

I remarked that moral perfectionism has not found a secure home in modern philosophy. There are various reasons for this homelessness, and, as I have said, the title perfectionism covers more than a single view. Taking Emerson and Nietzsche as my focal examples here, and thinking of them, I surmise that the causes for the disapproval of perfectionism will orbit around two features or themes of their outlook: (1) A hatred of moralism—of what Emerson calls "conformity"—so passionate and ceaseless as to seem sometimes to amount to a hatred of morality altogether (Nietzsche calls himself the first antimoralist; Emerson knows that he will seem antinomian, a refuser of any law, including the moral law). (2) An expression of disgust with or a disdain for the present state of things so complete as to require not merely reform, but a call for a transformation of things, and before all a transformation of the self—a call that seems so self-absorbed and obscure as to make morality impossible: What is the moral life apart from acting beyond the self and making oneself intelligible to those beyond it?

A thought to hold on to is that what Emerson means by conformity is to be heard against Kant's idea that moral worth is a function of acting not merely in conformity with the moral law but for the sake of the law. Kant famously, scandalously, says that a mother who cares for her child out of affection rather than for the sake of the

moral law exhibits no moral worth. Kant does not say that this woman exhibits no excellence of any kind, just not of the highest kind, the kind that makes the public life of mutual freedom possible, that attests to the realm of ends. Emerson's perception can be said to be that we exhibit neither the value of affection nor the worth of morality (neither, as it were, feminine nor masculine virtues), but that our conformity exhibits merely the fear of others' opinions, which Emerson puts as a fear of others' eyes, which claps us in a jail of shame.

This in turn is to be heard against John Rawls's impressive interpretation of Kant's moral philosophy in which he presents Kant's "main aim as deepening and justifying Rousseau's idea that liberty is acting in accordance with a law that we give to ourselves" and emphasizes that "Kant speaks of the failure to act on the moral law as giving rise to shame and not to feelings of guilt" (A Theory of Justice, p. 256). A text such as Emerson's "Self-Reliance" is virtually a study of shame, and perceives what we now call human society as one in which the moral law is nowhere (or almost nowhere) in existence. His perception presents itself to him as a vision of us as "bugs, spawn," as a "mob"; Nietzsche will say (something Emerson also says) "herd." It is a violent perception of a circumstance of violence. How do we, as Emerson puts it, "come out" of that? How do we become self-reliant? The worst thing we could do is rely on ourselves as we stand—this is simply to be the slaves of our slavishness: it is what makes us spawn. We must become averse to this conformity, which means convert from it, which means transform our conformity, as if we are to be born (again). How does our self-consciousness—which now expresses itself as shame, or let us say embarrassment—make us something other than human? I have elsewhere (in "Being Odd, Getting Even") tried to show that Emerson is taking on philosophy's interpretation of self-consciousness in its versions in both Descartes and Kant.

In Descartes, self-consciousness, in the form of thinking that I think, must prove my existence, human existence. When in "Self-Reliance" Emerson says that we dare not (as if we are ashamed to) say "I think," "I am," as if barred from the saying of the cogito ergo sum, his implication is that we do not exist (as human), we as if haunt the world. And I find this pattern in Emerson (of discovering our failing of philosophy as a failure of our humanity) also to be interpreting Kant's idea of freedom as imposing the moral law upon

oneself. It is for Emerson not so much that we are ashamed because we do not give ourselves the moral law—which is true enough—but that we do not give ourselves the moral law because we are already ashamed, a state surely in need of definition, as if we lack the right to be right. Again, it is not that we are ashamed of our immorality; we are exactly incapable of being ashamed of *that*; in that sense we are shameless. Our moralized shame is debarring us from the conditions of the moral life, from the possibility of responsibility over our lives, from responding to our lives rather than bearing them dumbly or justifying them automatonically. That debarment or embarrassment is for Emerson, as for Kant, a state other than the human, since it lacks the humanly defining fact of freedom. That we are perceived as "bugs" says this and more. Bugs are not human, but they are not monsters either; bugs in human guise are inhuman, monstrous.

How does Emerson understand a way out, out of wronging ourselves, which is to ask: How does Emerson find the "almost lost . . . light that can lead [us] back to [our] prerogatives?" (The American Scholar, p. 75)—which for Emerson would mean something like answering for ourselves. Here is where Emerson's writing, with its enactment of transfigurations, comes in. Its mechanism may be seen in (even as) Emersonian Perfectionism.

Perfectionism makes its appearance in Rawls's *A Theory of Justice* (sec. 50) as a teleological theory and as having two versions, moderate and extreme. In the moderate version its principle is one among others and "[directs] society to arrange institutions and to define the duties and obligations of individuals so as to maximize the achievement of human excellence, in art, in science, and culture." Then how shall we understand Emerson's and Nietzsche's disdain for the cultural institutions, or institutionalized culture, of the day (including universities and religions and whatever would be supported by what Rawls describes as "public funds for the arts and sciences"), a disdain sometimes passionate to the point of disgust? The distribution of nothing of high culture as it is now institutionalized is to be maximized in Emersonian Perfectionism, which is in that sense not a teleological theory at all. What Nietzsche calls "the pomp of culture" and "misemployed and appropriated culture" is, on the contrary, to be scorned. It makes no obvious sense to ask for some given thing to be maximized in what this perfectionism craves as the realm of culture, the realm to which, as Nietzsche puts it, we are to consecrate our-

selves, the path on which, as Emerson puts it, we are to find "the conversion of the world" ("The American Scholar," concluding paragraph). There is, before finding this, nothing to be maximized. One can also say that the good of the culture to be found is already universally distributed or else it is nothing—which is to say, it is part of a conception of what it is to be a moral person. Emerson calls it genius; we might call this the capacity for self-criticism, the capacity to consecrate the attained to the unattained self, on the basis of the axiom that each is a moral person.

The irrelevance of maximization (as a particular teleological principle) should be clearer still in what Rawls calls the extreme version of perfectionism, in which the maximization of excellence is the sole principle of institutions and obligations. As I noted earlier, *A Theory of Justice* epitomizes this extreme version by a selection of sentences from Nietzsche. They are from the third Untimely Meditation, *Schopenhauer as Educator*:

> Mankind must work continually to produce individual great human beings—this and nothing else is the task. . . . For the question is this: how can your life, the individual life, retain the highest value, the deepest significance? . . . Only by your living for the good of the rarest and most valuable specimens. (As in *A Theory of Justice*, p. 325, note 51)

This sounds bad. Rawls takes it straightforwardly to imply that there is a separate class of great men (to be) for whose good, and conception of good, the rest of society is to live. Rawls is surely right to reject this as a principle of justice pertinent to the life of democracy (see *A Theory of Justice*, p. 328). But as I also noted, if Nietzsche is to be dismissed as a thinker pertinent to the founding of the democratic life, then so, it should seem, is Emerson, since Nietzsche's meditation on Schopenhauer is, to an as yet undisclosed extent, a transcription and elaboration of Emersonian passages. Emerson's dismissal here would pain me more than I can say, and if that is indeed the implication of *A Theory of Justice*, I want the book, because of my admiration for it, to be wrong in drawing this implication from itself.

In Nietzsche's meditation, the sentence, "Only by your living for the good of the rarest and most valuable specimens," continues with the words "and not for the good of the majority" (*Schopenhauer as Educator*, p. 162). However the majority is then characterized still further in that sentence, it is not part of constitutional democracy

that one is to live for the good of the majority—something Rawls's book is the demonstration of for those committed to democracy. If not for the good of the majority, then is one to live for the good of each (for each societal "position")? I suppose this is not captured in the idea of making rational choices that have justifiably unequal benefits for all (measured by the Difference Principle, Rawls's second principle of justice), but it may yet be a life taken within the commitment to democracy. There will doubtless be perfectionisms that place themselves above democracy or that are taken in the absence of the conditions of democracy. The former might describe a timarchy, an oligarchy, or a dictatorship. These are not my business, which is, rather, to see whether perfectionism is necessarily undemocratic. I might put my thought this way: the particular disdain for official culture taken in Emerson and in Nietzsche (and surely in half the writers and artists in the 150 years since "The American Scholar," or say since romanticism) is itself an expression of democracy and commitment to it. Timocrats do not produce, oligarchs do not commission, dictators do not enforce, art and culture that disgust them. Only within the possibility of democracy is one committed to *living* with, or against, such culture. This may well produce personal tastes and private choices that are, let us say, exclusive, even esoteric. Then my question is whether this exclusiveness might be not just tolerated but treasured by the friends of democracy.

There are two further problems with the final sentence among those Rawls quotes from Nietzsche concerning living for rare specimens and not for the majority. First, Nietzsche's word translated as "specimens" is *Exemplare* (faithfully translated as "exemplars" later in *Untimely Meditations,* [1983 ed.] by the same translator from whom Rawls takes his Nietzsche sentences [R. J. Hollingdale, in his earlier *Nietzsche: The Man and His Philosophy*]. The biological association of "specimens" suggests that the grounds for identifying them (hence for assessing their value) are specifiable independently of the instance in view, of its effect on you; its value depends upon this independence; specimens are samples, as of a class, genus, or whole; one either is or is not a specimen. Whereas the acceptance of an exemplar, as access to another realm (call it the realm of culture; Nietzsche says, echoing a favorite image of Emerson's, that it generates "a new circle of duties"), is not grounded in the relation between the instance and a class of instances it stands for but in the relation between the instance and the individual

other—for example, myself—for whom it does the standing, for whom it is a sign, upon whom I delegate something. ("Archetype," translatable as "exemplar," is the word Kant associates with the Son of God in *Religion within the Bounds of Reason Alone*, e.g. p. 109.) Second, when Nietzsche goes on, in the sentences following the one about exemplars, to begin characterizing the life of culture, it must in a sense be understood as a life lived for the good of the one living it. It accordingly demands a certain exclusiveness, its good is inherently not maximizable (transportable to other lives). But it is not inherently unjust, requiring favored shares in the distribution of good. Its characteristic vice would not be envy (a vice methodologically significant for *A Theory of Justice*) but perhaps shirking participation in democracy. Then the question becomes, If it is not shirking then *what* is its participation? Nietzsche continues, after the sentences Rawls quotes, as follows:

> The young person should be taught to regard himself as a failed work of nature but at the same time as a witness to the grandiose and marvellous intention of this artist. . . . By coming to this resolve he places himself within the circle of *culture;* for culture is the child of each individual's self-knowledge and dissatisfaction with himself. Anyone who believes in culture is thereby saying: "I see above me something higher and more human than I am; let everyone help me to attain it, as I will help everyone who knows and suffers as I do." (*Schopenhauer as Educator*, p. 162)

In the next sentence the "something higher," the desire for which is created in self-dissatisfaction, is marked as "a higher self as yet still concealed from it." It is my own, unsettlingly unattained.

Maximization is roughly the last thing on the mind of the suffering individual in this state of self-dissatisfaction, the state of perceiving oneself as failing to follow oneself in one's higher and happier aspirations, failing perhaps to have found the right to one's own aspirations—not to the deliverances of rare revelations but to the significance of one's everyday impressions, to the right to make them one's ideas. It is a crucial moment of the attained self, a crossroads; it may be creative or crushing. To look then for the maximization of a given state of culture is to give up looking for the reality of one's own. To be overly impatient philosophically with this crisis is to be overly impatient with the explorations of what we call adolescence. Emerson and Nietzsche notably and recurrently direct their words to "youth" as words against despair, showing that

they themselves have survived the incessant calls to give over their youthful aspirations. For youth to be overly impatient with these calls is to be overly impatient with the adults who voice them; it is a deflection of the interest of the contest with adulthood, of the crisis in giving consent to adulthood, say with the arrogation of one's voice in the moral life, the law. Since democracy is the middle or civil world of political possibilities—not ceding its demands for itself either to possibilities defined courteously or violently (neither to diplomacy nor to rebellion), it may be taken as the public manifestation of the individual situation of adolescence, the time of possibilities under pressure to consent to actualities. The promise of Emerson and of Nietzsche is that youth is not alone a phase of individual development but—like childhood for the earlier romantics—a dimension of human existence as such.

When Nietzsche says, in the words of his passage last quoted, describing the young person as a failed work of nature and as a witness, "for culture is the child of each individual," and imagines one who seeks this child to pray that everyone will help him or her to attain it, could it be clearer that the "something higher and more human" in question is not—not necessarily and in a sense not ever—that of someone *else*, but a further or eventual position of the self now dissatisfied with itself? (The quantification is old-fashioned. Not, "there is a genius such that every self is to live for it," but, "for each self there is a genius." I am thinking particularly of the passage in "Self-Reliance" where Emerson reports that his genius calls him; it calls him, it turns out, to his own work, which, it happens, is writing. I do not imagine this to be some other person calling him.) Nietzsche goes on: "Thus only he who has attached his heart to some great man is by that act *consecrated to culture;* the sign of that consecration is that one is ashamed of oneself without any accompanying feeling of distress, that one comes to hate one's own narrowness and shrivelled nature" (*Schopenhauer as Educator,* p. 163). The perfectionist idea of culture is projected in contrast to this idea of "one's own nature." The sense is that the move from the state of nature to the contract of society does not, after all, sufficiently sustain human life. If the idea of unshriveling our nature is that of transforming our needs, not satisfying them as they stand, the moral danger that is run may seem to be that of idealistic moralism, forgetting the needs of others as they stand. Since the task for each is his or her own self-transformation, the representativeness

implied in that life may seem not to establish a recognition of others in different positions, so to be disqualified as a moral position altogether. "Representativeness" invokes one of Emerson's "master-tones," both as charcterized in his writing and as exemplified by his writing. And I think we can say: Emerson's writing works out the conditions for my recognizing my difference from others as a function of my recognizing my difference from myself.

Nietzsche's idea of "attaching one's heart," here to some great man, is, let us say, acting toward him in love, as illustrated by Nietzsche's writing of his text on Schopenhauer. But the author of that text is not consecrating himself to Schopenhauer—Schopenhauer, as everyone notes, is scarcely present in the text. If what you consecrate yourself to is what you live for, then Nietzsche is not living for Schopenhauer. It is not Schopenhauer's self that is still concealed from the writer of this text. The love of the great is, or is the cause of, the hate of one's meanness, the hate that constitutes the sign of consecration. ("The fundamental idea of culture, insofar as it sets for each one of us but one task [is]: to promote the production of the philosopher, the artist and the saint *within us* and without us and thereby to work at the perfecting of nature" (163, my emphasis). This is said to set one in the midst of "a mighty community." Obviously it is not a present but an eventual human community, so everything depends on how it is to be reached.)

Many, with Rawls, have taken Nietzsche otherwise than as calling for the further or higher self of each, each consecrating himself/herself to self-transformation, accepting one's own genius, which is precisely not, it is the negation of, accepting one's present state and its present consecrations to someone fixed, as such, "beyond" one. Perhaps it was necessary for Nietzsche to have left himself unguarded on this desperate point.

Emerson provides an explanation and name for this necessary ambiguity in the passage of "The American Scholar" of which Nietzsche's passage on the relation to greatness is a reasonably overt transcription (with sensible differences):

The main enterprise of the world for splendor, for extent, is the up-building of a man (p. 76) . . . in a century, in a millennium, one or two men; that is to say, one or two approximations to the right state of every man. All the rest behold in the hero or the poet their own

green and crude being—ripened; yes, and are content to be less, so *that* may attain to its full stature (p. 75).

But Emerson does not say that this contentment is the best or neces-
sary state of things. For him, rather, it shows "what a testimony,
full of grandeur [in view of what we might become], full of pity [in
view of what we are], is borne to the demands of his own nature [by
the poor and the low. The poor and the low are] to be brushed like
flies from the path of a great person, so that justice shall be done by
him to that common nature which it is the dearest desire of all to see
enlarged. . . . He lives for us, and we live in him" (p. 76). (Emerson
is unguarded; we are unguarded.) As we stand we are apt to overrate
or misconstrue this identification. Emerson continues:

> Men, such as they are, very naturally seek money or power. . . .
> And why not? for they aspire to the highest, and this in their sleep-
> walking they dream is highest. Wake them and they shall quit the
> false good and leap to the true, and leave governments to clerks and
> desks. This revolution is to be wrought by the gradual domestication
> of the idea of Culture. . . . Each philosopher, each bard, each actor
> has only done for me, as by a delegate, what one day I can do for
> myself. (p. 76)

Here there simply seems no room for doubt that the intuition of a
higher or further self is one to be arrived at in person, in the person
of the one who gives his heart to it, this one who just said that the
great have been his delegates and who declares that "I" can one day,
so to say, be that delegate. I forerun myself, a sign, an exemplar.

In the so-called Divinity School address, delivered the year after
"The American Scholar," Emerson will in effect provide the origi-
nating case of our repressing our delegation and attributing our
potentialities to the actualities of others, the case of "Historical
Christianity['s] dwell[ing], with noxious exaggeration about the
person of Jesus," whereas "the soul knows no persons." Evidently
Emerson is treating this form of worship or consecration, even if in
the name of the highest spirituality, as idolatry. (Here is a site for
investigating the sense that perfectionism is an attempt to take over,
or mask, or say secularize, a religious responsibility, something
Matthew Arnold is explicit in claiming for his perfectionism in
Culture and Anarchy, something Henry Sidgwick criticizes Arnold
for in "The Prophet of Culture.")

In Emerson's way of speaking, "one day" ("Each philoso-

pher . . . has only done, as by a delegate, what one day I can do for myself") always also means today; the life he urgently speaks for is one he forever says is not to be postponed. It is today that you are to take the self on; today that you are to awaken and to consecrate yourself to culture, specifically, to domesticate it gradually, which means bring it home, as part, now, of your everyday life. This is Perfectionism's moral urgency; why, we might say, the results of its moral thinking are not the results of moral reasoning, neither of a calculation of consequences issuing in a judgment of value or preference, nor of a testing of a given intention, call it, against a universalizing law issuing in a judgment of right. The urgency is expressed in Emerson's sense of fighting chagrin in every word, with every breath. If calculation and judgment are to answer the question Which way?, perfectionist thinking is a response to the way's being lost. So thinking may present itself as stopping, and as finding a way *back*, as if thinking is remembering something. (This is a kind of summary of the way I have read Emerson's "Experience" in my "Finding as Founding.")

The urgency about today is the cause of Emerson's characteristic allusions to the gospels. In "The American Scholar" it is rather more than an allusion: "For the ease and pleasure of treading the old road . . . [the scholar instead] takes the cross of making his own"—a road Emerson characterizes in that passage as one of poverty, solitude, stammering, self-accusation, and "the state of virtual hostility in which he seems to stand to society, and especially to educated society" (p. 73). In "Self-Reliance" the parody is as plain as the allusion: "I shun father and mother and wife and brother when my genius calls me. I would write on the lintels of the doorpost, *Whim*" (p. 150). The shunning reference is to the call to enter the kingdom of heaven at once, today, to follow me, to let the dead bury the dead (Matthew 8:22). Emerson's parody mocks his own preachiness, and while it acknowledges that the domestication of culture is not going to be entered on today, yet it insists that there is no reason it is postponed; that is, no one has the reason for this revolution if each of us has not. It is why he perceives us as "[bearing] testimony, full of grandeur, full of pity, . . . to the demands of [our] own nature," a remark transcribed in Nietzsche as "[regarding oneself] as a failed work of nature but at the same time as a witness to the grandiose and marvellous intentions of their artist." Bearing testimony and witnessing are functions of martyrdom. In Moral

Perfectionism, as represented in Emerson and in Nietzsche, we are invited to a position that is structurally one of martyrdom; not, however, in view of an idea of the divine but in aspiration to an idea of the human.

What can this mean? (Whatever it means it suggests why I cannot accede to the recent proposal, interesting as it is in its own terms, of taking Perfectionism to be exemplified by the well-rounded life. See the essay by Thomas Hurka.) And how does thinking as transfiguration bear on it? Which is to ask, How does Emerson's way of writing, his relation to his reader, bear on it? Which in turn means, How does his writing represent, by presenting, the aspiration to the human?

Before going on to sketch an answer to this pack of questions, it may be well to pause to say another word about my sense that the view Emerson and Nietzsche share, or my interest in it, is not simply to show that it is tolerable to the life of justice in a constitutional democracy but to show how it is essential to that life. What is the pertinence, for example, of perfectionism's emphasis, common from Plato and Aristotle to Emerson and Thoreau and Nietzsche, on education and character and friendship for a democratic existence? That emphasis of perfectionism, as I have said, may be taken to serve an effort to escape the mediocrity or leveling, say vulgarity, of equal existence, for oneself and perhaps for a select circle of like-minded others. There are undeniably aristocratic or aesthetic perfectionisms. But in Emerson it should, I would like to say, be taken as part of the training for democracy. Not the part that must internalize the principles of justice and practice the role of the democratic citizen—that is clearly required, so obviously that the Emersonian may take offense at the idea that this aspect of things is even difficult, evince a disdain for ordinary temptations to cut corners over the law. I understand the training and character and friendship Emerson requires for democracy as preparation to withstand not its rigors but its failures, character to keep the democratic hope alive in the face of disappointment with it. (Emerson is forever turning aside to say, especially to the young, not to despair of the world, and he says this as if he is speaking not to a subject but to a monarch.) That we will be disappointed in democracy, in its failure by the light of its own principles of justice, is implied in Rawls's concept of the original position in which those principles are accepted, a perspective from which we know that justice, in actual societies, will be

departed from, and that the distance of any actual society from jus-
tice is a matter for each of us to access for ourselves. I will speak of
this as our being compromised by the democratic demand for con-
sent, so that the human individual meant to be created and
preserved in democracy is apt to be undone by it.

Now I go on to my sketch in answer to how Emerson's writing
(re)presents the aspiration to the human, beginning from a famous
early sentence of "Self-Reliance" I have already had occasion to cite:
"In every work of genius we recognize our own rejected thoughts.
They come back to us with a certain alienated majesty." The idea
of a majesty alienated from us is a transcription of the idea of the
sublime as Kant characterizes it. Then the sublime, as has been
discussed in recent literary theory, bears the structure of Freudian
transference. (See, e.g., Weiskell, Harold Bloom, Hertz, and my
"Psychoanalysis and Cinema," note 29, pp. 257–258.) The direc-
tion of transference—of mine to the text, or the text's to me in a
prior countertransference (or defense against being read)—seems
to me an open question. In either case reading, as such, is taken by
Emerson as of the sublime.

This comes out in Emerson's (and Thoreau's) delirious denuncia-
tion of books, in the spectacle of writing their own books that dare us
to read them and dare us not to; that ask us to conceive that they do
not want us to read them, to see that they are teaching us how—
how *not* to read, that they are creating the taste not to be read, the
capacity to leave them. Think of it this way: If the thoughts of a text
such as Emerson's (say the brief text on rejected thoughts) are
yours, then you do not need them. If its thoughts are *not* yours, they
will not do you good. The problem is that the text's thoughts are
neither exactly mine nor not mine. In their sublimity as my re-
jected—say repressed—thoughts, they represent my further, next,
unattained but attainable, self. To think otherwise, to attribute the
origin of my thoughts simply to the other, thoughts which are then,
as it were, implanted in me—some would say caused—by let us say
some Emerson, is idolatry. (What in "Politics of Interpretation" I
call the theology of reading is pertinent here.)

In becoming conscious of what in the text is (in Emerson's word)
unconscious, the familiar is invaded by another familiar—the
structure Freud calls the uncanny, and the reason he calls the psy-
choanalytic process itself uncanny. Emerson's process of transfigur-
ing is such a structure, a necessity of his placing his work in the posi-

tion of our rejected and further self, our "beyond." One of his ways of saying this is to say "I will stand here for humanity" as if he is waiting for us to catch up or catch on. When this is unpacked it turns out to be the transfiguration of a Kantian task. To say how, I track for a moment Emerson's play, pivotally and repeatedly in "Self-Reliance," on inflections of standing up and understanding in relation to standing for and in relation to standards.

"Standing for humanity," radiating in various directions as *representing* humanity and as *bearing* it (as bearing the pain of it) links across the essay with its recurrent notation of postures and of gaits (leaning and skulking among them—postures of shame) of which *standing* or uprightness, is the correction or conversion that Emerson seeks, his representative prose. This opens into Emerson's description of our being drawn by the true man, as being "constrained to his standard." (Emerson says he will make "this" true—I assume he is speaking of his prose—and describes the true man as "measuring" us.) Now *constraint*, especially in conjunction with *conformity*, is a Kantian term, specifically noting the operation of the moral law upon us—of the fact that it applies only to (is the mark of) the human, that is, only to a being subject to temptation, a being not unmixed in nature, as beasts and angels are unmixed. If you entertain this thought, then the idea of "standard" links further with the Kantian idea that man lives in two worlds, that is, is capable of viewing himself from two "standpoints" (in Kant's term). It is this possibility that gives us access to the intelligible world—the realm of ends, the realm of reason, of the human—"beyond" the world of sense. If Emerson assigns his pages as standards (flags and measures) and if this is an allusion to, an acceptance of, the Kantian task of disclosing the realm of ends, the realm of the human, then what is its point?

The point of contesting the Kantian task is presumably to be taken in the face of its present failure, or parody, its reduction to conformity. In picking up its standard—and transfiguring it—Emerson finds the intelligible world, the realm of ends, closed to us as a standpoint from which to view ourselves individually (our relation to the law no longer has *this* power for us). But at the same time he shows the intelligible world to be entered into whenever another represents for us our rejected self, our beyond; causes that aversion to ourselves in our conformity that will constitute our becoming, as it were, ashamed of our shame. Some solution. Well, some problem.

Kant describes the "constraint" of the law as an imperative ex-

pressed by an ought. (*Foundations*, Second Section.) For Emerson, we either *are* drawn beyond ourselves, as we stand, or we are *not;* we recognize our reversals or we do not; there is no ought about it. It remains true that being drawn by the standard of another, like being impelled by the imperative of a law, is the prerogative of the mixed or split being we call the human. But for Emerson we are divided not alone between intellect and sense, for we can say that each of these halves is itself split. We are halved not only horizontally but vertically—as that other myth of the original dividing of the human pictures it—as in Plato's *Symposium*, the form of it picked up in Freud, each of us seeking that of which we were originally half, with which we were partial.

Here, in this constraint by recognition and negation, is the place of the high role assigned in moral perfectionism to friendship. Aristotle speaks of a friend as "another myself." To see Emerson's philosophical authorship as taking up the ancient position of the friend, we have to include the inflection (more brazen in Nietzsche but no less explicit in Emerson) of my friend as my enemy (contesting my present attainments). If the position of that loved one were not also feared and hated, why would the thoughts from that place remain rejected? If one does not recognize Emerson in his version of such a position, his writing will seem, to its admirers, misty or foggy; to its detractors ridiculous. (*Almost* everyone gets around to condescending to Emerson.)

How can philosophy have, in such a fashion, worked itself into the position of having to be accepted on intimate terms *before* it has proven itself? It seems the negation of philosophy.

If Emerson is wrong in his treatment of the state of conformity and of despair in what has become of the democratic aspiration, he seems harmless enough—he asks for no relief he cannot provide for himself—whatever other claims other perfectionisms might exert. But if Emerson is right, his aversion provides for the democratic aspiration the only internal measure of its truth to itself—a voice only this aspiration could have inspired, and, if it is lucky, must inspire. Since his aversion is a *continual turning away* from society, it is thereby a continual turning *toward* it. Toward and away; it is a motion of seduction—such as philosophy will contain. It is in response to this seduction from our seductions (conformities, heteronomies) that the friend (discovered or constructed) represents the standpoint of perfection.

The idea of the self as always to be furthered is not expressed by

familiar fantasies of a noumenal self, nor of the self as entelechy, either final or initial. May one imagine Emerson to have known that the word "scholar" is related in derivation to "entelechy" (through the idea of holding near or holding back, as if stopping to think)—so that by the American Scholar he means the American self? Then, since by Cartesian and by Kantian measures the self in America does not exist, America does not exist—or to speak in proper predicates, is still not discovered as a new, another, world.

And the question might well arise: Why does Emerson take on the Cartesian and Kantian measures? Why does he put english on the terms of philosophy? Instead of transfiguring these terms, why not take the opportunity of America as one of sidestepping philosophy, as one more European edifice well lost? Why does Emerson care, why ought we to care, whether he is a philosopher? Why care when we come to his page, his standard, whether the encounter with our further self, the encounter of reading, the access to an intelligible world, is a *philosophical* one? Evidently because the gradual domestication of culture he calls for—what he names his revolution—is a philosophical one. How?

How is this domestication—call it finding a home for humanity; Emerson and Thoreau picture it as building a house, another edification—how is this a task for philosophy? We may take for granted Plato's description of his task in the *Republic* as creating a "city of words," hence accept it that philosophy in the Western world unfolds its prose in a depicted conversation concerning the just city. Emerson's house of words is essentially less than a city; and while its word is not that of hope, its majesty is not to despair, but to let the "grandeur of justice shine" in it, and "affection cheer" it. Kant had asked, What can I hope for? Emerson in effect answers, For nothing. You do not know what there is hope for. "Patience—patience [suffering, reception]"; "abide on your instincts" (cp. "The American Scholar," p. 79)—presumably because that is the way of thinking. For him who abides this way, "the huge world will come round to him" (ibid.)—presumably in the form in which it comes to Emerson, one person at a time, a world whose turning constitutes the world's coming around—the form in which you come to your (further) self.

In coming to Emerson's text from a certain alienated majesty, we (each of us as Emerson's reader) form an illustrious monarchy with a population of two. It illustrates the possibility of recogniz-

ing my finitude, or separateness, as the question of realizing my partiality. Is the displacement of the idea of the whole man by an idea of the partial man worth philosophy?

I see it this way. Emerson's perception of the dispossession of our humanity, the loss of ground, the loss of nature as our security, or property, is thought in modern philosophy as the problem of skepticism. The overcoming or overtaking of skepticism must constitute a revolution that is a domestication for philosophy (or redomestication) because, let us say, neither science nor religion nor morality has overcome it. On the contrary they as much as anything cause skepticism, the withdrawal of the world. *Is* philosophy left to us, even transformed? Well, that is my question. I think it is philosophy's question, which accordingly now comes into its own—as if purified of religion and of science.

I can formulate my interest in Emerson's situation in the following way. Domestication in Emerson is the issue, or urgency, of the *day*, today, one among others, an achievement of the everyday, the ordinary, now, here, again, never again. In Wittgenstein's *Philosophical Investigations* the issue of the everyday is the issue of the siting of skepticism, not as something to be overcome, as if to be refuted, as if it is a *conclusion* about human knowledge (which is skepticism's self-interpretation), but to be placed as a mark of what Emerson calls "human condition," a further interpretation of finitude, a mode, as said, of inhabiting our investment in words, in the world. This argument of the ordinary—as what skepticism attacks, hence creates, and as what counters, or recounts, skepticism— is engaged oppositely in a work such as Heidegger's *What Is Called Thinking?*; hence the argument of the ordinary is engaged between these visions of Wittgenstein and of Heidegger. (It may present itself as an argument between skepticism and sublimity, between transfiguration down and transfiguration up.) It is why I am pleased to find Emerson and his transfigurations of the ordinary to stand back of both Wittgenstein and Heidegger. They are the two major philosophers of this century for whom the issue of the ordinary, hence of skepticism, remains alive for philosophy, whose burden is philosophy's burden; it is, to my mind, utterly significant that in them—as in Emerson—what strikes their readers as a tone of continual moral urgency or religious or artistic pathos is not expressed as a *separate* study to be called moral philosophy, or religious philosophy, or aesthetics. The moral of which—or the aesthetics of

which—I draw as follows: what they write is nothing *else* than these topics or places of philosophy, but is always nothing but philosophy itself. Nothing less, nothing separate, can lead us from, or break us of, our shameful condition. Philosophy presents itself as a (an untaken) way of life. This is what perfectionists will find ways to say.

Then, needless to say, in calling for philosophy Emerson is not comprehensible as asking for guardianship by a particular profession within what we call universities. I assume what will become "philosophy itself" may not be distinguishable from literature—that is to say, from what literature will become. Then that assumption, or presumption, is, I guess, my romanticism.

I come back to earth, concluding by locating what I have been saying in relation to a passage from John Stuart Mill's *On Liberty* that should be common ground among professional philosophers. I adduce it with the thought that what I have been saying suggests to me that Perfectionism, as I perceive the thing that interests me, is not a competing moral theory but a dimension of any moral thinking. Kant found an essential place for perfection in his view of it at the end, as it were, of his theory, as an unreachable ideal relation to be striven for to the moral law; in Emerson this place of the ideal occurs at the beginning of moral thinking, as a condition, let us say, of moral imagination, as preparation or sign of the moral life. And if the precondition of morality is to be established in personal encounter, we exist otherwise in a premoral state, morally voiceless. Mill's passage, while no doubt not as eager to court the derangement of intellect as Emerson's prose has to be, is no less urgent and eloquent in the face of human dispossession and voicelessness:

> In our times, from the highest class of society down to the lowest, every one lives as under the eye of a hostile and dreaded censorship. Not only in what concerns others, but in what concerns themselves, the individual, or the family, do not ask themselves—what do I prefer? . . . or, what would allow the best and highest in me to have fair play, and enable it to grow and thrive? They ask themselves, . . . what is usually done? I do not mean that they choose what is customary in preference to what suits their own inclination. It does not occur to them to have any inclination except for what is customary. Thus the mind itself is bowed to the yoke: even in what people do for pleasure, conformity is the first thing thought of; they like in crowds; they exercise choice only among things commonly done; pe-

culiarity of taste, eccentricity of conduct, are shunned equally with
crimes: until by dint of not following their own nature, they have no
nature to follow: their human capacities are withered and starved;
they become incapable of any strong wishes or native pleasures, and
are generally without either opinions or feelings of home growth, or
properly their own. Now is this, or is it not, the desirable condition of
human nature? (chap. 3, parag. 6)

I call attention to the toll of that Millian word "desirable." In a pas-
sage in *Utilitarianism*, Mill famously conceives the claim that
anything is desirable—on analogy with the claim that anything is
visible or audible—to rest finally on the fact that people do, or pre-
sumably under specifiable circumstances will, actually desire it.
Philosophers in the years I was in graduate school never used to tire
of making fun of that passage from *Utilitarianism*. Yet the drift of it
still strikes me as sound. According to it, the question at the conclu-
sion of the quotation from *On Liberty* becomes: Do you, or would
you his reader, under any circumstances, desire this censored condi-
tion of mankind? It is Perfectionism's question, its reading of the cry
of freedom, for a life of one's own, of one's choice, that one consents
to with one's own voice. The eloquence of Mill's passage is to
awaken its friend to the question, to show that it is a question. The
implication seems to be that until we each give our answers to the
question, one by one, one on one, we will not know what it is to
which—long before we begin our calculations of pleasure and of
pain—we are giving our consent.

2 THE ARGUMENT OF THE ORDINARY
Scenes of Instruction in Wittgenstein and in Kripke

The quotation from Mill's *On Liberty* that brought my first lecture to a close perceives human nature as having, by 1859, perfectly renounced inclination in favor of conformity, having by dint of not following our own nature left ourselves with no nature to follow; so that the point of moral judgment, of assessing the cry of liberty and the rights of happiness in forming our lives, is perceived by Mill as perhaps lost, the conditions of the moral life as perhaps not (any longer) in place. Earlier I had taken up Emerson's statement of the partiality of thinking in "Self-Reliance" and brought to it Heidegger's approach to thinking by way of uncovering what Heidegger calls our inclination to thinking (echoing, I took it, Kant's question of the incentive of thinking), which Heidegger finds internally related to the possibility of and our capacity for thinking; this uncovering, according to *What Is Called Thinking?*, is the assignment that philosophy is now to accept in overcoming the embrace in Western metaphysics of thinking as representation. In *Philosophical Investigations* Wittgenstein invokes inclination as an instance and emblem of the question of the voice I have in thinking, whether that means in relating myself, my words, to the world or in holding my society up to criticism. The idea of my voice in my history, in my acceptance of criteria, in assessing my agreement or attunement in language, is a principal theme of *The Claim of Reason*, which proceeds by way of taking Wittgenstein's idea of a criterion (in conjunction with grammar) to account both for the acceptance of attunement in the appeals to my voice in ordinary language procedure, and at the same time to account for the rejection of this attunement, hence of my voice, in skepticism; to show the character of our agreement in our words—that our consent or agreement in words cannot be contractual—as well as to show our falling, and our wish to fall, out of agreement or attunement. Since criteria and skepticism are one another's possibility, criteria cannot be meant to refute skepticism; on the contrary they show skepticism's power, even something one might call its truth. I sometimes think of this theme as our disappointment with our criteria.

I had meant this second lecture to take the issue of voice in Witt-

genstein's *Investigations* further, by way of relating my account of it to certain passages in Saul Kripke's influential and disturbing study *Wittgenstein: On Rules and Private Language*, and using that confrontation as a bridge to Emerson's transfiguration of something like inclination in connection with writing. This would mean going over yet again a favorite site of mine in "Self-Reliance" (alluded to in the first lecture) in which Emerson identifies his writing as the inscription of Whim, a transfiguration out of what Emerson later in the essay names whimpering, surely an association in turn from his sense of chagrin with the way the world is given to use words. But this plan has receded in my selection of material for the present lecture because to make even initially plausible what disturbs me in Kripke's account has proven to use most of the time at hand.

Kripke's is the only account I know, other than that in *The Claim of Reason*, that takes *Philosophical Investigations* not to mean to refute skepticism but, on the contrary, to maintain some relation to the possibility of skepticism as internal to Wittgenstein's philosophizing. My idea was to use Kripke's view in pressing further what in my first lecture I called Emerson's investment or attitude toward the ordinary, linking it to the paradoxicality associated with skepticism. The idea is that both Emerson's transfiguration of words (which he calls their conversion or aversiveness) and skepticism's hyperbolization of words ("You don't really, literally, directly, *see* the front surface of the object . . ."—which has struck certain writers, struck me, as perverse, thus revealing human nature as perverse) can both be given accounts of, hence be seen in mutual relation, in Wittgenstein's view of eliciting and of suppressing our criteria. But progress will have to be slower, because if Kripke's reading of Wittgenstein is right, then mine must be wrong.

Moreover, I do not think it likely that anything simple is wrong with Kripke's reading, anyway in a sense I find nothing (internal) at all wrong with it. Hence to say why, or the sense in which, it is, in my view, nevertheless not right (not true to the *Investigations*) is bound to take time. In taking rules as fundamental to Wittgenstein's development of skepticism about meaning, Kripke subordinates the role of criteria in the *Investigations*, hence appears from my side of things to underrate drastically, or to beg the question of, the issue of the ordinary, a structure of which is the structure of our criteria and their grammatical relations. In my seeing criteria as

forming Wittgenstein's understanding of the possibility of skep-
ticism, or say his response to the threat of skepticism, I take this to
show rules to be subordinate; but since Kripke's interpretation of
rules seems, in turn, to undercut the fundamentality of the appeal
to the ordinary, my appeal to criteria must appear to beg the ques-
tion from his side of things. These positions repeat the sides of what
I will call the argument of the ordinary, something I will take as
fundamental to the *Investigations*. It is an argument I seek a way
out of, as I suppose the *Investigations* does in seeking to renounce
philosophical theses.

Kripke opens his consecutive account of Wittgenstein's views
this way: "In §201 Wittgenstein says, 'this was our paradox: no
course of action could be determined by a rule, because every course
of action can be made to accord with the rule.' In this section of the
present essay, in my own way I will attempt to develop the 'paradox'
in question. The 'paradox' is perhaps the central problem of
Philosophical Investigations" (p. 7). Later in the text there is no
longer any perhaps about it: "The sceptical paradox is the funda-
mental problem of *Philosophical Investigations*" (p. 78); and pretty
clearly this claim about the *Investigations* is the fundamental claim
of Kripke's *Wittgenstein: On Rules and Private Language*, one
which proves to be the effect and/or the cause of at least the follow-
ing claims and assumptions: (1) that the concept of a rule is
fundamental to Wittgenstein's thought (in the *Investigations*, the
only work of Wittgenstein's to which I will refer); (2) that a certain
kind of example produces an experience that we can recognize as
that of skepticism; (3) that the solution to the skeptical paradox has
to do with a particular way of bringing the individual into commu-
nal agreement; (4) that the structure of *Philosophical Investigations*
has in general not been appreciated by other interpreters of it, and,
in particular, that sections 243 and following, usually identified as
the private language argument, are not designed to establish Witt-
genstein's "rejection" of "private language" (Kripke, p. 79), which
takes place as early as §202, but rather they are designed to take up
one of two major applications of the general conclusion about lan-
guage drawn in §§138–242, namely an application to the problem of
sensations; (5) that the point of this application is to defend the gen-
eral conclusion about language with respect to one of the two areas
in which it seems "especially unnatural" (Kripke, p. 79), namely
with respect to the problem of sensations. (The other area of es-

pecially unnatural application is mathematics: "[Wittgenstein] thinks that only if we overcome our strong inclination to ignore his general conclusions about rules can we see these two areas rightly. For this reason, the conclusions about rules are of crucial importance both to the philosophy of mathematics and to the philosophy of mind" (p. 80).)

While my own account of Wittgenstein's response to skepticism emphasizes the role of examples in creating and as created in skepticism's lines of thought, I will question whether Kripke's examples illustrate skepticism; as I will question whether the communal agreement Kripke finds in Wittgenstein reaches the depth of confidence Wittgenstein places in our "agreement." And since I fully share Kripke's sense that the issues he, after Wittgenstein, is raising apply not alone to mathematics but "to all meaningful uses of language" (p. 7) (that is, that Wittgenstein's "conclusions" "are of [meant to be of] crucial importance both to the philosophy of mathematics and to the philosophy of mind" (*supra*), but since I nevertheless do not share the sense that Wittgenstein attaches salvational importance to rules, I cannot share the sense that the cases of mathematics and of mind (or in general the "rest" of language) are to be understood as special cases to which the application of rules seems especially unnatural. In *The Claim of Reason* (pp. 343–53) I too find that the role of sections 243 and following has been misemphasized or misconceived by readers of the *Investigations* who do not recognize that they contain nothing new about the possibility of privacy. I shall not repeat here my earlier claims about those passages (having to do with ideas of the disappointment with expression and the fear of inexpressiveness); but in the face of Kripke's formidable account of the relation of mathematical cases with the "rest" of language (I would like to say with *ordinary* language), I must arrive at an alternative understanding of that relation.

My impression is that Wittgenstein takes the ideas Kripke is explicating and organizing to be more various and entangled and specific than Kripke seems to me to give Wittgenstein credit for, especially to my mind those of a rule, of being in agreement, of an inclination, and of the ordinary. Indeed I take Wittgenstein to say fairly explicitly that rules cannot play the fundamental role Kripke takes him to cast them in. In the sentence succeeding the one Kripke quotes from the beginning of §201, in which Wittgenstein names

"our paradox," Wittgenstein writes: "The answer was: if every-
thing can be made out to accord with the rule, then it can also be
made to conflict with it. And so there would be neither accord nor
conflict here." This seems to me equally readable as suggesting not
that this paradox is "central" but that it is no sooner named than its
significance is undermined. Wittgenstein's tone is: What our so-
called paradox came to was no more than this so-called answer can
completely tame. The facts about possible interpretations of a rule
are not sufficient to cause skepticism (though they may play into a
skeptical hand, one that has already portrayed rules and their role in
language in a particular way). The Wittgensteinian issue is, as else-
where, why we imagine otherwise. In which case what Kripke
proposes as a serious intellectual "solution" to the paradox can-
not—so it seems to me—be Wittgenstein's.

How do I know that what I called Wittgenstein's "tone" is what I
say it is? My claim is based, for example, on taking Wittgenstein's
remark at §199, "This is of course a note on the grammar of the
expression 'to obey a rule',"—in response to a question whether
obeying a rule could be something only one man can do and only
once in his life—to apply to his entire discussion of rules, for exam-
ple, to questions of what counts as obedience, following, interpreta-
tion, regularity, doing the same, ordering, custom, technique, ex-
ample, practice, explaining, understanding, guessing, intuition,
possibility, intention . . . no one of which is less or more funda-
mental than the concept of a rule, and each of which is to be
investigated grammatically (hence by way of eliciting criteria).
Why things look otherwise to Kripke—how they can, and so con-
sistently—would have to be made out in order to convince someone
who is convinced by him that the conviction is forced, which would
require showing not merely a discrepancy between Kripke's and
Wittgenstein's use of the major terms Kripke cites from Wittgen-
stein, but showing why Kripke's take the particular form they
have—where "showing why" would require recognizing that the
interpretations Kripke employs are already encoded and questioned
in Wittgenstein's text. I am not going to try directly to make this
out. I will simply say, starting out, that Kripke's account, in dras-
tically underestimating, or evading Wittgenstein's preoccupation
with the ordinary (hence with "our criteria," which articulate the
ordinary), evades Wittgenstein's preoccupation with philosophy's
drastic desire to underestimate or to evade the ordinary.

My tack in approaching Kripke will be, in a sense, as indirect as this description of what I am calling the argument of the ordinary suggests it must be, an argument neither side should win. What Kripke calls the "solution" to the skeptical question or paradox turns on a picture of how the "isolated" individual comes to be "instructed" (and accepted or rejected) by the "community," in terms of "inclinations" expressed by someone (presumably regarding himself or herself as representing the community) who "judges" whether the "same" inclinations are expressed by the other seeking (as it were) the community's recognition or acknowledgment. My tack is to suggest that Kripke's portrait of this scene of acceptance or rejection is not Wittgenstein's (that it is indeed a significant reversal of a crossroads scene of Wittgenstein's), hence that it is in particular not Wittgenstein's "skeptical solution" to what Kripke calls Wittgenstein's "skeptical paradox"; and that if not, the problem to which Kripke offers the solution is not (quite) Wittgenstein's either.

What I have to say consecutively about Kripke's reading will focus on what I get from the following seven or eight sentences from his book:

> The entire point of the skeptical argument is that ultimately we reach a level where we act without any reason in terms of which we can justify our action. We act unhesitatingly but blindly.
>
> This then is an important case of what Wittgenstein calls speaking without 'justification' ('Rechtfertigung'), but not 'wrongfully' ('zu Unrecht'). It is part of our language game of speaking of rules that a speaker may, without ultimately giving any justification, follow his own confident inclination that this way (say, responding '125' [when asked for the sum of 68 and 57]) is the right way to respond, rather than another way (e.g. responding '5') [which would be right on another function, one which Kripke shows cannot be ruled out as the one being acted on]. That is, the 'assertability conditions' that license an individual to say that, on a given occasion, he ought to follow his rule this way rather than that, are, ultimately, that he does what he is inclined to do. (pp. 87–88)

Kripke contrasts this case taken as "one person considered in isolation [where] the notion of a rule guiding the person who adopts it can have no substantive content' (p. 89) with the case of a teacher and child, where another has "justification conditions for attributing correct or incorrect rule following to the subject, and these will

not be simply that the subject's own authority is to be accepted" (p. 89). And finally:

> Now, what do I mean when I say that the teacher judges that, for certain cases, the pupil must give the 'right' answer? I mean that the teacher judges that the child has given the same answer that he himself would give. Similarly, when I said that the teacher, in order to judge that the child is adding, must judge that, for a problem with larger numbers, he is applying the 'right' procedure even if he comes out with a mistaken result, I mean that he judges that the child is applying the procedure he himself is inclined to apply. (p. 90)

But I find that this is not how I conceive Wittgenstein's portrait of the child and of instruction in the *Investigations*.

I shall recast Kripke's reading in a form that allows it to be, so to speak, placed over a familiar passage from the *Investigations*, focusing on Kripke's phrases "inclined to do" and "inclined to apply," which respectively end the two blocks of quotation I have taken from his book. The familiar passage from the *Investigations* is at §217:

> If I have exhausted the justifications I have reached bedrock, and my spade is turned. Then I am inclined to say: "This is simply what I do."

I recast Kripke's reading as follows:

> If I have exhausted . . . [etc.] Then I am licensed to say: "This is simply what I am inclined to do."

My recasting of Kripke's reading varies Wittgenstein's words in two places: it shifts the position of the word "inclined" and replaces its original position with the word "licensed." (Kripke introduces the idea of a practice licensing the application of a rule in the way it strikes one, in the case of "one person taken in isolation" (p. 88); when that one is shown "interacting with a wider community," then while his inclination is no longer the basis for licensing what he does, what he does is licensed or not on the basis of the inclination of another (cp. p. 91). This is supposed to be a solution to the problem of the privacy of language. On the view I recount of the *Investigations*, this public licensing would be no step beyond privacy. I might say it does not capture the ideas of agreement or of authority as portrayed in the *Investigations*, but this means to me that it does not

capture the privacy, or separateness, achieved there either. This question is treated only implicitly in what follows here.)

Call Wittgenstein's passage (at §217) his scene of instruction. Kripke's scene, on my construction, expands quite differently.

Wittgenstein speaks of something I am inclined to say. What I am *inclined* to say is precisely not something I necessarily go on to say: I may be inclined to say yes to an invitation, but there are considerations against it, and I hesitate to give an answer on the spot. Might not the teacher in Wittgenstein's scene of instruction have considerations against saying, "This is what I do," hence be expressing hesitation in saying it? It is with a pang that I hear Kripke add, after citing what he calls the skeptical argument, according to which we act without reason: "We act unhesitatingly but blindly." (p. 87). Speaking in terms of blind obedience is how Wittgenstein expresses himself in the passage (in §219) in which he is speaking of how things *strike* him, that is, in an explicitly symbolic or mythological mode. I assume Wittgenstein means to contrast speaking mythologically with giving (literal) explanations. Speaking mythologically gives, let us say, a perspective on ourselves. If I accept the invitation blindly I fail to take into consideration certain more or less obvious risks (of status, awkwardness, misunderstanding) in doing so. If I obey someone's order blindly I reluctantly or gladly give over responsibility for my actions. If I take blind assurance from a prophecy, I fail to see that it can be taken another way. Since in following a rule there are no risks nameable in advance, and my responsibility is foregone beyond reluctance or gladness, and there is no alternative interpretation to be seen, it might strike us that a rule has a power of compulsion beyond anything we know. Then it might further strike us that it is we who are yet more powerful than rules since we can pick and choose among them. But perhaps we are only choosing the length of the chains that hold us. Blindness expresses the rule's power as our power to subject ourselves to it. The counteridea of my spade's being turned is a "symbolical expression" (*Investigations*, §221) of the rule's impotence as my impotence in subjecting anyone else to it. Without going on here, it seems that our symbolical expressions are as demanding as rules are, commanding beyond all notice.

A consideration against going on to say, "This is simply what I do"—hesitation over expressing oneself so—might arise over how definitive the idea of "this" can be, with reasons run out. Compare:

"But surely another person can't have THIS pain!" (§253)—which Wittgenstein answers with a rejection, noting in effect that what looks like a substantial proof of unique existence is at most a shadow cast by the promise of a criterion of identity which is not forthcoming, could not be forthcoming, since if you identify a pain as, for example, tapping yourself on the knee, the somewhat nauseating sensation that brings back the day you fell from a swing and twisted your leg, then we may very well have a common world of background against which I have a pain that I identify as that very somewhat nauseating sensation associated with a childhood fall. If you persist in denying that it is the same, that will at some point be taken to mean that you will not *allow*—that you have entered the metaphysical place from which it is not allowable—that a sensation in another body may be the same as one in yours. In the scene of instruction the common background against which I define the *this* that I do is not available, not because it is, as it were, denied in my philosophical determination to assert my uniqueness, but because along with my reasons our common world of background has become exhausted. ("Reaching bedrock" is disputable. If someone replies, "The absence of justifications precisely means that you have *not* reached bedrock, that on the contrary philosophy must now go to work," this hyperbolicization of "bedrock," if it finds no metaphysical satisfaction, will end in the (skeptical) declaration that there *is* no foundation, anywhere. I am not—I mean Wittgenstein is not, in the *Investigations*—exactly trying to stop it.)

I conceive that the good teacher will not say, "This is simply what I do" as a threat to discontinue his or her instruction, as if to say: "I am right; do it my way or leave my sight." The teacher's expression of inclination in what is to be said shows readiness—(unconditional) willingness—to continue presenting himself as an example, as the representative of the community into which the child is being, let me say, invited and initiated.

I emphasize that the divergences in question in Wittgenstein's original scene of instruction and in the one I recast in Kripke's name, are independent of the difference between saying and doing, since in continuing a series, making a move is both saying and doing. I imagine no pragmatist invitation here. In my Wittgenstein the exhaustion of justifications is marked by an inclination to say that I can only show something—*this!*—and then I may, or not, go back to my steps, without conclusion. In Kripke's Wittgenstein the exhaus-

tion of justifications is explained by saying or finding that justifications were always only inclinations, mine or yours, after which I go on to watch the other's steps. Moving from the case of teacher and child to that of peers, speakers of equal authority over words, the analogous feeling of confidence in one's arithmetical or linguistic powers—"the feeling one can give correct responses in new cases"—is a state Kripke glosses with the words, "Now I can go on" (p. 90). But those words in the *Investigations* (e.g., §§ 151, 179) do not express my confidence in taking my next step. They describe cases in which I suddenly catch on to steps someone *else* is taking. Before my exclamation of knowing how, I was not taking pertinent steps at all. I am not testing my confidence in following rules but my agility in determining them, given that they are being followed. ("Let us imagine the following example: A writes a series of numbers down; B watches him and tries to find a law for the sequence of numbers" (*Investigations*, §151). I might imagine that it was I whom I was undertaking to observe the productions of, to find their law. (Cf., "If I listened to the words of my mouth, I might say that someone else was speaking out of my mouth" (*Investigations*, p. 192). But then I (as the observed, or overheard) would not exclaim, except under specific circumstances (being watched watching another), "Now I know how to go on." *I* would, I feel like saying, have no confidence, *or* lack of confidence, in general *to be expressed.* My associations, free or bound, would be incomparably more interesting, and communicative, than any confidence I may feel. If the words "now I can go on" are, alternatively, part of a case in which I am recovering myself, say from a sudden onset of pain, I would be continuing my past, my life, as having been interrupted, as from within; and the confidence I express is directed not to my knowledge of my next step but toward my recovered capacity to take it.

When Kripke says that "a speaker may, without ultimately giving any justification, follow his own confident inclination that this way is the right way" (p. 88), the idea prepares for the gesture of excluding, or accepting the exclusion, of the child from participation in the community. This *can* be the teacher's reaction as representing the community, and doubtless allegorizes certain dimensions of our, or any known, community. But Wittgenstein's dark, Swiftian humor in suggesting separating out the child who does not continue a series as we expect, and treating it as a lunatic, comes off the case of the child not being able to continue far enough without help, which

is a different matter—one I do not go into here—from one in which
the child computes the "wrong" way, that is, in "his" way. (See *The
Brown Book*, p. 93; *The Claim of Reason*, p. 112; the lunatic case
does not appear, I believe, in the *Investigations*—the obvious place
for it was §208.) "Confident inclination" suggests inclination that
becomes intensified in response to being thwarted or contested. In
saying, "A speaker may, without ultimately giving any justifica-
tion, follow his own confident inclination that this way (say
responding '125') is the *right* way to respond, rather than another
way (e.g., responding '5')" (Kripke, pp. 87–88), the appearance of
"inclination," that is, (confident) "inclination that this way" is
right, has been motivated by preparing a nasty surprise for the
speaker. I do not find that this sense of confident inclination is ex-
pressed in Wittgenstein's cases of "going on," where the favored
gesture of justification is to say something like, "When he suddenly
knew how to go on, when he understood the principle, then possibly
he had a special experience . . .—but for us it is the circumstances
under which he had such an experience that justify him in saying in
such a case that he understands, that he knows how to go on" (*Inves-
tigations*, §154).

Wittgenstein's cases concerning, as he puts it, "*This* use of the
word 'to know,' [namely] 'Now I know!'—and similarly 'Now I can
do it!' and 'Now I understand!' . . . [and] 'Now I can go on!'" are
cases of a capacity "that makes its appearance in a moment" (§151),
as contrasted with cases in which one says that knowing is a state or
disposition (e.g., §149). Knowing in the moment, like suddenly
claiming to remember a tune, does not *claim* to be right: the only
thing it could be right about is what it claims to know or to be able to
produce on the spot, in the moment, which preempts the room for
claiming, for justifying. It is not a claim to be justified by evidence
or reasoning, but a sally of conviction; its failure is no surprise and
no threat to the powers of human knowledge. Given the complex-
ities of our powers, this sort of thing is bound to happen, not the
failure but the sally, failing or succeeding. The response to this fail-
ing is not like, "So I didn't know I could go on after all," but just, in
full, roughly, "Damn!"

Is someone here being considered in isolation? But he is, I might
imagine, responding to me, to what I do. What better company can
he have? And do I constitute, just by being another person, his cir-
cumstances? And what could my inclination, or profound faith, ever

have to do with justifying him here (or licensing him, or judging his action to be correct)? Suppose that driving you to work I say, "I'm inclined to run this red light"; if you reply, "My inclination agrees with yours," have you licensed me to run the light? You may be encouraging license. If when the light turns green I say, "I have faith in going now," and you reply, "My faith agrees with yours," have you made sense of me, and I of you? We may conceive a case in which the circumstances of someone's justification, say of the investment she has made practicing the violin, have not presented themselves; then our faith in her may carry her until that time, when the justification will remain in her hands (though not the certification). If the situation is as Kripke says Wittgenstein says, why ever say more than: "I agree with you. That is my inclination too"? Paraphrasing a wonder of Wittgenstein's: What gives us so much as the idea that human beings, things, can be right? (Cf. §283) If the matching of inclinations is all Wittgenstein's teaching leaves us with, then I feel like asking: What kind of solution is that to a skeptical problem? Kripke calls it a skeptical solution. Then I can express my perplexity this way: This solution seems to me more skeptical than the problem it is designed to solve.

A strong suggestion of my remarks is that the teacher's *confidence* should be placed no more in himself (what he or she simply does) than in the child (what he or she does)—which is not to say that confidence should be shifted onto the child. The idea of trust registered in the concept of confidence comes from an idea of waiting, say patience. There is a question, it seems to me, whether we are to imagine a Kripkean counterconcept so that its deviance can, in principle, show up or so that it cannot. When Kripke appeals to the "drama" (p. 10) of imagining a sudden frenzy or a bout of LSD as explaining the deviance, it seems it can show up. But then we may or may not accommodate ourselves to what shows up, and that would accordingly not for me count as skepticism. But if we are not allowed the drama of imagining that a drug will wear off or a frenzy pass, but rather that the world will remain forever sensuously indistinguishable from the way it now presents itself, that we all may be, and always were, using different concepts that will forever have a coincidence of manifestations, then if we put aside the question whether I really understand what I am to imagine, it seems no different from other skepticisms; and then the question arises as to why I must consider the skeptical possibility (as in considering that I may be

dreaming now or that others may be automata). If I cannot rule out the possibility that I and/or others are automata, would it seem to be a "solution" to this "problem" to interpret our interactions as if I am to monitor your inclinations or your motions against mine? But such things may for practical purposes pose no problem for me at all.

Nothing I have said denies that the scene of instruction ends in a crisis—there is anxiety over whether teacher and child will go on together. It strikes me as a crisis of consent.

I feel sure my sense of Kripke's Wittgenstein's solution to the crisis as more skeptical than the problem it is designed to solve is tied up with my sense that this solution is a particular kind of political solution, one in which the issue of the newcomer for society is whether to accept his or her efforts to imitate us, the thing Emerson calls conformity. The scene thus represents the permanent crisis of a society that conceives of itself as based on consent. In suggesting that there is an alternative to taking "this is simply what I do" as expressing confidence in myself rather than confidence in the other, I am, I guess, suggesting—my Wittgenstein is suggesting?—a certain opening of the idea, or direction, of consent. What is causing these fantasies of politics is doubtless my confusion over the air of power or violence in the solution by "confident inclination." If the child is separated out, treated as a lunatic, this shows at once society's power and its impotence—power to exclude, impotence to include.

But placing confidence in the other—waiting—means letting my confidence be challenged, anyway become hesitant in, thoughtful about, expressing itself. And what kind of solution is this? If I let my confidence or authority be challenged, and I wait, it cannot be that I conceive myself to be wrong about how I add or, in general, talk. And I can perhaps then come to an astonishing insight—that my authority in these matters of grounding is based on nothing substantive in me, nothing particular about me—and I might say: there is no fact about me that constitutes the justification of what I say and do over against what the other, say the child, says and does.

In thus coming upon a derivation of some of the language of Kripke's formulation—"there was [and is] no *fact* about me that constituted my having meant [or meaning]" (p. 21, see also pp. 38, 39, 71, 108)—I am surely struck by its truth and gravity. But I find

that I do not wish to draw a skeptical conclusion from this insight, something to the effect that I do not know what I mean, or whether I mean one thing rather than another, or mean anything at all. (Kripke generally uses the "rather than" formulation. It is not Wittgenstein's central case, but I do not think it matters at this stage.) One reason I resist a skeptical moral here is perhaps that I do not know, as it were, whether or how meaning something requires there to be a fact about me that constitutes meaning it: What is not there when there is not this fact? In terms more or less from *The Claim of Reason*, I might express my resistance this way: Kripke takes the discovery of the absence of his fact to be itself a fact, to have (eventually) that stability. Whereas I take this "absence of the fact" not as a (skeptical) discovery but as the skeptic's *requirement*. (Cf., "The more narrowly we examine actual language, the sharper becomes the conflict between it and our requirement" (*Investigations*, §107.) But where does this requirement (for purity, call it) come from? If I am surprised by joy is there a fact about me that constitutes my joy? If there were a fact about me, would that help convey my condition to another? What justifies what I do and say is, I feel like saying, *me*—the fact that I can respond to an indefinite range of responses of the other, and that the other, for my spade not to be stopped, must respond to me, in which case my justification may be furthered by keeping still. The requirement of purity imposed by philosophy now looks like a wish to leave *me* out, I mean each of us, the self, with its arbitrary needs and unruly desires. But there is more than one way, more than philosophy's way, in which to get rid of or to empty the "I," say to make privacy the nothing it is, the wholly unexceptional.

I said I cannot say that I am—think myself to be—wrong at the level of grounding, wrong in general in the words I use, wrong in presenting myself as a representative of meaningful speech. Can I nevertheless say that I am right, though without justification? (Cf. *Investigations*, §289; Kripke, p. 87.) Not exactly. But if to say, "This is simply what I do" is not necessarily to say, "I am right," it may mean something like, "Follow me, I am the way"—which is hardly less immodest. This moment recalls the problematic of the perfectionist relationship that in the first lecture I characterized, using Emerson's word, as "illustriousness." It is the question of how we each, how I, for example, take my representativeness of what is

said and done as the source of my *authority* in speaking for "us." Knowing how to go on with a series is, I still think it is worth saying (as in *The Claim of Reason*, p. 122), like—a figure of speech for— knowing how to go on with a word in further contexts. If I tell you that this, what I am writing on, is a dining room table, I do not feel that I am speaking for the *inclinations* of the masses of individuals whose agreement (with me) on such matters is beyond question for me. (My hunch is that many of these individuals are sometimes inclined, for instance, to legislate their tastes or inclinations. Even if I shared their inclination, I do not *have* the authority to speak for them unless they *grant* me the authority.) The skeptic is no more in disagreement with me than with himself. If he is to learn something more, he must teach himself. What the skeptic claims not to know in not knowing with certainty that there is a table here is not a fact about this particular table, nor this specific context, nor about, in particular, him (this does not, so far, disagree with Kripke); it is about not less than everything, the strongest and weakest of claims. That the (representative) fact cannot be stated and cannot be settled, as facts are (grammatically) stated and settled, would once upon a time have been taken to mean that the idea that there is such a fact is to be dismissed as meaningless. Kripke's Wittgenstein and my Wittgenstein refuse this dismissal. But unlike Kripke's, my Wittgenstein refuses the skeptic's self-interpretation of his "position" (that he has discovered a fact, or the absence of a fact) with the same breath that he refuses the skeptic's dismissal. There is no (human) position but ours. What is it? What the skeptic knows, everyone and no one knows. What therefore can be *told*?

To my ear Kripke is too lighthearted about what he calls his "dramatic device" (p. 10) (of the "bizarre hypothesis" of always having meant "quus," or taking LSD, or falling into an insane frenzy). It is not surprising (to me) that the issue keeps coming to a matter of writing, or, say, presentation. ("The concept of a perspicuous presentation is of fundamental significance for us. It earmarks our form of presentation" (*Investigations*, §122). I have somewhat modified the Anscombe translation.) Kripke is on the whole gratifyingly nonreductive about Wittgenstein's style, call it. Yet it was bound— to my way of looking at things—to get in his way: "So Wittgenstein, perhaps cagily, might well disapprove of the straightforward formulation given here. Nevertheless, I choose to be so bold as to

say: Wittgenstein holds, with the skeptic, that there is no fact as to whether I mean plus or quus" (Kripke, pp. 70–71). My sense is not that Wittgenstein could not have said the words expressing what Kripke says he "holds," taking up Kripke's fascinating example. But the presentation would, I fancy, have given the words a voice that prompts at once some countervoice: "—As if I have discovered that the world has a gap in it, which all the generations of human beings have hitherto thought filled." I keep hearing Kripke's "fact" as a Wittgensteinian "something," or I guess his "no fact" as a Wittgensteinian "nothing" (Cf. *Investigations*, §304). So I repeat: my emphasis is not on showing Kripke's view to be just wrong but on showing a consistent alternative—a consistent response from the *Investigations* indicating that it is always already combating Kripke's view—that shows it cannot just be right.

Kripke's remark about Wittgenstein's imagined disapproval of straightforwardness suggests a piece of advice I have for one who (for a moment, or from some now on) has freed himself or herself from Wittgenstein's spell and would like to believe that the writing, while no doubt distinguished, is not really essential to the teaching; not just that it fails sometimes, which is inevitable, but simply that it *cannot* matter *that* much, as much, say, as its fervor continually seems to declare. My advice is to take the writing of the *Investigations* as perfectly straightforward—or as straightforward (say undigressive) as any can be with spade turned, empty of theses, no agenda to complete. It is Wittgenstein's posture of philosophy, always arriving at a standstill ("peace"), as if there is no (other) goal. That there is limitation in this manner I would not deny, but the unstraightforward is as much part of its power as of its impotence. Images associated with the turned spade, the unassertive pen, will continue to return.

When Emerson describes the moment his genius calls him ("Self-Reliance," para. 7) and this presents itself to him as having something, as it were, to tell, he depicts himself as withdrawing to write, and this writing is emblematized for him by his writing "Whim" at the place, or as the message, of withdrawal. It is the announcement of nothing to assert; and the entailed most visible withdrawal from, or shunning of, others—perhaps to the commonness of our condition—is a refiguration of Wittgenstein's moment of the returning turned spade. The interlocking, or interlocution, of

power and impotence is expressed by Emerson in the apparently paradoxical, "Who has more obedience than I masters me" ("Self-Reliance," p. 272), which is a fairly straightforward presentation of himself as a thing to be read, a text, a language. It is a claim about philosophical authority, that it is based on nothing.

Something I am driving at can be expressed, I think, in the question: Is the astonishment I might feel, at the insight that my authority is based on no fact about me, to be understood as skeptical astonishment? Kripke reports that sometimes, contemplating the situation of discovery that one may mean nothing at all, he has had "something of an eerie feeling" (p. 21), and that "the entire idea of meaning vanishes into thin air" (p. 22). Is this, I ask myself, like the feelings I have had, under a skeptical surmise, of the world vanishing (as it were behind its appearances), or of my self vanishing (as it were behind or inside my body)? These feelings have been touchstones for me of skeptical paradox, of conclusions I cannot, yet become compelled to, believe. Or is Wittgenstein's discovery of the vanishing of meaning like the discovery that the earth moves around the sun, or that the human is a subject of evolution, or that the mind is essentially unconscious? These are matters about human life that human beings have in various degrees accommodated as part of their human lives (the movement of the earth widely; human evolution less widely; the unconscious mind perhaps much less still, at least in the Western world). I would like to say that when the entire idea of meaning vanishes into thin air what vanishes was already air, revealing no scene of destruction. ("As it were . . . leaving behind only bits of stone and rubble. What we are destroying is houses of cards [*Luftgebäude*: air structures, thick air]" (*Investigations*, §118).)

I think here of an early paragraph of mine that still strikes me as a report of Wittgenstein's insight into the collapse of a picture of authority. It seems to me congruent with Kripke's report of his eerie feeling, and the absence from it of the competing mathematical function allows me some confidence that I can assess its consequences. (This absence of the mathematical may be the essential, so that I am not noticing the first move in a magic trick I am about to play on myself; that is part of my question.) One hits these things off with varying success over the years but the following attempt is useful in its very unguardedness as a step in recognizing the threat of skepticism.

We learn and teach words in certain contexts, and then we are expected, and expect others, to be able to project them into further contexts. Nothing insures that this projection will take place (in particular, not the grasping of universals nor the grasping of books of rules), just as nothing insures that we will make, and understand, the same projections. That on the whole we do is a matter of our sharing routes of interest and feeling, modes of response, senses of humor and of significance and of fulfillment, of what is outrageous, of what is similar to what else, what a rebuke, what forgiveness, of when an utterance is an assertion, when an appeal, when an explanation—all the whirl of organism Wittgenstein calls "forms of life." Human speech and activity, sanity and community, rest upon nothing more, but nothing less, than this. It is a vision as simple as it is difficult, and as difficult as it is (and because it is) terrifying. ("The Availability of Wittgenstein's Later Philosophy," p. 52)

For all the youthful bravado in this address beyond philosophy to the universe, I have meant nothing essentially different—I have meant it as a further step of discussion—when later, instead of introducing such instances of human attunement by saying "nothing insures" them, I have, following Wittgenstein, said things like "there is no reason" that we share these things, emphasizing indeed that sometimes we may not. But would I mean something different if I said, with Kripke, "there is no fact" on which any instance of this attunement or agreement is based? I note two differences. First, as I was more or less just saying, this puts the matter as though something is lacking from the human intellectual repertory—as it were, an oversight in its evolution—rather than characterizing that repertory as, let us say, finite, the possession of a creature of a certain kind, the one that talks. Second, it leaves no room, or not at the right place, for the idea of reasons "coming to an end"; but without the idea of intellectual exhaustion there is no asymmetry of position in the scene of instruction and we may not find ourselves at a question of the ground of our meaning and conduct.

The English translation of Wittgenstein's scene of instruction does not follow Wittgenstein's shift from the first paragraph, which raises some question of justifications and where Wittgenstein has *Rechtfertigung*, to the second paragraph, which gives some response and where Wittgenstein has *Begründungen*. The English version has "justification(s)" in both places, so it misses the chance to register that the metaphorical strain in *Begründung*, that is, grounding

or foundation, is followed out as this sentence in which the image of ground occurs continues the image by invoking hard rock and the spade it turns back. (This may be a good instance from which to consider further that philosophy seems characteristically to miss such chances, and that perhaps it means to.) If this continuation is itself not chance, it paints the scene so that I see that my hand, as teacher, is not forced, my next move is not necessarily final: my spade is turned, which is to say, it cannot keep going *straight*, be simply straightforward. An image of something straight underlies *Rechtfertigung*, the idea of right. But does this not leave me room, perhaps ground, for choice over whether to take this stumbling block as a rejection, from which I recoil, or as a discovery, say of the other, to which I yield? I mean, if I discover resistance I might shift my ground, or take a new approach, or blast my way through, or exclude the site and this block from my plans altogether. However I take it, the scene with its spade is going to remain for me, in light of things said in my first lecture, one of cultivation, of constraint.

The passage I quoted from my early philosophical self, concluding with the claim that human speech and community "rest" only on human attunements, does not quite say that I have no ground of agreement (with others or with myself) but rather suggests that if I am inclined to present myself as such a ground (or thin reed)—when, that is, I am inclined to say, "This is simply what I do"—I had better be prepared to say more about my representativeness for this role, since obviously it is not me personally, this whole man, who in particular bears this burden. But my question is—taking the passage as a test case—whether it expresses skeptical, paradoxical doubt. My answer has in effect been that it does not, that I can accommodate such a revelation of my life in my life, that I mean to, that I want no solution to it, that it is not insane—while it is not exactly what I hoped sanity would be like. In composing the passage I was trying also to capture the experience of reading certain thoughts of Pascal, such as:

> In writing my thought, it escapes me sometimes, but that makes me remember my weakness, which I forget at every hour, which instructs me as much as my forgotten thought, for I hold only to knowing my nothingness. (as quoted in *Pascal, Adversary and Advocate*, p. 256)

> Our inability to prove quite forbids dogmatism. Our instinct for truth quite forbids skepticism. (*Pensées*, sec. 174)

Man is neither angel nor beast, and the mischief is that he who would play the angel plays the beast. (*Pensées*, sec. 187)

When Descartes perceives human dependence he sees a proof of God's radically other existence and draws the moral that we not permit our will to exceed our human powers of judgment. When Pascal perceives human dependency he sees us as dependent on everything that happens to us, hence distracted from God, and draws the moral that we not deny human groundlessness.

The irreconcilability in Pascal of the human position between grandeur and debasement is, I find, matched in the irreconcilability in Wittgenstein between our dissatisfaction with the ordinary and our satisfaction in it, between speaking outside and inside language games, which is to say, the irreconcilability of the two voices (at least two) in the *Investigations*, the writer with his other, the interlocutor, the fact that poses a great task, the continuous task, of Wittgenstein's prose, oscillating between vanity and humility. Skepticism appears in *Philosophical Investigations* as one of the voices locked in this argument, not as a solution or conclusion.

These voices, or sides, in the argument of the ordinary, do not exhaust the space of the *Investigations*, or the tasks of its prose. There is the space not party to the struggle of the sides (I do not think of it as a further voice) often containing its most rhetorical or apparently literary passages—as, for example, about the icy region of the sublime, or the keyboard of the imagination, or turning our investigation around as around a still point, or repairing a spider's web—that are gestures of assessment as from beyond this struggle. The turning of my spade is part of such a passage. —By now it is becoming clear that each of the voices, and silences, of the *Investigations* are the philosopher's, call him Wittgenstein, and they are meant as ours, so that the teacher's and the child's positions, among others, are ours, ones I may at any time find myself in. How else would the *Investigations* form its portrait of the human self, on a par with Locke's *Essay*, Hume's *Treatise*, Kant's *Foundations of the Metaphysics of Morals*, and, like Plato's and Freud's visions, a self that incorporates selves?

In casting the ordinary as setting the stakes of the struggle of voices in the *Investigations*, I do not therefore mean that what is at stake for it is not science and mathematics. I feel at one with Kripke's repeated point that the *Investigations* takes up mathematical examples as among the meaningful uses of language as

such—takes the mathematical, one might say, as the sign of the universality of its concerns. (This is, I believe, how I was thinking when, as cited a moment ago (p. 78), I spoke of its use of the mathematical function of "'continuing a series' as a kind of figure of speech for an idea of the meaning of a word, or rather an idea of the possession of a concept.") Kripke proposes the treatment of mathematics and of psychological concepts, especially sensation, as special cases of the main general argument (about following a rule (privately)) of the *Investigations,* so that if I am not to deny the generality of the concerns of that work I will have to indicate the specialness of mathematics from within an account of the ordinary. And if it falls to me to indicate what such an account turns on, it cannot be one that requires a contribution to mathematics, but one—in reconceiving the connection between following a rule (say of that for addition) and applying a concept of ordinary language (that is, talking)—that makes a contribution to understanding the investment of the ordinary.

The point of my rereading or recounting of the sense of "This is simply what I do" is not to convince one convinced by Kripke's reading that his is wrong, only that it is not necessary, and that if not the problem for which it is the solution stands to be reconceived, again recounted. So I ask again: Do I—or, how do I—expect there to be a fact about me (in such a way as to be astonished to discover its absence) that explains or grounds or justifies or is the reason for my applying a concept, using a word, as I do? This can surely be taken as a hyperbolic expectation, one demanding what Wittgenstein calls "a super-order between—so to speak—super-concepts" (§97); in the present case between "fact about me," "rule," and "justification." One who takes it so will find that, to be a fair reading of the *Investigations,* Kripke's reading ought to subject itself to Wittgenstein's diagnoses and treatments of this "illusion" (§97). But one convinced by Kripke's account may feel that it has brought this subjection itself into question.

The generality of the question (of authority) may show itself more intuitively if we put into play a connection made early in the *Investigations,* at §25: "It is sometimes said that animals do not talk because they lack the mental capacity. And this means: 'They do not think, and that is why they do not talk.' But—they simply do not talk. . . . Commanding, questioning, recounting, chatting, are

as much a part of our natural history, as walking, eating, drinking, playing."

Take the parity in our natural history between commanding and walking, and adduce Wittgenstein's speaking of obeying a rule as like obeying an order (e.g., §187; more explicitly in §206). Then let us ask whether in applying the concept of walking, for example, to ourselves, we will come to seem to have or to lack a fact about me that explains why I go on taking steps as I have in the past. Suppose one day I start sliding my feet one after the other rather than lifting them (lots of people more or less do that now), or start skipping or hopping or goose-stepping or whirling once around on the toes of each foot in succession. If you question me about this perhaps I answer: "I've always meant to do this, you just did not know," or, "I didn't know what moving along the ground could be until now, the inclination is powerful and the results are wonderful." But suppose I answer: "I don't know what has come over me, I don't want this, the inclination is not mine, it mortifies me." Or just: "I'm doing the same as I always have done, the same as you do, making measured moves in a given direction under my own steam. I am not moving faster than walking, we are comfortably keeping up with one another—not like our acquaintance far back there who takes a step once a minute and calls that walking." Wittgenstein's comment seems in place here: "It would now be no use to say: 'But can't you see?'—and repeat the old examples and explanations" (§185). That is, I surely know everything about walking that you do. What you respond to as deviant behavior in me is a threat to me; what I do smacks a little of insanity and I will soon be kept, at least, out of most public places. You might put tremendous pressure on me to conform—do you think I do not know intolerance? I know very well the normativeness of the way things are done—and not just in this society (as though the normativeness were merely something justified by custom or morality); I know of no society that enjoys, or deplores the fact that it engages in, walking as I do, though I might explore for one. (My allegory, concentrating on taking steps, does not take up the possibility of walking in what we call different directions and calling this, say, different routes that we take in common. This implies the concept of a goal or end, which is a further matter.)

We are likely in the case of this walker (qualker?) to think there must be a reason he does it as he does (rather than our way). Just

possibly we will, because of him, be impressed by the groundless-ness of our way—there are plenty of justifications for our way, but they will come to an end. We may feel the reason for the walker's deviance to lie in the presence of some fact about him. But do we feel our lack of ground to lie in the absence of a fact about us? Here again a question about the skeptic's claim comes to the fore. If his question strikes us as insane, how do we come to take him as representatively human, no different from us—come to see that the matter is not one of accommodating ourselves merely to him (or of not)? How has what is at most the barest of possibilities come to represent itself as a fàct—or as the absence of a fact—in the human condition? What fact? Surely not—at least in the case of walking—a biological fact, since the conditions of walking (as humans do) must be the same as those for hopping and whirling (as humans do). I might wish there to be such a fact, as some assurance that I will not become deviant, go out of control, an assurance against a certain fear of going mad, or being defenseless against the charge of madness. It may seem a fear for the human race. I assume this is the fear Descartes expresses by the fourth paragraph of the first meditation. ("How could I deny that these hands and this body is mine, were it not that I compare myself to certain persons . . . who imagine that they have a earth-enware head or are nothing but pumpkins or are made of glass?") It is an anxiety, it seems to me, that Wittgenstein's examples habitu-ally cause or court. ("But what if one insisted on saying that there must also be something boiling in the picture of the pot?" (§299); "Look at a stone and imagine it having sensations" (§284); "If I lis-tened to the words of my mouth, I might say that someone else was speaking out of my mouth" (p. 192).) And the fear of insanity, es-pecially in the form of melancholy, should be taken into account in thinking of Emerson's tireless efforts to cheer his reader—the efforts so tirelessly criticized by his critics. But, so far at least, the deviance of another's walking, and the possibility that I might find myself—since walking is groundless or grounded only on the human and the ground—sometime in another gait, does not gener-alize to (does not cause, or court) a paradoxical conclusion.

But perhaps this is because walking is—what shall I say?—too physical, or for some other reason unimportant, or because its range of "correctness" is not perfectly specified. For whatever reason, the concept of walking in any case fails to satisfy Kripke's formulation according to which there is no fact about me in which the function I

claim to be following consists, a something substantive in me; or rather, I don't know whether to affirm or to deny that there is any fact about me in which my walking might be conceived to consist— other than my walking itself. (This oddly resembles a passage in Descartes's reply to Hobbes's objection that deriving my existence from my thinking fails to prove I am incorporeal because my existence can equally be derived from my walking; to which Descartes replies that—quite apart from its falsity in supposing the argument meant in itself to prove incorporeality—Hobbes's argument does not get off the ground since "there is here no parity between walking and thinking; for walking is usually held to refer only to that action itself, while thinking applies now to the action, now to the faculty of thinking, and again to that in which the faculty exists.")

Then let us take the example Kripke uses to show that

> these problems apply throughout language and are not confined to mathematical examples, though it is with mathematical examples that they can be most smoothly brought out. I think that I have learned the term "table" in such a way that it will apply to indefinitely many future items. So I can apply the term to a new situation, say when I enter the Eiffel Tower for the first time and see a table at the base. Can I answer a skeptic who supposes that by "table" I mean tabair, where a "tabair" is anything that is a table not found at the base of the Eiffel Tower, or a chair found there? Did I think explicitly of the Eiffel Tower when I first "grasped the concept of" a table, gave myself directions for what I meant by "table"? (p. 19)

It seems irresistible to ask why I *have* to answer this skeptic, I mean on Wittgenstein's behalf, since his "tabair" example begs the relevance of two of Wittgenstein's characteristic responses to "new" cases: that "we haven't rules for every possible application" (§80; cf. §68); and that reasons come to an end.

The proposal about "tabair" prejudices what I think when "I think I have learned the term 'table' in such a way that it will apply to indefinitely many future items"; it makes it seem that a reason I call (the criteria I have for calling) items tables is that they are either not in the tower or else are chairs there. Whatever the mystery within the tower, if a reason I have for calling a table a table is that it is not in the tower, it is the same as a reason I can have for calling any object what I call it outside: explanations have not come to an end somewhere; there is so far nowhere for them to begin. If I have a reason, known or unknown to me, for including the inside and the

outside of the Eiffel Tower in the function for a concept, I will be able to realize this reason only if I already possess criteria for applying the concept outside and applying it inside, so that, for example, in applying the concept tabair I am sure to stick with tables outside and with chairs inside and so avoid getting tabairs confused with "chables" (chairs outside, tables inside) or with "tabaseballs." I agree that a skeptical onslaught is such that something happens to our criteria, which is to say, to our relation to and of the world and with one another. But what happens in the grip of skepticism, as I have cast it in Wittgensteinian terms, is something like finding ourselves forced to strip criteria from ourselves, and not like finding ourselves incited to complicate and build on them at will (as "tabair" does)—though I am not arguing against that latter possibility or its potential significance.

It is worth emphasizing separately that in explaining the concept tabair this skeptic dissociates criteria from the realm of what Wittgenstein calls our "natural reactions." I suppose one could say that my natural reactions change in the face of the Eiffel Tower, but would this not owe an account of why this has happened just to me and in such a way as to produce this concept? At §145 Wittgenstein gives the general idea: "The effect of any further explanation depends on his reaction." It is at §185, after a case in which the pupil points to the series and says, "But I went on in the same way" that Wittgenstein observes: "It would now be no use to say: 'But can't you see. . . . ?' " It is here that Wittgenstein claims the similarity of such a case with "one in which a person naturally reacted to the gesture of pointing with the hand by looking in the direction of the line from finger-tip to wrist, not from wrist to finger-tip." There is decisively good reason (justification, explanation) for the direction in which we normal ones look—it allows me to point for you in the direction I am looking in, so that ease and accuracy are incomparably better assured than in the alternative possibility. But I can imagine that someone just may not get it, or perhaps find what we call pointing horrifyingly rude, or for some reason feel the need to sight along my arm as along a rifle, which is easier done from the finger end. Reasons are not likely to be more use now than pointing also with the other hand and perhaps making repeated punching gestures with both arms. Whether and how we accommodate ourselves to our impotence here, or to the other's power, will probably

depend on our relationship with this person beyond this incident, if there is any.

(Did Wittgenstein not know, in linking the following of rules with the pointing hand, or would he not have cared, that the root of the idea of right, and so of *Recht*, as in *Rechtfertigung*—that which specifies its idea of the straight—is that of directing in a straight line, hence of stretching out (the hand), reaching out for? This idea of ordering is also related to the idea of (re)counting.)

In these difficult and obscure matters I seem to be hanging on to the thought that Wittgenstein's idea of our lacking "rules for every possible application," is used by him, so far as I can see, to characterize the application of nonmathematical concepts, and not, for example, to characterize the rule for addition. I quoted Kripke's observation concerning the problem of applying a concept (inevitably based on a finite number of past cases) to "future items" in which he says that the mathematical examples bring out the problems of language "more smoothly." Certainly I agree, as said, and agree to the importance of the fact, that Wittgenstein's problem of grounding concepts applies throughout language and is meant to include mathematical cases. But the relation of—the difference between—the mathematical and the ordinary cases does not seem to me brought out by saying of the mathematical that they bring out the problems more smoothly, or perhaps *more* anything at all.

I suppose that something that makes a mathematical rule mathematical—anyway that makes adding adding—is that what counts as an instance of it (whether the computation is correct or not, and whether the function behaves as we expect or not) is, intuitively, settled in advance, that it tells what its first instance is, and what the interval is to successive instances, and what the order of instances is. The rule for addition extends to all its possible applications. (As does the rule for quaddition—otherwise it would not rhyme with addition, I mean it would not be known to us as a mathematical function.) But our ordinary concepts—for instance that of a table— are not thus mathematical in their application: we do not, intuitively, within the ordinary, know in advance (not smoothly *and* not roughly—there is no such thing as, it is not part of the mythology of the ordinary that there exists) a right first instance, or the correct order of instances, or the set interval of their succession. And sometimes we will not know whether to say an instance counts as falling

under a concept or to say that it does not count; no concept is "bound" by ordinary criteria though we can in particular cases bind it, as perhaps in the case of "tabair."

Far be it from me to define what makes the mathematical mathematical. But I have to take it upon myself to say that, in Wittgenstein's idea of criteria, which grammatically control the application of ordinary words, there is the idea that ordinary concepts—that is, here, nonmathematical concepts—are nevertheless equally based on counting, that the connection between applying a concept and counting is as strong throughout ordinary language as it is in the instance of addition, with its rule(s). Criteria (following their development in *The Claim of Reason*) are means by which something is marked (say inscribed) and portioned out—its idea is that of differencing, selecting, sharing, as by a plowshare, dividing; for our purposes now, the specific feature in question is that of tallying. Mathematical rules, and the counting they make possible, are as specific to mathematical concepts, as ordinary criteria and the tallying they make possible are to the (rest of the) concepts of ordinary language. In precision, in accuracy, in the power of communication, ordinary concepts are the equal of mathematical. The ordinary (nonmathematical) concepts are by no means the equal of the (ordinary) mathematical in, let us say, abstractness, or universality, or completeness. To say that concepts of ordinary language do not determine the first, or the succession, or the interval of their instances is perhaps to say that the instances falling under an ordinary concept do not form a series. (Of course for various purposes we might order them in a series, for example, according to size or color—say all the instances in this field falling under the concept "red apple." But nothing, under ordinary circumstances, could in general carve out these things from all other things more perfectly than "red apple." This is not praise of the ordinary, but a noting of its humdrum perfection. In certain circumstances it will not work well: certain apples in the field are disguised pears or change color unpredictably. Then mathematics will not help either.) To say that ordinary concepts are not mathematically precise means just that ordinary concepts are not mathematical; it does not mean that ordinary concepts are not precise. The "normativeness" or "sublimity" of mathematics and logic makes things seem otherwise, but that is open to diagnosis (§81, §89).

Put otherwise: "Ordinary concepts are not precise" is not exactly

ly false but roughly ambiguous. What it may say clearly (but mis-
leadingly) is that there is a distinction *within ordinary language*
between concepts that are associated with a mathematical function
(e.g., addition or quaddition) and those that are not. The idea seems
right enough. What it also, as it were, may try to say is that ordi-
nary concepts not associated with mathematical functions lack
something. The former, in specifying the association, gives a sense
to the distinction between ordinary and mathematical precision, ac-
cording to which the mathematical is not *more* precise but, one
might say, gives precision a certain shape: that mathematical and
nonmathematical concepts are different is then true, obvious, of
great practical importance and of intellectual interest. The latter,
the sense that ordinary concepts lack something, wants to say some-
thing more. The something more it wants to say Wittgenstein diag-
noses as sublimizing. If so—if I am right here about Wittgen-
stein and if Wittgenstein is right—then the wish is not that of
the mathematician but that of the philosopher. That there are
mathematical functions that go beyond the mathematical functions
that are part of (associated with concepts of) ordinary language,
and express ideas inexpressible in ordinary concepts, is not doubted
by me. That ordinary language expresses ideas no *less* precise and
as beyond common sense, and as in need of and rewarding of
philosophical investigation as mathematics is, is also not doubted
by me. When Wittgenstein says that concepts are not bounded
(§68; cf. §80), I understand him to be using the term "bounded"
as an ordinary one and at the same time as one carrying mathe-
matical associations, as a way of stressing the difference in preci-
sions between the ordinary and the mathematical. That both
precisions are forms of counting is the way I would like to under-
stand how Wittgenstein's problems of grounding apply throughout
language.

 Ordinary counting is a function, as mathematical counting is not,
of what counts for us, what matters: it is how grammar says what
we count anything to be (cf. §373, "Theology as grammar"). Natu-
rally some will deny that counting as enumerating and counting as
mattering are inflections of the same concept. Then the sides in the
argument of the ordinary will beg one another's question at this
point. It may seem that the concept of telling underlies that of
counting: "telling," so to speak, says that talking is counting. But
there are no shortcuts here, and the question recurs whether telling

as tallying or enumerating and telling as saying or imparting are inflections of the same concept. When Wittgenstein, pressing the idea of communication, asks, "But how is telling done?" (§363) he focuses on *Mitteilung*, imparting, and the idea of sharing here cuts back into the idea of a criterion. Then what is the relation of counting and recounting? Both mathematical and narrative recounting can be thought of as checking an answer, but in the mathematical case what is in question is a conclusion, in the narrative case an ending. In *The Winter's Tale* the portrait of the skeptic (Leontes) is of a man who would undo counting (as in my *Disowning Knowledge*, pp. 200–207).

Ordinary language will aspire to mathematics as to something sublime; that it can so aspire is specific to its condition. The idea of ordinary language as lacking something in its rules is bound up with—is no more nor less necessary than—this aspiration. This is the place at which Wittgenstein characterizes logic (and I assume the rule for addition is included here) as "normative," as something to which we compare the use of words (§81)—to the discredit of words; he takes this further a few sections later in posing the question, "In what sense is logic something sublime?" (§89). In this role of the normative, the mathematical is not a special case of a problem that arises for the ordinary; without the mathematical this problem of the ordinary would not arise.

It is exactly as important to Wittgenstein to trace the disappointment with and repudiation of criteria (which is how *The Claim of Reason* interprets the possibility or threat of or the temptation to skepticism) as to trace our attunements in them (to which Austin confined himself). We understandably do not like our concepts to be based on what matters to us (something Wittgenstein once put by saying "Concepts . . . are the expression of our interest" (§570)); it makes our language seem unstable and the instability seems to mean what I have expressed as my being responsible for whatever stability our criteria may have, and I do not want this responsibility; it mars my wish for sublimity. The human capacity—and the drive—both to affirm and to deny our criteria constitutes the argument of the ordinary. And to trace the disappointment with criteria is to trace the aspiration to the sublime—the image of the skeptic's progress. I am the instrument of this argument, I mean no one occupies its positions if each of us does not. So it is nowhere more than in each of us, as we stand, poor things, that the power of the ordi-

nary will or will not manifest itself. (Some find that nothing is any longer ordinary for us—Chekhov and Beckett, for example. This seems to mean for them—as similarly for Wordsworth and for Thoreau—that nothing any longer interests us, nothing more than anything else. Their advice may be: try to stop talking. Only why in the world, and to whom, might they *give* the advice? It would not quite be a way to imagine Wittgenstein's advice.)

Our criteria for a thing's being a table—part of the grammar of the word "table"—is that *this* is what we call "to sit at a table." (Cf. *The Blue Book*, p. 24; *The Claim of Reason*, p. 71) That we sit at it this way to eat and that way to write (closer in, resting an arm on it if the writing is by hand) and the other way to position a coffee cup, are all criteria for calling it a table. You can sit on a table, or on a flagpole, but not in those ways; and unlike a flagpole, a chair can be used for a table (as well as vice versa) or a tree stump serve as a table. That will not make chairs and tree stumps tables; but put some legs under an even, sturdy slice made straight across a tree stump, bark still on it, and you can get a table. It is obviously essential, from what has been said, that the table top be a fairly smooth and quite horizontal surface supported by one or more legs generally waist high. Is this all that is essential? It is all, even a little more than, my dictionary gives. So far nothing has been said about scale or proportion or shape, but a disk whose radius is the length of the long side of a football stadium, supported ankle high, will not count (is it more definite that one whose diameter reaches from where I sit to just beyond the horizon, so that I cannot see the person sitting as it were directly opposite me, will surely not count?); nor will a half-inch rail the "right" height running the length of a dining room (though it, and a cross rail, may, for certain purposes, represent a table). Somewhere between the stadium possibility and the rail there will be doubtful cases. As the Kripkean skeptic properly observes—but with that skeptic's animus—I probably did not think of the tree stump or the stadium possibilities nor of that of the rail when I learned the term "table," nor for that matter ever thought explicitly that the support of a table must rise from the floor (not be propped from a wall, in which case it is a shelf), settling roughly (when you sit at it) at the waist, which evidently says why a table's support is characteristically (called) a leg. I can testify that I have never thought that a shape for a table top is ruled out—even when an object is within the rough scale and proportion and height range of a

table—whose edge is lined continuously with triangular projections just longer than long human arms, narrower at the base than the base of a cup, and too close to one another for a thin human being to squeeze between. You couldn't place things on it (by hand). Though I did not think of these things when I learned the word "table," I can think of them now, I can bethink myself of them, and more. I can do this because of our agreement in our criteria.

Kripke speaks of our "achieving agreement in our criteria," (p. 105) but that suggests to me a rejection of Wittgenstein's idea of agreement, or let me say a contractualizing or conventionalizing of it. On Wittgenstein's view, the agreement criteria depend upon lies in our natural reactions. We may laugh and cry at the same things, or not; some experience may throw us out of, or into, agreement here, but the idea of *achieving* agreement in our senses of comedy or tragedy seems out of place. When the child starts to walk, she or he walks, tentatively, as I do; we agree in walking; but we have not achieved this agreement, come to agree; it makes more sense to say that we have each come to walk. Before the child is a master of our language he or she may not discriminate between a table and a tray. Here I find I do not want to say that we do not agree about what a table (or a tray) is—the child will call a table anything (well, lots of things) I call a table, and I will call (almost) everything the child calls a table a table (when talking to the child). One might say that our agreement on this point lacks a certain depth, but this lack pales before the vastness of agreement implied in our (provisional) agreement that trays are tables.

How might my past behavior with tables have been different, or my future be? If chairs cease to exist in our world, so that the alternative to standing and leaning or lying is, or becomes, to squat or to sit on the ground, and so that if what we (now) call tables become indistinguishable from altars, or anyway from surfaces for communal displays, then something would happen to our concept of a table. I do not insist that one agree that the concept would change, but the role of the concept of a table (because the role of tables) in our lives would be different, perhaps absent. What would incline me to call anything a table? (*Investigations*, §570: "Concepts lead us to make investigations; are the expression of our interest, and direct our interest.") We do not, I suppose, imagine a mathematical concept "altering" or vanishing under such pressures from the world. And it seems to me right to say: ordinary concepts have histories, mathe-

matical do not; mathematical concepts have befores and afters, not pasts and futures; they are eternal ("I always meant this"). We might accordingly say of "tabair"-like examples that they exemplify the possibility of subjecting our ordinary concepts to a special form of mathematization, or definition.

But what good can it do for me to insist that our grammatical criteria for the application of an ordinary word, say "inclination," tell what kind of thing an inclination is (roughly, the expression of a desire, but one under conscious check)? A view that subjects the application of a word in general to inclinations will of course subject the choice of the word "inclination" to what it calls inclinations (where roughly neither desire nor its check are in play, but instead are replaced with something like generalized sources of energy.) (Inclinations as forming a realm of the psyche distinguishable as a whole from the realm of reason is as fateful a Kantian legacy as the thing-in-itself.) What good, then, to insist that in taking a series of steps you are not *inclined* to take a next step within the series, unless perhaps there is a puddle just there and you are inclined to make a splash? No good.

And it is, I guess, in thus stripping us of our criteria that Kripke's solution (or Wittgenstein's if it is Wittgenstein's) seems to me more skeptical than the problem it is designed to solve. Suppose I insist: the perspective or attitude from which the mind is always speaking from specific inclinations to take its next steps is a perspective from which the mind seems a medium of somethings and nothings, and so can, of course, only arbitrarily relate to the world. Why should the reply not be, "So be it!" Wittgenstein's dark remark, "It is not a something, but not a nothing either" (§304), which he composes in response to the accusation that he keeps reaching the conclusion that the sensation is nothing, must apply as well to the intention in following a rule or criterion. But Wittgenstein's remark can have no bearing if one is content with, or forced to, the mind as a medium of somethings, call them impressions and ideas.

In reaching the gesture expressed as, "This is simply what I do" I reach the end of the criteria I can bethink myself of in accounting for why I do and call what I do as I do. I say I cannot then say I am right. And in going on to say that the repudiation of deviance is a stance, a voice taken in disapproval, betokening social repression; and in remarking further that the violence in claiming to be right where there is no right repudiates the ordinary (our criteria for the applica-

tion of everyday concepts, e.g., that of "inclination"—since it is dissociated from desire—of "this"—since it counts on a criterion that is already rejected—of "I"—since it seeks to represent a community that does not exist); I have spoken of finding *Philosophical Investigations* to attest to a way beyond sides, beyond private voices, in this opposition. Here is where I had wanted to adduce Emerson's breakthrough essay "Experience." (A reading of passages of "Experience" is the burden of my "Finding as Founding.") My economy now allows me just to state what interests me in it.

The "experience" of its title, as said in my first lecture, heralds an enactment of grief over the philosophical presentation of experience—in Hume and in Kant, for example—as a constitution of reality that forever seems to remove us from, to substitute for, what we desired of the world, of connection with it, of being in it. "I cannot get it nearer to me," Emerson says—and he is expressing the fact of his son's death as for him the best case of the nearness of the world. He diagnoses this uncloseable distance as one in which "things make no impression," by which, in Emerson's way of saying things, he means that the empiricist's idea of "impressions," from which all experience is made and all ideas are derived, is precisely unable to account for our connection with things, our interest in them, reactions to them, what matters about them to us, what counts. (The philosophical idea of "inclination," would be of impressions from within.) (Cf. §600: "Does everything that we do not find conspicuous make an impression of inconspicuousness? Does what is ordinary always make the impression of ordinariness?") Emerson's therapy for this is a turning around of the picture of approaching the world, so that the world may be allowed to approach us. This sounds animistic; what it means is that we must stop denying something. The way out takes the image in Emerson's "Experience" of walking, treading a stairway, an image whose fantastic ramifications go to show walking—say knowing how to go on—to be humanly as important (or spiritual) as thinking, even to be Emerson's philosophical picture of human thinking.

But let us, seeking to conclude, go back once more to the inclination Wittgenstein expresses to say: "This is simply what I do." It is the same "simply" (*eben*) as in Wittgenstein's response to the idea that animals do not talk because they do not think. "But—" Wittgenstein finds, "they simply do not talk" (§25). The idea is not: Do not seek an explanation for animals' not talking, any more than for

our (we humans') talking, because you will not find one. The idea is rather: See how philosophical explanations will seek to distract you from your interests (ordinary, scientific, aesthetic); how they counterfeit necessity. That the advice is all but impossible to take is Wittgenstein's subject: we do seek, and therewith we demand a finding, and therein comes the skeptical conclusion, or solution: the demand for a philosophical solution is the skepticism. (This is of course not true of science nor of art. Then how do you know when philosophy has intervened? Simply as a result of the self-stultification?)

Wittgenstein introduces the gesture, "Explanations come to an end somewhere" in the opening section of the *Investigations*, in a comically sudden moment. The first example of the *Investigations*, that of sending someone shopping with a slip marked "five red apples" produces the first suggestion of a voice of the other, "But how does [the shopkeeper] know where and how he is to look up the word 'red' and what he is to do with the word 'five'?" To which Wittgenstein replies, "Well, I assume that he acts as I have described. Explanations come to an end somewhere" (§1). But already? And here, in response to so bizarre a set of actions as described there?: "The shopkeeper . . . opens the drawer marked 'apples': then he looks up the word 'red' in a table and finds a color sample opposite it: then he says the series of cardinal numbers . . ." In the face of these actions—so mechanical, alien, anything but ones about which, were they mine, my confidence is that I could not be wrong—I stake my understanding of myself? But the very comedy of the moment suggests that a moment comes, sooner or later, at which explanations of one's ground end inconveniently, embarrassingly.

That there is something, but inevitably so little, to say in explanation or justification of my ground—that the teacher so soon has to keep still (the better the teacher the better he or she knows when, knows how to wait)—produces a certain anxiety, say, over human separateness; but again the force of this astonishment is not skeptical paradox. It is this anxiety that I am saying Wittgenstein's sudden closing expresses. Here I return again to the comparably comic moment of Emerson's "Self-Reliance" in which, after speaking of his genius calling him and his shunning father and mother and wife and brother, he says, "I would write on the lintels of the door-post, *Whim*. I hope it is somewhat better than whim at last, but we cannot spend the day in explanation." I read this as follows: There is nothing I can say in general about why I write as I do, speak

the way I speak. At this stage, or at any other, it may reduce for you to a matter of my whim, or say inclination. Yet to say why I write is in a sense what I explain all day, or show, in every word I write, so that it may clarify itself at any moment. (It will hardly help to explain that the reason I would write on the lintels of the doorpost is that the Bible demands it, in order that one and all may see; because you would then want to know why, despite all, I care to do as the Bible demands, in my way. And then you would want to know what my way is. Can I tell you?)

Accordingly, I will say: the stake for me in the scene of instruction is that it specifies Augustine's description of his learning of language, the opening words of *Philosophical Investigations*, as that of a scene of instruction, a scene that haunts the *Investigations* as a whole, since Augustine's words precisely announce the topics of the book as a whole. I recite the words: when, my, elders, name, some object, accordingly, move, toward, I saw, this, grasped, called, sound, uttered, meant, point, intention, shown, bodily movements, natural language of all peoples, expression, face, eyes, voice, state of mind, seeking, having, rejecting, words, repeated, use, proper places, various sentences, learnt, understood, signified, trained, signs, express my own desires. I have elsewhere and often emphasized the standing possibilities of competing ways (well, one standing way and one sitting way) to take Augustine's descriptions, namely either as ordinary, perfectly communicative, and unremarkable, or as metaphysical, utterly remarkable, and isolating. Augustine's first sentence runs, "When my elders named some object and accordingly moved towards something, I saw this and I grasped that the thing was called by the sound they uttered when they meant to point it out." In "Declining Decline" (pp. 60–64), I sketch the "two ways" (at least) of taking Augustine's descriptions with respect to the first extended example in the *Investigations*, about the builders, so with respect to a scene of naming and calling (hence about what not?). The altercation over two ways may sound as follows: One observes, "What could be less remarkable than Augustine's remark about his elders moving around and uttering sounds?" Another retorts, "Less remarkable—when we are in a maze of unanswered questions about what *naming* is, what it *is* to call a thing or a person, what constitutes an *object*, *how* we (with certainty) grasp one idea or image or concept rather than another,

what makes a pointer *point*, a talker *mean!?"* Nothing is wrong; everything is wrong. It is the philosophical moment.

Wittgenstein's metaphysical appears as the ordinary hyperbolicized, Wittgenstein sometimes says sublimized (cf. *Investigations*, §94). (The familiar as unfamiliar: Freud calls this the uncanny.) A question for me is how Emerson's sublime is a response to philosophical sublimizing (let alone how Freud's sublimation responds), not transcending the ordinary philosophically, so not having to declare its immanence in the ordinary. Transcendentalism as countering the transcendent: it is what Kant sets out to accomplish. I earlier described Emerson's withdrawal to write as an announcement of nothing to assert. I might put this by saying that Emerson is renouncing (that is, foregoing and at the same time recalling) assertibility conditions for what he has to say. The philosopher looks for assertibility conditions to measure communication (see, e.g., Kripke, p. 90). For Wittgenstein the assertion of assertibility conditions is precisely useless in his work to distinguish either preventing or curing a metaphysical way of taking words. Since the metaphysician (in us) contests the (ordinary) conditions of assertibility, the (re)assertion of those conditions is no "solution" to his problem. (Cp. *The Claim of Reason*, pp. 66–70.)

This time around, for some reason, what strikes me about Augustine's description is how isolated the child appears, training its own mouth to form signs (something you might expect of a figure in a Beckett play), the unobserved observer of the culture. The scene portrays language as an inheritance but also as one that has, as it were, to be stolen, anyway in which the capacity and perhaps the motivation to take it is altogether greater than the capacity and perhaps the motivation to give it. Haunting the entire *Investigations*, the opening scene and its figure of the child signals that the question "Where did you learn—what is the home of—a concept?" may at any time arise (and not only in the couple of dozen sections in which the child explicitly appears), that the inheritance of a culture—the process of cultivation (or what is the point of spading?)—comes not to a natural end, or rather to its own end, but to one ended, by poor resources, or by power; that when explanations in particular circumstances run out, teaching becomes heightened while control over what it is that is taught, say shown, is lessened. I have said that each of the voices and silences of the *Investigations* is ours (except

where it may be poorly composed). If an exchange with an interlocutor ends with a question, you do not know whether it will have an answer ("How can I go so far as to try to use language to get between pain and its expression?" (§245)); and if it ends with a declaration, you do not know whether anyone is listening ("how much we are inclined to say something which gives no information" (§298)). At any time I may find myself isolated. A moral I derive from the *Investigations* along these lines is accordingly: I am not to give myself explanations that divide me from myself, that take sides against myself, that would exact my consent, not attract it. That would cede my voice to my isolation. Then I might never be found.

3 THE CONVERSATION OF JUSTICE
Rawls and the Drama of Consent

I have left myself, in what follows, little time in which to discuss Eric Rohmer's film version of Henrich von Kleist's tale *The Marquise of O____*, for example to consider that in the film a sequence opens with the Marquise shown still asleep in the sleep in which she had been, we will learn, raped by the Count, and then awakened with a start by the sound of a firing squad executing the soldiers from whom the Count had, as it were, rescued her. Her awakening reads as if the execution were part of her dream and poses the question whether her dream represents the violation done to her or one that she exacts—of the Count—in revenge. (The latter possibility is emphasized in the next appearance of the Count, as the Marquise and her mother both take him, so to speak, for a ghost; she had seen to it that he was dead.) But I might not have yielded to the inclination to let the study of film, which has afforded me so much interest over the years, share the occasion of these lectures at all but for a moral dimension in their study that I have left largely implicit and about which this occasion—given my choice of Emersonian orientation—seems to me to demand explicitness. I have elsewhere gone into certain aesthetic issues associated with film (e.g., with the possibilities and necessities in its medium or mediums in photography and motion and sound and color and narrative) and certain epistemological issues inevitable in thinking about film (its relation to fantasy and to reality, to presentness, to the relation between animate and inanimate objects). But the specific films I have written about at greatest length—falling into two related genres that I have named comedies of remarriage and melodramas of the unknown woman—work out their aesthetic and epistemological issues or dimensions in narratives that take the form of studies of what I now identify as Moral Perfectionism. I have, from the beginning of my study of the films, insisted on Emerson's presence in them, but of course that was always vulnerable to being taken just as an emphasis on the ruggedness or zaniness of the individuals portrayed in them, hence as evidence less of the presence of moral perception than of its defiance.

While there has been over these same two decades in the literary

world something called an Emerson revival, it has not on the whole involved a rethinking of Emerson's moral imagination. And on the contrary, within the past several years Harold Bloom and John Updike (the former the most prominent of Emerson admirers, the latter one in the long line of detractors) have spoken of Emerson as at best equivocating on the hope for democracy, at worst as smoothing the way for fascism. Given who I think Emerson is, I would not like to let such judgments, from such sources, pass uncountered. It was importantly Bloom's and Updike's statements that prompted the talk of mine, "Hope against Hope," included as an appendix to this volume. Rawls's *Theory of Justice* does not go that far, but it does suggest a position for Nietzsche—and hence, according to my reading of Nietzsche and Emerson, of Emerson—that is morally more or less indefensible, anyway one I would not care to defend, either in Emerson's name or in mine.

It might be suggested that this suggestion of Rawls's account of the principle of perfection is simply a side effect, or artifact, of Rawls's concentration on social institutions rather than on personal and individual conversation, so that Nietzsche's full view, let alone Emerson's, is not really part of Rawls's concern. This is important, but it does not seem to me enough to say. If it is true that personal conversation is not exactly in the foreground of *A Theory of Justice*, there is threading throughout that text the thing I call the conversation of justice, something prepared by the debate explicitly required in establishing the principles of justice in the original position; and contrariwise, my defence of Emersonian conversation is as of something of public importance.

Since Emersonian Perfectionism underlies the moral outlook of the genres of film as a whole that I have studied, I might have taken any one of them to exemplify the outlook. For various reasons I decided instead to specify its oddly inflected presence in *The Marquise of O____*, a film that bears inner relations to both of the American genres. I am motivated by the fact that the Kleist story "The Marquise of O____," which the film follows with astonishing faithfulness, has played a favored, if obscure, role, along with Shakespeare's *The Winter's Tale* and Ibsen's *A Doll's House*, among the literary sources shaping my view of the films. To say how, however, I have to spend a good part of my time in this lecture specifying the participation of these genres of film in Moral Perfectionism.

The genre of the comedy of remarriage I have characterized on

the basis of a kind of argument among themes and structures syn-
thesized in seven Hollywood comedies, spanning the years 1934–
49, that I claim are the best of, hence definitive for, the genre: *It
Happened One Night, The Awful Truth, Bringing Up Baby, His Girl
Friday, The Philadelphia Story, The Lady Eve,* and *Adam's Rib,*
films that are among the most celebrated and most beloved of world
cinema. Those who are suspicious of a claim to the moral (or artistic)
seriousness of these films (even perhaps when they would grant the
possibility of seriousness to certain other films) can dismiss them as
"fairy tales for the Depression," and treat them as morally soft-
headed rather more than hard-hearted, as if to say, Well of course,
when people are as favored socially and lucky in natural fortune as
the characters played in these films by the likes of Katharine Hep-
burn, Spencer Tracy, Cary Grant, Irene Dunne, Barbara Stanwyck,
Claudette Colbert, Henry Fonda, Clark Gable, then it is no particu-
lar wonder that these people are well behaved. Those initially
disposed to give (the) films more credit may sense moral issues in
them concerning the isolation or withdrawal of the principal pair
from society at large (a rebuke directed to their turning away from
the very social circumstances that favor them) and the asymmetry
of the pair's relations to one another, where the male provides the
woman with an education the woman feels herself to stand in need
of (and where the very fact of her need, granted its presence, can
only betoken an injustice so compromising of the society that sup-
ports them as to destroy its moral claims upon her). My view,
further, is that the significance of the facts of withdrawal from soci-
ety and of wealth and of who has and who lacks education, together
with a loop of other features—such as the absence of children (that
is, the fact that the woman is never portrayed as a mother) and the
absence of the woman's mother—are to be derived from the central
condition of these films as a certain mode of conversation.

The title "remarriage" sets as the most notable narrative feature
of the genre that its members, unlike classical comedies, concern not
a young pair's efforts to overcome an obstacle and to get together in
something called marriage (where the obstacle is a social prohibition
generally represented by a senex figure, an older man, usually the
girl's father) but rather concern a somewhat older pair's efforts to
overcome a threatened divorce (say an inner obstacle to the mar-
riage) and to get together *again, back* together. The idea of the
genre is, according to me, that the bond of marriage has become un-

recognizable or invisible (the wedding of the pair is never shown; wedding, if shown, is always parodied, subverted, or interrupted), projecting the idea that what constitutes marriage lies not, as it were, outside of marriage (in church, state, sexual satisfaction, or the promise of children) but in the willingness for marriage itself, for repeating the acknowledgment of the fact of it, as if all genuine marriage is remarriage. In this narrative, the topic of marriage forms an essential argument of the pair that constitutes between them the state of conversation. I take the idea of this readiness for exchange as constituting marriage, from John Milton's revolutionary tract on divorce, in which he justifies divorce in terms of a conception of marriage as "a meet and happy conversation." Milton's idea of conversation is indispensably one of words but not confined to words (attested to in modern English by the word "intercourse," conversation's twin concept). It is worth hearing some sentences from Milton, whose tract, published eight years before Hobbes' *Leviathan*, hence a generation before Locke's *Second Treatise on Government*, makes the contract creating marriage an analogy of that creating society.

> He who marries, intends as little to conspire his own ruin as he that swears allegiance; and as a whole people is in proportion to an ill government, so is one man to an ill marriage. If they, against any authority, covenant, or statute, may by the sovereign edict of charity save not only their lives but honest liberties from unworthy bondage, as well may he against any private covenant, which he never entered to his mischief, redeem himself from unsupportable disturbances to honest peace and just contentment. And much the rather . . . for no effect of tyranny can sit more heavy on the commonwealth than this household unhappiness on the family. And farewell all hope of true reformation in the state, while such an evil as this lies undiscerned or unregarded in the house: on the redress whereof depends not only the spiritful and orderly life of our grown men, but the willing and careful education of our children.

Since nothing can be of greater moment to the state than combating the effect of tyranny, nor in general than reformation, nothing can be of greater moment to it than freedom from an unhappy marriage. It follows that the state at large has no solace or interest sufficient to revive one in bondage to that unhappiness. It seems to follow more specifically from Milton's descriptions that one who suffers its effects makes the commonwealth suffer in terms very like those in

which he himself suffers. The unhappiness in marriage, remember, is bondage to "a mute and spiritless mate"; now we are told that its effect on the commonwealth is a "heaviness," and that without redress from it the life of its members cannot be "spiritful and orderly," that is, life in the commonwealth is dispirited and disorderly, or anarchic. It is as if the commonwealth were entitled to a divorce from such a member, but since from a commonwealth divorce would mean exile, and since mere unhappiness is hardly grounds for exiling someone, the commonwealth is entitled to grant the individual divorce, hoping thereby at any rate to divorce itself from this individual's unhappiness. It seems to me accordingly to be implied that a certain happiness, anyway a certain spirited and orderly participation, is owed to the commonwealth by those who have sworn allegiance to it—that if the covenant of marriage is a miniature of the covenant of the commonwealth, then one may be said to owe the commonwealth participation that takes the form of a meet and cheerful conversation.

The genre of melodrama that I derive from the genre of remarriage comedy, entitling it after its most accomplished instance, Max Ophuls' *Letter from an Unknown Woman* (and including *Gaslight, Now Voyager,* and *Stella Dallas* among its members, films from the same years in Hollywood as the remarriage comedies) specifically negates this possibility of conversation between a woman and the men there are, which means that these films do not, with remarkable exceptions, end in marriage for the woman, certainly not marriage as it stands. What replaces conversation in the melodramas is a heavy, symbolic irony. These films have, on the whole, been received and remembered as tales enforcing the highest virtue of women to be noble self-sacrifice—to the needs of a man and of children, that is, as so-called women's films or tearjerkers. But it seems to me fully evident that the women in these films are shown to be possessed of the moral sensibility and intelligence from which a film derives its power of judgment, and that the power of the central woman's irony condemns the society that enforces its conforming view of sacrifice upon her. Why this counter-cultural pressure is denied by the culture that has produced these films may perhaps seem obvious. But then, how it is that this is what the films show—how they have been produced by the culture to be beloved yet to represent their own rejection by the culture, our rejected selves—opens the question of what film is.

Irony is present systematically throughout *The Marquise of O___*, no more in the overwhelming fact that the rescuer is the villain than in successive details of the narrative, such as the father's brutal rejection of the daughter's innocence by his mocking remark, "She did it in her sleep!" (p. 70) and in the mother's speculation whether the daughter really knew the man who published the reply to her appeal (p. 72). It is as if every word rebukes itself with its unconscious truth. Then the question posed by *The Marquise of O___* will be: How does the pair's conversation resume, or rather begin?

I will for a few moments follow certain immediate implications in the light thrown on the conversation of marriage in remarriage comedy by what I am calling the conversation of justice in *A Theory of Justice*.

Appeal to the conversation of justice is, as said, a recurrent gesture in Rawls's work, although it is not always as explicit as it is in the introductory chapter where the principles of justice accepted by us in the original position are said to be such that those engaged in institutions that satisfy them "can say to one another that they are cooperating on terms to which they would agree if they were free and equal persons whose relations with respect to one another were fair" (p. 13). I focus on the idea of our living under conditions in which we are enabled to say something to one another and the idea that what we are enabled to say is that we agree, or would agree, which refers to the expression of consent that a theory of the social contract must invoke. Rawls's conception of the original position, which he says corresponds to the state of nature in the traditional theory of the social contract (p. 12), is able to avoid the traditional depiction of that state (in Hobbes and in Locke, for all their differences) as a scene of violence. A great advantage of this is its role in permitting Rawls to distinguish between strict or ideal theory and partial compliance theory, the former asking what a perfectly just society would be like, the latter comprising "the pressing and urgent matters . . . that we are faced with in everyday life" (p. 8). So *A Theory of Justice* is a contribution to the theory of constitutional democracy considered as a Utopia (its rhetoric of constituting and directing institutions is sufficient indication of this); and my reservations—if that is what they are—is that the full Utopia must give a place to Perfectionism in a way Rawls seems not to leave open.

The avoidance of the context of violence is achieved in thinking of

the original contract not "as one to enter a particular society or to set up a particular form of government. Rather, the guiding idea is that the principles of justice for the basic structure of society are the object of the original agreement. . . . Men are to decide to advance [once and for all] how they are to regulate their claims against one another and what is to be the foundation charter of their society" (p. 11). But then how does this "higher level of abstraction [of] the familiar theory of the social contract" (ibid.) affect the traditional role (or myth) of the social contract in establishing my society, establishing my bond with my society, call it my identification with it? (To clarify what constitutes "identification" here, Freud would have to play a larger role than Rawls allows for him. Specifically, Rawls's principles of moral psychology build up from the law that we love what, in justice, loves us (p. 490ff.). In Freud's vision we also hate what loves us because, in justice, it also threatens and constrains us. The contract must pose a threat violent enough to overcome the violence of nature.) I suppose I do not want to accept my society "once and for all" as I do the principles of justice: society, judged by those principles, may come to forfeit my loyalty. But how would the principles carry the revolutionary potential of consent, or consent forfeited, if I did not at the same time give my consent to society?

I assume that we know in the original position that any actual society will be imperfectly just; I assume, that is, that the theory of *A Theory of Justice* is composed only with knowledge available in the original position, and it says that existing constitutions are bound to fall short of what is just (p. 360) and that "the measure of departure from the ideal is left importantly to intuition" (p. 246). The idea of directing consent to the principles on which society is based rather than, as it were, to society as such, seems to be or to lead to an effort to imagine confining or proportioning the consent I give my society—to imagine that the social contract not only states in effect that I may withdraw my consent from society when the public institutions of justice lapse in favor of which I have foregone certain natural rights (of judgment and redress) but that the contract might, in principle, specify how far I may reduce my consent (in scope or degree) as justice is reduced (legislatively or judicially). But my intuition is that my consent is not thus modifiable or proportionable (psychological exile is not exile): I cannot keep consent focused on the successes or graces of society; it reaches into every corner of society's failure or ugliness. Between a society approach-

ing strict compliance with the principles of justice and one approaching causes of civil disobedience, there is the ground on which existent constitutional democracies circumscribe everyday lives. We know what the original position has prepared us for, what the lifted veil has disclosed: the scene of our lives. The public circumstances in which I live, in which I participate, and from which I profit, are ones I consent to. They are ones with an uncertain measure of injustice, of inequalities of liberty and of goods that are not minimal, of delays in reform that are not inevitable. Consent to society is neither unrestricted nor restricted; its content is part of the conversation of justice.

Now take Rawls's claim that "the force of justice as fairness would appear to arise from two things," one of which is "the requirement that all inequalities be justified to the least advantaged" (p. 250). Here is a further instance of the conversation of justice. Can it go forward? Those who are least advantaged are apt to put up with the way things are, keep quiet about it, not initiate the conversation of justice. Their silence may be a sign of demoralization, or it may signal a belief that whatever can be done for them is being done by the normal political process. But their mood may shift drastically with events, and resentment may flare. Rawls says, "Those who express resentment must be prepared to show why certain institutions are unjust or how others have injured them" (p. 533)—another instance of the conversation of justice. Show this to, converse with, whom? It may be part of the resentment that there is no satisfactory hearing for the resentment. I assume the force of requiring justification to the least advantaged is that those of greater-than-least advantage will be easier to justify inequality to; that is, all others, say us. But is this true?

Let us take at some length a case fundamental both to the experience of the comedies and to the melodramas that I claim participate in Emersonian Perfectionism—that of Nora in *A Doll's House*. Her disadvantages are not—or turn out not to be—material ones, indeed eventually her comparative advantages turn out to be the sign of her dispossession of herself; she perceives herself in terms that align with the description Mill gives of people as having come to have no inclinations of their own. The moral importance of Nora's outrage is not confined to the manifest content of the explicit moral argument she has with her husband, concerning whether she was right to borrow money in secret in order to save her husband's life

and spare her dying father's feelings, and then to skimp household and personal expenses in order to maintain interest payments on the debt. Such an issue is the staple of domestic melodramas or, say, soap operas. In *A Doll's House* the thematics of Nora's climactic charges against her husband, Torvald Helmer, put the social order as such on notice, deploying, enchaining, among others, the concepts of conversation, education, happiness, becoming human, fathers and husbands, brother and sister, scandal, becoming strangers, fitness for teaching, playtime, honor, the miracle of change, journey or departure, the bond of marriage. The tone of her charge, while within the bounds of decorum due the man whose children she has borne and whose life she has shared, is colored by her outburst, "I could tear myself to pieces." She is outraged, dishonored, ashamed. Each of these themes or concepts of her charge also control the conversation of remarriage comedy, and various selections shape the outlook I am calling Moral Perfectionism, as thematized in the Introduction to these lectures.

My question is, Do we feel that Nora's expressions of dishonor and outrage at the state of her so-called marriage require that she be prepared to show why certain institutions (here the institution of marriage) are unjust or how others have injured her? But when Nora tries to show this to Torvald he replies that she is talking like a child, that she does not understand the world she lives in (with which she agrees and which is an essential part of her determination to leave this husband and their children). Hence it is internal to her "argument," if one may call it that, to say to him that this ending conversation is the first serious talk they have ever had, to which he replies, "Serious? What do you mean by that?" Nora has no reasons that are acceptable, and she surely knows all the reasons that can be given her. She could tear herself to pieces for having listened to these reasons all of her life, for having consented, as it were, to live without a voice in her history. Rawls says at the outset of his work, "Each person possesses an inviolability founded on justice that even the welfare of society as a whole cannot override" (p. 3). But Nora senses herself to be violated, and it is, it seems to me, violation that Emerson expresses in his totalizing remark, "Every word they say chagrins us." (It is this sense of violation that I have claimed, in effect, is at the origin of the attentiveness to or attractive reliance on every word that is the mark of perfectionist authorship, its drawing of its reader to another way.) And no one argues that the woman's

or the philosopher's violation is to society's welfare as a whole, or to anyone else's at all. On the contrary, what they sense as their violation others may see as their welfare; that is part of their sense of violation. The sense may be pathological. Emerson reports that "a valued advisor" suggested to him that his impulses, which he trusted more than "the sacredness of traditions," "may be from below, not from above" ("Self-Reliance," 149–50); and when Nora says to Torvald, "I must find out which is right—the world or I," he replies, "You're ill, Nora—I almost believe you're out of your senses." I do not quite wish to apply to Nora's case the words of the young Marx, according to which there is a position or "sphere" in society that "lays claim to no particular right, because it is the object of no particular injustice but of injustice in general" ("Towards a Critique of Hegel's *Philosophy of Right*," p. 72); and I suppose it is clear that I am not saying that all societies which intuitively depart from ideal compliance with justice should be walked out on, have the door shut upon them. This would suggest that no actual society is worthy of support—which is a view, but not mine. I am claiming, rather, that the inevitable distance from ideal compliance is not to be accommodated to by imagining an argument of right and wrong that cannot be won and should not be lost.

This means two things. It means that arguments over everyday moral issues are not ones that necessarily raise the question of society's distance from perfect justice; some such distance will be taken for granted on both sides while a conclusion and disposition are sought that allow civil life to go on in the face of broken promises, conflicts of interest, discrimination and affirmative action, abortion and euthanasia, and so on. It also means that I recognize that at some time my sense of my society's distance from the reign of perfect justice, and of my implication in its distance, may become intolerable. Then if an argument should not take place (under present conditions?), what should take its place? (I assume that constitutional debate is not here in order.)

I note that Nora feels herself representative beyond herself, beyond personal resentment as it were (I assume no one supposes her, or Ibsen, envious of the man, her husband, for whom she feels pity and contempt as well as tenderness and rage); and representative, it seems to me, beyond the sphere of women. When Torvald says that he would endure hardship for her, but, "No man would sacrifice his honor for the one he loves," her reply, "Thousands of women

have," can strike one as almost casual, as if she is pointing only to the most incontestable or visible of examples. A more general representativeness is indicated by the daringly blatant dramatic irony at the beginning of the climactic, ending conversation. When Torvald, in a fit of ultimate blindness and self-congratulation, tells Nora that he forgives her (instead of begging for her forgiveness), she thanks him and leaves; he follows her to the door from beyond which, at his questioning her, she tells him she's taking off her fancy clothes; whereupon he resumes expatiating on the genuineness of his forgiveness and her need of it as he paces outside her door, stopped only as she reappears: "What's this? Not in bed? You've changed your clothes." And Nora replies, "Yes, Torvald, I've changed." This blatant association of trivial and outer with radical and inner change, or say with what Nora will in a few moments call the miracle of change (which she says has not happened for them), and in a context in which there is a question of going to sleep, enacts, in some kind of comic ecstasy, the passage in the New Testament (1 Cor. 15:51–52); "Behold, I show you a mystery; We shall not all sleep, but we shall all be changed." The point of this enactment I take to be Ibsen's participation in a perception shared by Marx and Emerson and Nietzsche, that "the criticism of religion is the presupposition of all criticism." When Marx used those words he prefaced them by claiming that in Germany the criticism of religion is essentially complete, while Nietzsche a generation later will show it to be still beginning, as Emerson had, in effect, shown him.

If I recall the magnitude of Ibsen's standing as a writer, as measured say by his recognition by the advanced writers of the next generation, it is to warn against a hasty impulse to dismiss Nora and Torvald's case as unrepresentative of the state and aspiration of the moral life. The issue of the illustrative range of an example is no more to be taken for granted, positively or negatively, in a theory of morality than in a theory of knowledge. (The fatefulness of examples is discussed in The Claim of Reason under the title of "best cases." Cf. e.g., pp. 53–55, 329.) More specifically, it is here that the topic of theatricality, opened implicitly in the issue of shame and of the embarrassment of reason, is opened further in the conversation of justice. Rawls's idea of the "position" from which the state of society is to be viewed and judged has, so I should like to suggest, a theatrical dimension, and should thereby invoke the problematic of sympathy (say the evaluation of the other) famous from the eigh-

teenth century in the work of Shaftesbury and Rousseau (see Marshall, *The Figure of Theater* and *The Surprising Effects of Sympathy*).

I am taking Nora's enactments of change and departure to exemplify that over the field on which moral justifications come to an end, and justice, as it stands, has done what it can, specific wrong may not be claimable; yet the misery is such that, on the other side, right is not assertible; instead something must be shown. This is the field of Moral Perfectionism, with its peculiar economy of power and impotence. In moral encounter, unlike the scene of instruction in the newcomer's initiation into language and its culture, the exhaustion of justifications, the sense of something unacceptable, is reached first by the one out of authority, the position of pupil, or say victim; there is a cause, it is not dismissable as envy and not otherwise as incompetent in raising the cry of outrage. Then the alternative to persisting in the claim to be right cannot be, as in the initiating scene of instruction, to say, "This is simply what I do," and wait; which is to say, that would not provide an alternative, but a reiteration of right. The alternative would be to find myself dissatisfied with what I do, what I consent to; it is not natural to me as my language is natural to me; yet it too cannot be changed by me. Here, as society's moral representative, when reasons suddenly, embarrassingly run out, I am left in the state of impersonal shame characterized by Emerson and Nietzsche.

Then, if, as is overwhelmingly likely, I continue to consent to the way things are, what must be shown, acknowledged, is that my consent, say my promise, compromises me; that that was something I always knew to be possible; that I know change is called for and to be striven for, beginning with myself. But then I must also show, on pain of self-corruption worse than compromise, that I continue to consent to the way things are, without reason, with only my intuition that our collective distance from perfect justice is, though in moments painful to the point of intolerable, still habitable, even necessary as a stage for continued change. Nora and Torvald are on opposite sides of this pain, divided by it; and I imagine that each member of the play's audience is to see this division in himself and herself.

I think we may imagine Torvald's future in various ways, depending on how we imagine his eventual understanding of Nora. Here is a place from which we can perhaps usefully consider Rawls's

principle concerning the adoption of a plan of life: "A rational indi-
vidual is always to act so that he need never blame himself no matter
how things finally transpire" (p. 422). This is based on the idea that,
if one does "what seems best at the time [then] if [one's] beliefs later
prove to be mistaken with untoward results, it is through no fault of
[one's] own. There is no cause for self-reproach" (ibid.). This is hu-
mane advice, for certainly one may paralyze oneself with needless
and useless self-reproach. But it seems important to me that Torvald
does not so far as we are shown say this to himself, or for himself,
and that we can imagine him either as coming to this conclusion or
as refusing to. Torvald begins with some such idea ("No man would
sacrifice his honor") but he seems not to wind up in that position,
and we may for that reason feel him to have advanced. There has
been a moral shipwreck. That Torvald is not exactly personally to
blame is doubtless true enough, but how he picks up these pieces is
as morally fateful for him as Nora's leaving is for her. He can no
doubt be imagined to persist in, or return to, his initial view of her,
in her outrage, as a foolish child and as out of her senses, as if she is
to blame for the shipwreck, as if it exists only if she says it does.
That possibility suggests the consequence that disturbs me about
the advice to act so as to "insure that our conduct is above reproach"
(Rawls, p. 422), which here I am associating with the rejection of
Moral Perfectionism.

It goes back to a disturbance I express in *The Claim of Reason*
concerning a point in Rawls's early paper, "Two Concepts of Rules."
There I take exception to an analogy Rawls draws between games
and morality, according to which, for example, one can think of
someone asking to get out of a promise being cited a rule in the in-
stitution of promising, as one can think of someone asking for four
strikes being cited the three strike rule in baseball. My criticism of
the analogy was that no rule can function in the moral life as the
three strike rule functions in its game. One who asks for four strikes
in the game of baseball is incompetent at the game and can perhaps
be taught what it is. In the moral life the equivalent finality is car-
ried not by a rule but only by a *judgment* of moral finality, one that
may be competently opposed, whose content may then enter into a
moral argument, one whose resolution is not to be settled by appeal
to a rule defining an institution; a judgment, hence, that carries con-
sequences unforeseen or forsworn in games.

If I take your actions as slights or as treachery and refuse to en-

dure them any longer, this judgment is itself my response and my responsibility. Certain promises are ones a community has a stake in direct enough to legalize as contracts, e.g., ones concerning the exchange of money, rights of property, and marriage. Apart from the community's stake, you and I had an understanding—so I say; maybe you say so too, or deny it. No judge or rule knows better than we, and we have no rules that will decide the issue or that will rule one of us out as incompetent to decide. This is why there is a moral argument between us, why it has its forms. No explicit promise would have been more sacred than our understanding, or, given our supposed mutual trust, even appropriate. I may forgive you in response to, or asking for, your heartfelt apology and your promise not to repeat what (you know, knew, perfectly well) so pained me. If you repeat it I may decide you are morally incompetent and thereupon either forgive you again or break off. If I stay, it might be that I have a use for a relationship in which I feel morally superior; or it might be that I feel a certain responsibility in myself for your treachery, a feeling that might be justified or unjustified. If there are grounds on which to take the matter to court, I may or may not choose to. If I do, I have not decided to let the court tell me whether enough is enough: taking the matter to court is an expression of my judgment that it is enough. Whatever the court (or anyone in the office of umpire) decides does not enforce my judgment of you (e.g., that you are morally incompetent) but replaces my need to judge. It is another ballgame. You may feel my decision to go to court shows moral incompetency in me. Sue me. Recourse to court might not replace my need for revenge, but it modifies the form revenge may take.

Torvald's judgment, "You're talking like a child," is of Nora's incompetence as a moral agent; his judgment condemns him while the legal rules are perhaps on his side. One may object that his accusation of Nora's childishness is not a considered judgment, only a momentary outburst of pain. But the issue of *A Doll's House* is precisely that of treating a grown woman, a wife and mother, as a child. Torvald's road back begins—if, as I do, you take him to place his foot on that road—in recognizing that his former valuing of Nora was not based on his judging for himself, and bearing responsiveness to his judgment, but on the imagination of rules that, as it were, replaced his judgment. (As rules do, except at limited, specified junctures, in games. This is something that allows games to be *practiced*

and *played*, their intentions to be shaped, their consequences to be confined, scored. The limits of responsiveness are known—contract-like—in advance.) And now the whole of a society, such as Torvald is counting on, looks like a doll house, or marionette theater.

These matters ramify out of proportion to this phase of the discussion of the conversation of justice and of living above reproach. In leaving them here, I note that in my discussion of "Two Concepts of Rules" in *The Claim of Reason*, I argue against Rawls's idea that promising is an institution, saying, in effect, that it is no more an institution than is warning or cursing or beseeching or forgiving. But this leaves quite open the question—it may be all that is pertinent to my difference with Rawls on the nature of promising, which thereby becomes a side issue—why it is that promising has a relation to contracts and the law quite unlike warning or beseeching or forgiving. One might feel that promising is the basis of all institutions, the institution of institutions, perhaps something Nietzsche saw when he found the right to make promises man's true problem (*Genealogy of Morals*, p. 57). Conceive the level of this idea to be that man is the animal who can give his word, where that is a function of *having* words, that is, having language. From this perspective, looking at promising as an institution is like looking at talking as (contract-like) speech acts. But I think of the scene of instruction, in which being inclined to say, but not saying, "This is simply what I do" is the sign of a kind of promise, say of initiation into a culture, and (its) language, and (its) promises, its unattained but attainable states. (In leaving these complexities, for another time, I note that *A Theory of Justice* reasserts promising as an institution in sec. 52; and I would like to recommend on these subjects Annette Baier's "Promises Promises Promises," in *Postures of the Mind*.)

Nora's imagination of her future, in leaving, turns on her sense of her need for education whose power of transformation presents itself to her as the chance to become human. In Emerson's terms this is moving to claim one's humanness, follow the standard of the true man (what man?), to follow the unattained. I have said that this describes the work of remarriage comedy. And a conceptual environment of a woman's violation, her transformation, becoming or accepting being human, and a rejection of conversation, is a reasonable one within which to turn to *The Marquise of O____*.

Kleist's writing was in any case waiting for attention in the con-

text of ideas and texts I have been placing against one another in these lectures. *The Marquise of O____*, like *The Winter's Tale*, ends with the attainment of remarriage after the man is apparently forgiven by the woman for something apparently unforgivable he has done to her, associated in both cases with a crisis of knowledge concerning the fact of a pregnancy, of doubt raised to the point of skeptical madness. In both the comedy of remarriage and in its derived melodrama, skepticism is accommodated (so avoiding tragedy)—in the melodramas by explicit transformations of the woman's identity, associated with the presence of her child; in the comedies accommodated to in a problem of her existence whose solution one particular man is in a position to share with her, and whose need and cost seem figured by the absence of children, as if this absence signals for the woman a reserve in the investment she is prepared to make in the world and the world of men.

Kleist's writing, moreover, is quoted to the point by Nietzsche in the meditation on Schopenhauer quoted by Rawls in *A Theory of Justice* and requoted by me in my first lecture, when Nietzsche cites a notorious letter Kleist wrote in 1801 to his fiancée:

> Not long ago I became acquainted with the Kantian philosophy—and I now have to tell you of a thought I derived from it, which I feel free to do because I have no reason to fear it will shatter you so profoundly and painfully as it has me.—We are unable to decide whether that which we call truth really is truth, or whether it only appears to us to be. If the latter, then the truth we assemble here is nothing after our death, and all endeavor to acquire a possession which will follow us to the grave is in vain. (*Schopenhauer as Educator*, pp. 140–41)

Nietzsche takes this as exemplifying a danger run by one who would be the "human example" (p. 137) he takes Schopenhauer for, what I interpreted as Emerson's "true man," his "standard," "standing for humanity,"—the danger namely of "despair of the truth," (p. 140) which Nietzsche sees as a final stage of "skepticism and relativism" (ibid.).

I touch on the complex story of the Marquise of O____ just as that bears on an extreme form of the moment of morality at which the conversation of justice is stopped, where each side knows all the other knows, each is compromised by the promise of justice, and no specific wrong can be voiced and no appeal to the structure or rules of institutions is sufficient to establish right. I said the conversation

cannot go on—there is nothing to say—unless something is shown, by the one before whom the cry of outrage is raised, the one favored enough by society to represent it. It is the moment represented by the overcoming of divorce in remarriage comedy, which implies that in my view this comedy presents marriage, as in Milton's tract on divorce, as an emblem of society, in contrast to, say Locke, in his *Second Treatise*, for whom the marriage and the parental bonds contrast with the bond of society. The fact that in the comedies the couple at the end, at their reconciliation or resumption, are isolated from society, not directly reconciled to, or resuming with, society as it stands—are a rebuke to society as it stands—is an interpretation of their society. The fact of their isolation marks society as itself incompletely socialized; tolerably, but discontinuously, well ordered. We might say that between those groups or pairs bound by ties of justice, there are uncharted areas in which we remain in a state of nature, suggesting an understanding of the perfectionist's call (as in Emerson and Nietzsche) for freedom demanding a new consecration to culture (i.e., out of nature).

There are, for the principal pair of the comedies, no clear grounds for divorce; the conversation of marriage has not turned unhappy, it has stopped, perhaps turned aside, perhaps each is waiting. This is associated not exactly with anything specific the man has done to the woman, or nothing new she has to accept. In *Adam's Rib* the block is pictured as her registering the difference between a friendly slap and an unfriendly slug, the latter of which she takes offense at, as at a taint of villainy in the very fact of maleness. The conversation resumes when the man shows himself anew (perhaps in his willingness to show himself in tears to the woman or otherwise to suffer humiliation; and in his unfailing and unbullying appreciation of her) to be the one with whom for her the intelligible world is opened, her further self sought and acknowledged, the adventure of the human city undertaken. Their getting together again is neither a good thing to do as captured in Utilitarianism, nor the right or dutiful thing to do as captured in Deontology, but is the basis for them of moral encounter, of the constraint that announces the moral law, the standard attesting to the realm of ends, as developed in Emersonian Perfectionism. (The bond to the other as a function of the further self—Emerson also pictures it as the onward self—will at some stage have to be understood in contrast with bonds of narcissism—of the "mirror stage"—and those of erotic fanaticism.

Perfectionism sees and contests these bonds, which is to say: the draw toward the further self is a draw toward one's freedom, not from the chains forged by society but from the violence shaped by the lack, or the falseness, in the social, what Rousseau and Emerson call its conspiracies—say it is society's partaking of the state of nature, what perfectionists perceive as its lack of the thing they call culture—which they also describe as the natural, which is for the human an achievement.)

Eric Rohmer's film of Kleist's narrative registers the entwinement of nature and culture in its persistent juxtaposition of violence and beauty, its stiff or stylized gestures and sounds taken from war and rank, its look taken from the spotlessness of David, Ingres, Vermeer, and so on. Here is this film's general declaration of the medium of film, in its linking of modes of conquest, as a medium of the mutual shaping of representation and desire. But how does perfectionism fit Kleist's text? Not only is there a specific wrong in *The Marquise of O——*, there is a wrong of the vilest sort; nothing to *take* offense at, but something absolutely offensive, outrageous; here there is no mere "taint of villainy" but the perfect melodramatic villain, dressed in honor while in reality a violent despoiler of virtue, who surely and richly deserves the same punishment (on Deontological or on Utilitarian grounds) meted out to the rough soldiers from whom he rescued her. Yet she forgives him. How? What is the basis of it? Are we to say that this violent, obscure man, with whom this woman has refused conversation, is recognized by her to be her further self, her sign of the intelligible world, access to mutual freedom in the eventual city—that this is something a perfectionist relationship, as an origin of morality, may look like?

In the memorable closing words of Kleist's story the woman is reported (in the film, she is shown) to say to the man that he would not have looked like a devil to her then (when he appeared as the father of her child) if he had not seemed like an angel to her at his first appearance. This seems a fair announcement that he has come to represent for her the sign of the human, the human as the unstable goal of the human, as if we represent an incomplete adventure; or, as in Pascal, an unending temptation: "Man is neither angel nor beast, and the mischief is that he who would play the angel plays the beast" (cited in my preceding lecture, p. 83). It may seem luckier never to have fallen into such ideas or images; then perfectionism shows what happens when one is not so lucky. The woman's idea

seems to be precisely that what has caused her worst moments was her very perfectionism, taking that now as an aspiration to transcend the human; yet her best moments seem caused by her accepting this very aspiration, and its domestication, as the mark of the human as itself, transformed, what is to be aspired to.

But why with this man? How are they meant for one another, to share one another's fate? How can this defilement yield romance? Or is Kleist's aim just to parody romance, say to defile it, as if for its claiming the possibility, in some sense the right, to purity?

The answer must lie in the very outrage of the invisible origin of these events, the rape of the woman in her sleep, the sense of the invisible violence as confined specifically to the act of darkness, and of that violation as itself maintaining sleep. As a representation of fantasy there is a neat psychoanalytic economy that explains how for each of the pair this fantasy grants a wish: in the case of the woman it is a wish for the satisfaction of desire under conditions in which it remains unknown to herself; in the case of the man the wish is, more obviously, for the satisfaction of desire under conditions in which it remains unknown to anyone except himself, in particular unknown to the woman, the object of his desire. The neatness consists in linking the characterizations laid down in such a work as Freud's "Inhibition, Symptom, and Anxiety" according to which this woman would be characterized by hysteria and the man by obsession. This pair share a fantasy of sexuality as soiling and being soiled: the man must dirty the object (spatter mud on the swan) in order to make possible its violation; the woman must purify the object (perceive it as an angel) in order to make possible being violated by it. Otherwise sexuality is incompatible with his sense of honor and her sense of purity. Then will the woman be able to grant forgiveness because she sees they are equal? Are victim and victimizer equal?

If it is right to take *The Winter's Tale* as a representation of skepticism, in which madness is depicted as an inability to count (itself depicted as an inability to apply concepts to the world, to speak coherently) and in which skeptical doubt is represented as the denial of one's children as one's own; then the question arises as to the gender inflection of skepticism: in that text of Shakespeare's the entire drift of things is that it is the man, and not the woman, who doubts. But of course this is relative to this specific representation, with the child as object of doubt. In *The Marquise of O——* a woman doubts

in such a degree and a scope as to threaten her with madness, but her object of doubt is not her child but the identity of the father of her child. In *The Winter's Tale* the father is accepted back by the woman after he has recovered from his madness and eaten his heart out in a state of sanity for sixteen years, that is, until the child he denied and cast out is grown and reappears. In *The Marquise of O___* the father asks to be accepted after the woman has drawn herself back from the brink of madness to which his act of rape and his continued silence have driven her. What does she see as the basis of her eventual acceptance of him?

In both *The Winter's Tale* and in *The Marquise of O___* it is nothing, as it were, in the man himself that causes what we can perhaps call the woman's forgiveness of him; in both cases its precipitating cause is to secure the recognition of the child, and the absence of any sufficient expiation or recompense on the man's part seems the point of Shakespeare's romance, as if nothing but a recognition of common humanity is sufficient to achieve this virtue, as if each instance of forgiveness constitutes in small a forgiveness for being human, a forgiveness of the human race. Its role is such that their meeting of minds must not be dismissable as pathological, otherwise it is not forgiveness in question, but perhaps infatuation or a guilt that seeks punishment. So that the shared fantasy is a recognition of Freud's discovery of the traumatic nature of human sexuality as such (see Laplanche, *Life and Death in Psychoanalysis*, pp. 42, 105).

If both the man and the woman require recognition of the fact of being human, why the asymmetry in its being the woman who is to suffer and to forgive, at least to go first? One may note that in each case the woman has an older woman as companion and guardian (the Marquise has her mother, Hermione has Paulina) who is possessed of mysterious powers of perception; but this only suggests that the woman has the means to forgive, not the basis on which she offers forgiveness.

Let us compare their versions of the fantasy of human sexuality. The man's childhood story of the swan whom he spattered with mud and who dived under the water to rise pure and shining again is not hard to tell; and his telling of his associating the image of the swan with that of the Marquise during the feverish delirium of his illness, including the details of his unsuccessfully calling to the swan to get her to come to him from her haughty position on the flaming

current, is acceptable to the woman as a love story or token. (The film version emphasizes this in its most radical narrative displacement of the Kleist text, saving the end of the story for the ending exchanges of the film, showing that it is in response to the man's tale that the Marquise reveals her version of the images in terms of the devil and the angel.) That his story is an allegory of the cause of his raping her in her sleep, interpreting the act as one of revenge for her distance but also as one breaching the distance between himself and his early desire, is something the woman will have to accept if she is to accept him.

Her story to overcome distance and despoiling is not easy to tell. Everyone to whom she tries telling her conviction about her impregnation laughs at her or chastises her—the doctor, the midwife, at first her mother. Her ultimate acceptance of this man in association with the fantasy of bearing the child of a god, is not simply her explanation to herself of her otherwise inexplicable condition but is a continuation of her vision of this man as an angel; but to tell this would merely compound incredibility. There is no one to tell her story to—except to this man. But this can hardly exactly be why she accepts him back. It is rather why she rejects him when he appears in answer to her letter in the newspaper—exactly because he is a mere human being, needy in the way she is, from whom to derive understanding would be to equate her position with his, effacing heaven as thoroughly as a devil would. She accepts him back just because he has answered her summons (acknowledged his fatherhood to the world—otherwise he is no father) and because she knew who would appear. As her mother says to her: "We are such idiots—whom else but him—?" That is: She should have know him both from the fact that he had appeared to her as the angel of Annunciation heralding her sense of divine impregnation; and from the fact of his appearing in answer to her letter, since who else but one who has raped unseen would answer this summons to a humiliating confession of it? The summons continues, and satirizes, the man's honorable idea of himself as a rescuer. Accepting this, the woman will eventually accept further that he is asking for rescue from his need for perfection, as she accepts this rescue of herself from him. Thus are they one another's rejected selves, showing Moral Perfectionism to be the rescue from a false perfectionism, call it a false autonomy.

After the Marquise's devil/angel association, the film concludes

with an endtitle that takes the final sentence of Kleist's remaining two. "After a year [the Countess] consented for the second time, and a second marriage was celebrated happier than the first, after which the whole family moved to V____. A whole line of young Russians now followed the first." The notation of a second, repeated marriage is naturally a provocative detail for me, and it seems to betoken what it does in remarriage comedy—doubt about what constitutes consent and about what a contract constitutes. At the same time no film either of the comedic or of the melodramatic genre spanned by the Kleist story ends in this same way, with an eerie realization of the injunction to be fruitful and multiply. Here I can merely, in effect, list the sorts of issues that I wish to think about in connection with these events.

If, as with remarriage comedy, the conditions of the Marquise's bond of marriage form an allegory of the consent that creates modern society, its violent terms throw the possibility of a society so based into question. That the woman consents twice results in a mythologically endless family, but divulges no public life beyond that. This mystery about consent is duplicated in the mystery about contract. For the first wedding the father "submitted a marriage contract to the Count in which the latter renounced all his rights as a husband." This is a contract only a father could love, and the second wedding seems called for to overcome the contract of the first. Then there is perhaps no contract in effect, which implies that the family remains in the state of nature. What seems to be missing, for the consent to society to exist, is a political equivalent of the moment of forgiveness between the pair of romance, a kind of forgetting, as if we know from the beginning that amnesty must accompany every step in the consent to a new constitution. Another signal of the absence of society is the depiction, no less remarkable and explicit in Kleist's text than in Rohmer's film, of the father and daughter as if lovers, happily presided over by the mother, as if this family romance is what keeps the family intact. If one takes into consideration the view of Freud and of Lévi-Strauss that the creation of the social from the natural is a process in which the issue of incest is to be overcome, then, since philosophy's idea of the social contract also plays the role of creating the social from the natural, one might wish to explore the structural connection between the avoidance of incest and the myth of the social contract. (Both require giving up one

form of violence for another, more orderly form of violence, say an outer for an inner, or a private for a public; and both result in the formation of, let us say, separateness, of strangers who are not foreigners, aliens who are yet my others, whose differences are for me to take an interest in.)

These mysteries may be seen to be at work in Kleist's story if one can take it as an allegory of his response to his being shattered by Kant's making impossible the decision between truth and appearance. The Marquise's is a story in which someone shattered by skepticism—isolated by a knowledge of ignorance—finds a way back to the world by writing, specifically publishing, an open appeal to someone unnamed. This writing is not to be answered privately; when the Count tries to whisper a secret to the Marquise, presumably to explain to her his "absolute conviction in her innocence," she shrinks from him as from a fresh violation—surely a joke concerning his identification with the angel of the Annunciation and a suggestion that to use the position of intermediary for one's own private advancement is to be a devil—hence opening the possibility that all men are usurpers; let us say, unoriginal. What the Count blurts out in attempting to whisper something to her is that he is as convinced of her innocence "as if my own soul lived in your bosom." To which she cries, "Let me go." Her fleeing from him declares, in effect, that a man's omniscience is always at the price of making a bargain that deprives the woman of her separate existence, steals her own reason. However taken, the man is forced to answer the woman's public, written announcement with a public, written announcement of his own. The allegory of Kleist's response to reading Kant then takes the form of recognizing Kleist to be interpreting writing, writing that assigns itself the philosophical burden of recovering from the news of skepticism, as arising simultaneously from both positions, simultaneously an appeal and an appointment, one announcing motherhood, the other fatherhood.

It is further to the point that the Marquise's appeal is an offer of marriage, a kind of open marriage contract, and that the Count's answer is an offer of acceptance, or rather an appointment to beg to be accepted. If this exchange constitutes a recovery from skepticism, then skepticism is recognized as requiring a return of the world that has the structure not of an ignorance or uncertainty of something whose lack is overcome through its representation, but of a denial, a

violent forgetting of something whose reappearance is uncanny and may begin and recur as disappointing, hence is not a recovery of a former appearance or presentation.

A word about the significance of the idea of disappointment in what I have been saying in these lectures. The idea has come up both in connection with our relation to the criteria of our ordinary words, as well as in connection with our relation to the state of democratic existence. The relation in each case evidently has to do with the idea of, and the instability of, finding and maintaining a communal life. The connection between the epistemological and the moral threat to human existence lies in companion ways in which we give over the little crossroads of perspective and freedom at our disposal—in morality through conformity, stripping ourselves of our partiality; in epistemology through an apparently innate perverseness, stripping ourselves of our shared criteria, opting for false totalities, theories of our lives. Hitherto I have taken up these connections as between skepticism and tragedy. In the context of democracy, tragedy changes its appearance, or stage; and in the hands of perfectionist philosophers, among whom I count Wittgenstein and Heidegger— where ethics is present but is no longer a separate study—the voicing of every word that arrives, as if replacing each by itself, becomes a moral act.

But I pass to a conclusion concerning my claim that American remarriage comedies and their associated film melodramas are in conversation with their culture, of the kind they depict, an aversive conversation which is yet meet and happy, and that the moral outlook they enact is that of Moral Perfectionism, whose democratic version I locate as coming into play at the end of the conversation of justice, when moral justifications come to an end and something is to be shown.

I will say that when these perfectionists find their lives to be without justification (perhaps explicitly because they would be ashamed to argue to those less advantaged that those others are without claim against those more advantaged and that nevertheless society continues to deserve their consent from below) that then what they show is their consent to their lives, hence consent from above to the society that makes both their lives and the other lives possible. Someone may imagine that consent from above is trivial, follows trivially from the very fact of favor and fortune. But I expect others will—as I do—find this to trivialize the aspiration to democ-

racy. Consent from above is an acknowledgment of one's sense of being compromised by the persistent failures of democracy and shows the persistence of one's consent to this shameful condition of society by living now in an illustrious monarchy, hence one reachable from here (and for those of us here, only from here); which means living as an example of human partiality, that is to say, of whatever Moral Perfectionism knows as the human individual, one who is not everything but is open to the further self, in oneself and in others, which means holding oneself in knowledge of the need for change; which means, being one who lives in promise, as a sign, or representative human, which in turn means expecting oneself to be, making oneself, intelligible as an inhabitant now also of a further realm—Kant and Mill, and Nora Helmer and Tracy Lord in *The Philadelphia Story*, call this the realm of the human—and to show oneself prepared to recognize others as belonging there; as if we were all teachers or, say, philosophers. This is not a particular moral demand, but the condition of democratic morality; it is what that dimension of representativeness of democracy comes to which is not delegatable. It is the force of Emerson's endless harping on the individual as inheriting the predicates of majesty (autonomy, authority, bearing, magnetism, followers), why his message to the scholar is to raise and cheer, as if the alternative is not to be ineffectual (which one might either fear or desire), but to depress and cynicize and ironize, which in a democracy are political emotions. So that conformity is not a mere lack of community, but its parody, learning and teaching the wrong thing of and to one another. The price of liberty is our subjection to eternal vigilance. It is to withstand this consequence that the scholar cheers us.

When the Count and his wife, the former Marquise, disappear from our view, "the whole line of young Russians [who] now followed the first" may strike us as this pair's having given up on the idea of society, that Kleist as the Countess has overcome skepticism privately but Kleist as the Count has found "the effort to acquire a possession to follow us to the grave" (as he put his ambition to his fiancée) only as children "following" birth on a line to the grave. But Kleist in his story of the pair in conversation yet to my mind points to the comedy of remarriage in which, as the pair in remarriage comedies disappear from our view, the aphoristic endings of the films—of the essence of their accomplishment—turns the moment back to us, either by declaring us to be witnessing a film (the

darkening, tumbling blanket in *It Happened One Night;* the mechanical figurines in *The Awful Truth;* the collapsing skeleton of matching parts, signaling film frames, in *Bringing Up Baby;* the stilled photograph in *The Philadelphia Story)* or by telling us otherwise to mind our own business (the closing doors or curtains in *The Lady Eve* and *Adam's Rib;* the pair running from us in *His Girl Friday)*—as if the work before us is to remind us of unfinished business, in what it shows and in what it does not show. So we are challenged either to dismiss the pairs' partiality with one another— these pursuits of happiness—as illusion or in some other way irrelevant to everyday life or else to let their foundings of partiality challenge us to find our own. Thus is their meet and happy conversation meant for us, a sign of their consent to a world in which such a life can be adventured on, can be justified only by being adventured on, not denying unhappiness, not accepting it either. Then these instances of democratic art, in exemplifying change, imagining departures from our lives as constituted, from their departures from themselves as they had imagined themselves, participate in the aspirations of the highest art, and so can, of course, similarly be dismissed.

Let us give Emerson the last word. "Books are for the scholar's idle times" he says famously—but suspiciously, since a scholar just means one whose times are idle, or of leisure; hence the observation is a kind of tautology. He goes on: "When he can read God directly, the hour is too precious to be wasted in other men's transcripts of their readings. But when the intervals of darkness come, as come they must—when the sun is hid and the stars withdraw their shining—we repair to the lamps which were kindled by their ray, to guide our steps to . . . where the dawn is" ("The American Scholar," p. 68). This announces that books are exclusively, and in every word, for the going and the coming of the dark times, hence must at all times be ready to meet us then. Yet Emerson is incessantly accused, in Santayana's words, of being "impervious to the evidence of evil." Could Emerson have made his ambition clearer? To whom?

EPILOGUE

Near the close of the essay "Manners" (in *Essays: Second Series*), in what, for all we have been alerted to, might have been ending as a genial essay, contenting itself with the good Emersonian theme that manners are more important to human kind than we imagine and less important than we think, Emerson's mood breaks and he turns toward us with sudden impatience and intensity:

> But we have lingered long enough in these painted courts. The worth of the thing signified must vindicate our taste for the emblem. . . . What is vulgar, but to refuse the claim on acute and conclusive reasons?
> The king of Schiraz could not afford to be so bountiful as the poor Osman who dwelt at his gate. Osman had a humanity so broad and deep, that although his speech was so bold and free with the Koran, as to disgust all the dervishes, yet was there never a poor outcast, eccentric or insane man, some fool who had cut off his beard, or who had been mutilated under a vow, or had a pet madness in his brain, but fled at once to him,—that great heart lay there so sunny and hospitable in the centre of the country,—that it seemed as if the instinct of all sufferers drew them to his side. And the madness which he harbored, he did not share. Is not this to be rich? this only to be rightly rich?

Consider that Emerson is here identifying his writing as opening the space, and containing the bounty, of Osman who dwelt in poverty at the king's gate; hence that Emerson is claiming to be bold and free with the "Koran," which is an Emersonian way of naming any bible or book eminently worth study, and that the disgust this causes officials, even official beggars, allows him to be hospitable to the mad; that "the instinct" that draws sufferers to his side is to be contrasted with the news of the king's court on the other side of the gate, hence wall; that the instinct is a tropism of his affinity with their suffering, and his richness an ability not to share "the madness which he harbored," say not to communicate it further, as it sits, not to be driven mad by it, but to air it, sun it; that if what is written as his essays, in his call for philosophy and his competition with it and his parodies of it, is after all philosophy, then a condition of philoso-

127

phy, of this thinking, is the willingness to host an ecstasy in the midst of madness—so that the claim that Emerson is too cheery, hence does not know suffering, is a further invitation to him to madness; that then the question is open in Emerson as to whether in challenging philosophy we are to understand philosophy as a prize to be won for America from Europe, or whether we are to regard philosophy as the great European construction of thought which, as such, our thinking is to overcome, or whether there is an American philosophical difference to be contributed in philosophy's further construction; and hence that the question is kept open as to where philosophy occurs, what it looks like, at which gate it sits, in the intellectual economy of a nation. Who asks this to be considered? Of whom? Who knows what who is?

HOPE AGAINST HOPE

This is a most happy occasion for me and I do not wish to mar it by speaking of unhappy things. But I will not belittle it by using it to speak of anything less than what matters most to me as a teacher and a writer and a citizen. One of these matters I share in common with every thinking person on earth, the imagination, or the refusal of imagination, of nuclear war, the most famous issue now before the world. Another matter is, in comparison, one of the most obscure issues of the world, and I share it, at most, with a few other obscure persons, the inability of our American culture to listen to the words, to possess them in common, of one of the founding thinkers of our culture, Ralph Waldo Emerson, an inability which presents itself to me as our refusal to listen to ourselves, to our own best thoughts. The particular odd matter I am moved to speak about by this occasion—on which a faculty is gathered to honor students, before their proud families, joined gratefully by me together with my family—is how this famous matter of destructiveness and this obscure matter of the repression of thinking have conjoined in my mind.

The precipitating cause of this conjunction was my coming into two sets of documents over the past summer. The first set consisted of two essays on Emerson published last year, one by one of our most influential literary critics, Harold Bloom of Yale, the other by one of our most prolific and celebrated novelists, John Updike. The second set of documents consisted of material concerning a form of Christian fundamentalism that believes nuclear war will be the fulfillment of the biblical image of Armageddon as given in the book of Revelation, that accordingly a final war is scheduled between us and our enemies in which the stakes are the victory of cosmic good over cosmic evil. (If you disagree with, or disapprove of, what I will be saying, I hope you can at least regard it as of a certain interest in showing the kind of heaping and hooping together of contrary appeals and protests and accusations and denunciations that compete for our attention every day, each asking for the loan of our voices because each is demanding the right to speak for us. It seems that the more total our access to information becomes, the more complete becomes our ignorance of why it is given us, over what it means, over whom to believe, and over what fruitful action we could take on

This address was composed for and delivered at the honors convocation at Iona College in October 1985. The published form of the text given below is reprinted from the January/February 1986 issue of *The American Poetry Review*.

its basis.) Since President Reagan is reported on a number of occasions to have endorsed this fundamentalist view—sometimes called "end-time theology," the view that in our time we will see the end of time—it is understandably a question for many of us whether his administration has the will and the taste to muster and be constant to whatever practical wisdom is within human command on the subject of nuclear war. The material on endtime theology was sent to me at my request by a friend and student of religious education who has enlisted in the labors of nuclear education. I should say at the outset that I agree with the sense of many of those similarly enlisted, to whom I feel indebted, that the idea of a final nuclear war as God's own instrument and plan for human kind is an expression of despair. This will hardly imply that we have nothing to fear; on the contrary it implies that despair, always a mortal temptation, is now itself a mortal danger, since it is precisely a climate of despair that will ease the fulfillment of our worst fears.

This is where the repression of Emerson's thinking comes into mind, for it was precisely despair that was the climate in which Emerson felt he wrote and which his writing was meant to withstand and disperse. He calls this mood "silent melancholy." His disciple Thoreau, sharing the vision, called it "quiet desperation" and said famously that this is the life led by the mass of men. I imagine that some of you will wish to reply in something like the following way: "But now things are different. In Emerson's and Thoreau's day there were many things to be feared but there was no external cause such as we now living have for hopelessness. For them it still made sense to say that the external threats of life do not cause despair, that on the contrary despair is itself the ultimate spiritual threat. Emerson could say: The office of the scholar is to cheer and raise us; the post of the poet is the delight in common influences, so that their metamorphosis through him excites in us an emotion of joy. But for us, an Emersonian cheerfulness and hopefulness would simply express a childish ignorance of our real situation." The trouble with this reply is that it was always the reply to Emerson; he is forever taken by his detractors, and not by them alone, to ignore the tragic facts of life. Whereas Emerson seems to take despair not as a recognition of life, not even a tragic recognition of it, but as a fear of life, an avoidance of it. I persist in thinking this is correct, then and now.

Call this my (American) faith. It is not optimism. I see that I hang on to it as for dear life in one of the first essays I wrote that I still use, just over twenty years ago, concerning the interplay of what may be called literature with what may be called philosophy, a reading of Samuel Beckett's play *Endgame*, first performed in the mid-1950s, a play that pretty obviously takes place at some end of the world, among the survivors of some holocaust. I quote a few lines from myself of twenty-one years ago: "*Endgame* [suggests] . . . that we think it is right that the world end. Not perhaps

morally right, but inevitable; tragically right. In a world of unrelieved help-lessness, where Fate is not a notable [trio of] Goddess[es] but an incon-spicious chain of command, it would be a relief to stop worrying and start loving the bomb." This does not deny that our times are different from Emerson's times but it suggests that their differences lie not in our occasions for despair but in our means for expressing and enacting it. To quote one more sentence from my essay on Beckett's *Endgame*: "The Bomb has final-ly provided our dreams of vengeance, our despair of happiness, our hatreds of self and world, with an instrument adequate to convey their destruc-tiveness, and satisfaction." The idea is that world-destroying revenge is a kind of despair caused by an illusory hope, or an illusory way of hoping—a radical process of disappointment with existence as a whole, a last glad chance for getting even with life. It frightened me then to find myself hav-ing such thoughts, and now the organized cultivation of the wish for the end of time works to harden the fright.

Is Emerson really up to finding the measure of hope even here? To an-swer this I have to specify how I find what I called "our best thoughts" are to be discovered in Emerson. It will depend on seeing his words as those of something like a philosopher. Since that form of accuracy is generally not granted him, I will need to say why I insist upon it.

When I spoke, interpreting Beckett, of the Bomb as satisfying our dreams of vengeance, I was taking it that, for example, Nietzsche had spot-ted our vengefulness, our gloomy self-destructiveness, about as near the end of the nineteenth century as we are near the end of the twentieth, in his prediction, or warning, of nihilism, the will to nothingness. And near the end of the century before Nietzsche's, in 1794, Immanuel Kant, in an essay I had quite forgotten until the thoughts I am reporting on here led me back to it, very fully expressed his offense both as a philosopher (which I share) and as a Christian (which I am not in a position to share, but to admire and rejoice in) at the efforts he saw around him to link the end of the world to human means. Kant's essay is entitled "The End of All Things" and it un-dertakes to show, as the author of the monumental *Critique of Pure Reason* might be expected to do, that the idea of an apocalyptic end of the world is absolutely unknowable by us (exactly as unknowable as the ultimate nature of the world or of ourselves). It is unknowable exactly *because* the end of all things implies the end of time, and the human capacity for *knowledge* takes place only *within* time as one of its necessary conditions. The end of time is, however, according to Kant, *conceivable*; it is not a meaningless idea; and moreover the idea in its generality—only in its generality—is necessitated by human aspiration itself. Our moral and religious natures *must* aspire to the perfection for which they have been created, and they *must* understand themselves as capable of changing in the direction of perfection; and this perfection has in view the goal and end of moral struggle. Moral struggle,

however, cannot end within time, in which change is called for; so the human being is bound to conceive in some way or other of an end to change and an end to struggle, and hence in some way of an end to time. But for Kant this moral struggle is an inner one of each soul with itself, in its fallenness, so that any apocalyptic end must be taken as an allegory or figure of that struggle, not as moral literalized outer substitute for it. To know the conflict between the allegorical or figurative and the literal may be taken as the first lesson of reading. So to learn reading has now become a matter of literal life and death. Preachers of nuclear "end-time" theology pretty clearly believe that there will be change *after* the war they speak of, so it is not the end of time, not the final war, they are imagining, but just the end of one more war; and they are not imagining the end of a nuclear so-called war because they speak of a group of exceedingly contented survivors of their war.

But to suppose that the human being can know or seriously predict what the end of days will be, as we can know or predict the end of a given day, is for Kant, as said, not only philosophically offensive but Christianly offensive. This is because it leads men to imagine that they can fashion the human means of bringing about God's purposes for human kind. "The end of all things which pass through men's hands even if their purposes are good is folly, i.e., the use of means which are opposed to the purposes they are supposed to serve. [This] practical wisdom . . . abides alone with God." Moreover, the result of taking the means into human hands Kant says will destroy the hope of Christianity. "If Christianity promises rewards . . . as if it were an offer to bribe, as it were, to exhibit good conduct; . . . Christianity would not be worthy of love. Only a desire for such actions as arise from disinterested motives can inspire human respect toward the one who does this desiring; and without respect there is no true love." The result will be that "Christianity, though indeed intended to be the universal world religion, would not be favored by the workings of fate to become so, and the (perverse) end of all things (in a moral point of view) [i.e., an end of all things for which we are responsible, not God] will come to pass." So how can we translate God's wisdom, as to his purposes for us, into human practical wisdom? Kant's advice is to recognize that the hope of securing ourselves against the folly of supposing ourselves to have laid hold of God's plan lies only "through trials and frequent change of plans" and "as fellow citizens [not through the exercise of authority, to]draw up plans and agree on them for the most part, [to] demonstrate in a trustworthy way that truth is of concern to [us]."

From Kant to Emerson is an immeasurable step. Emerson himself took the step in one direction saying that the title Transcendentalism, which names what he calls his and his friends' American Idealism, comes directly from Kant's use of the term Transcendental. In saying that the step is im-

measurable I mean that we are in no position to measure it. In the first of what is becoming a set of essays of mine in which Emerson figures prominently, I say that he "challenges the basis of the argument of the *Critique of Pure Reason*," indeed that he is therewith challenging philosophy as such. I also say that to challenge philosophy is something the major modern philosophers since Descartes and Locke have typically done, but I recognized that almost no one would now grant Emerson the intellectual stamina to challenge Kant philosophically. If he indeed were entering a challenge to Kant it could only be on some literary or spiritual ground or other. I also say that if—as uncontroversially, in our century, Martin Heidegger and Ludwig Wittgenstein do—you challenge philosophy philosophically, then the answer to the question whether what you are composing is or is not philosophy is necessarily unstable. (If you challenge philosophy as such how can what you are doing remain philosophy? But if what you are doing does not remain philosophy how can it challenge anything philosophically?) Anyone who considers Emerson will want to know what kind of writing it is that Emerson has produced. My answer, in effect, is that since the answer to this question, to be correct, must be unstable, and since this instability is a function of Emerson's challenge of philosophy, this instability constitutes Emerson's capture of philosophy for America. (My effort is accordingly not to ask us to restrict our intellectual attention to our native writers but to recognize Emerson, in founding thinking for America—discovering America in thinking—as finding our own access to European thought).

So I was likely not to be satisfied with the recent essays I have cited by Harold Bloom and John Updike, both of which turn the title of philosopher from Emerson; both of which question Emerson's essays as pieces of writing without allowing that writing itself to recognize the question and to participate in it; and both of which—most astoundingly to me—pretty much on the whole take what Emerson says at face value, without supposing the demand of interpretation. Their similarities on these and other points are the more notable since Bloom loves Emerson and he has put us in his debt for having done as much as anyone has done in the past two decades to bring Emerson back to his culture's attention; whereas Updike is one more in the line of artful detractors of Emerson who from time to time are moved to get him in perspective by condescending to him. Bloom's praise of Emerson is not exactly praise for the wrong reason, but let me say for a stinted reason, and this, I cannot but feel, helps to keep condescension toward him in respectable orbit. It helps to keep our culture, unlike any other in the West, from possessing any founding thinker as a common basis for its considerations. If one were to say, truly enough, that Emerson is himself responsible for his disreputable, or overly reputable appearances, then I say that Emerson should be the first for us to enlist in understanding that about him. He may, for example, exactly wish to write in order to deprive us of a

philosophical founder, of all foundation of a certain sort. This may not, well understood, exactly be a bad thing. But it is an uncannily philosophical thing.

As evidence for Emerson's demand of interpretation, take the famously quoted passage from "Self-Reliance" which both Bloom and Updike requote (Bloom a little more extensively):

> Then again, do not tell me, as a good man did today, of my obligation to put all poor men in good situations. Are they *my* poor? I tell thee, thou foolish philanthropist, that I grudge the dollar, the dime, the cent, I give to such men as do not belong to me and to whom I do not belong. There is a class of persons to whom by all spiritual affinity I am bought and sold; for them I will go to prison, if need be; but your miscellaneous popular charities; the education at college of fools; the building of meeting-houses to the vain end to which many now stand; alms to sots; and the thousandfold Relief Societies;— though I confess with shame I sometimes succumb and give the dollar, it is a wicked dollar, which by and by I shall have the manhood to withhold.

Updike at once replies, "A doctrine of righteous selfishness is here propounded." Bloom takes a little longer to say so, stopping first to remark that "Emerson meant by his 'class of persons' such as his friend Henry Thoreau, the mad poet Jones Very, and his precursor, the Reverend William Ellery Channing, which is not exactly . . . Ronald Reagan, and the Reverend Jerry Falwell." But Bloom continues: "Self-Reliance translated out of the inner life and into the marketplace is difficult to distinguish from our current religion of selfishness, as set forth so sublimely in the recent grand epiphany at Dallas" (i.e., I imagine, the last Republican National Convention).

Was *selfishness* so much more clearly in evidence at the Republican than at the Democratic national convention? And is Emerson really so difficult to distinguish from those who may be taken as parodies of him? Not so difficult, it seems to me, apart from a suspicion that his parodists may just be right about him: Bloom says that "Emerson is more than prepared to give up on the great masses that constitute mankind"; but then where does Emerson expect his readers to come from, and why does he write as he does, which so often offends what you might call the elite, the educated classes? One may well feel that Emerson leaves himself too open to the purposes of his parodists; then that should specifically be understood and assessed. Let's look at the passage I just again requoted. Emerson does not say he does not give to the poor; on the contrary he says he does (sometimes he succumbs, he says; no one, I suppose, gives to *every* cause that presents itself). Nor does the difficult question "Are they *my* poor?" imply that he recognizes *no* poor as his for charity; on the contrary the question implies that some poor *are* his. Thoreau and Jones Very are no doubt among those whom Emerson would say he belongs to and who belong to him. They are his, his equals let us say; which suggests that a charitable dollar is wicked because it is given to unequals, because it supports what it is that keeps them down; which fur-

ther suggests that when Emerson adds of the wicked dollar, "which by and by I shall have the manhood to withhold," he does not exactly mean that he will further harden his heart but that by and by he will live in a society that has achieved manhood, that one day human kind will not require the dole from one another. So to style such as Thoreau, Very, and Reverend Channing as his poor seems arch.

To see who Emerson's poor are we can adduce the sentences preceding the ones I quoted, perhaps no less familiar:

> I shun father and mother and wife and brother when my genius calls me. I would write on the lintels of the door-post, *Whim*. I hope it is somewhat better than whim at last, but we cannot spend the day in explanation. . . . Then again, do not tell me . . . of my obligation to . . . all poor men.

Shunning father and mother is what Jesus required of who would belong to him, and in that context the cry of the poor is of those that you have always with you ("but me ye have not always," John 12:8). The spirit in which that is said has always demanded interpretation and is itself appropriatable for selfish ends. It no less requires interpretation in Emerson's case, unless one supposes him not merely righteously selfish but a moral lunatic, raising the issue of the poor only in order to glory in his riches. Emerson addresses his remark about the poor to "thou foolish philanthropist"; Jesus' remark about always having the poor with you was addressed to Judas Iscariot, who had just criticized Mary, the sister of Martha and Lazarus, for anointing Jesus' feet with costly ointment. Judas was there undertaking to instruct Jesus in the claims of charity. Emerson is accordingly placing the most extreme pressure on his discernment of when and where to encounter the poor.

Emerson's poor are those to whom he has preached poverty and who have listened to him. These are ones he calls (American) scholars, to whom he had given warning in his earlier, most famous address to them:

> The office of the scholar is to cheer, to raise, and to guide men by showing them facts amidst appearances. . . . Long he must stammer in his speech; often forego the living for the dead. Worse yet, he must accept—how often!—poverty and solitude. For the ease and pleasure of treading the old road, accepting the fashions, the education, the religion of society, he takes the cross of making his own, and, of course, the self-accusation, the faint heart, the frequent uncertainty and loss of time, which are the nettles and tangling vines in the way of the self-relying and self-directed; and the state of virtual hostility in which he seems to stand to society, and especially to educated society.

Are these the accents of selfcongratulation to be heard in the kind of Dallas event Bloom cites from which he says it is difficult to distinguish Emerson's view? Bloom speaks of Self-Reliance as "the American religion [Emerson] founded." Emerson's casting his genius figuratively in the role of Jesus, whose severe call he obeys, supports the idea; but Emerson's figuration

here, while drawn in deadly earnest, at the same time shows him laughing at himself, at the position history has prepared for him. As he is laughing, and in deadly earnest, when he imagines writing Whim on the lintels of the door-posts. Performers at political conventions of the sort Bloom imagines, and those who prophecy world doom for their enemies and escape for themselves, are not laughing at themselves. To put writing on the door-post is the Old Testament command specifically at the time of Passover, as a sign to the angel of death to pass the house and spare its first born; and generally to put writing on the doorpost is a sign of faithfulness to God's command to "lay up these my words in your heart and in your soul and . . . write them upon the door posts of thine house" (Deuteronomy 6 and 11). Emerson's laughing use of Whim is a stumbling block to the perception of him, and he surely meant it to be. Here is Updike:

> Totalitarian rule . . . offers a warped mirror in which we can recognize, distorted, Emerson's favorite concepts of genius and inspiration and whim; the totalitarian leader is a study in self-reliance gone amok, lawlessness enthroned in the place where law and debate and checks and balances should be. . . . The extermination camps are one of the things that come between us and Emerson's optimism.

Quite apart from this whimsical picture of totalitarian leadership, how is Emerson recommending so much as the private breaking of law in his passage about writing Whim? (When he does recommend disobedience to law there is no doubt about it, as in his outraged denunciation of the Fugitive Slave Act, whose support by Daniel Webster Emerson took as a betrayal of principle.)

Take three facts about the picture Emerson sketches for us: that when his genius calls him he shuns family ties; that what it calls him to do he cannot explain beyond writing Whim in a place of his own that is both public and dedicated to the sacred; and that what he does under that sign is done in hope ("I hope it may be better than whim at last"). What I understand him specifically called by his genius to do, on the occasion on which he writes Whim, is exactly to *write*—it is what he does, it constitutes his part in all our encountering of him; the passages before us are accordingly precisely what has become of his hope that his writing will be better than Whim at last; and self-evidently *before* he produces his words in hope and notes their effect (their effect as creating their own readers, which may or may not include his relations) he cannot post them as the justification for producing them, and what more can he *say* beforehand, before finding his words, than to stammer "Whim" and "hope"? If he *knew* he could produce inspired writing whenever he closed his door to his mother and father and wife and brother and miscellaneous relief societies and listened alone to his genius and wrote—if he *knew* this he would not require hope. But then why raise the issue of the poor at all?

I have mostly given my answer, that Emerson asserts that what he is withdrawing in order to do is done for the poor. This announces his act as moral, as announcing moral principles whose application will rebuke those who rebuke him for failing his moral obligations. There are two complementary moral principles implied in Emerson's scene. One is: to claim that an action is so important that you must shun your domestic obligations to perform it, you must be able to communicate the hope in which it is undertaken and you must be ready to declare publicly that you are without further explanation, or authority. A public declaration of your uncertainty will limit what it is you can ask people to do, and subject them to. You will have, if you are in political power, to take those over whose lives you have the power of life and death into your confidence. Speaking in confidence is the precise opposite of speaking in slogans and out of untold secrets; in confidence is the way to speak to fellow citizens. The further principle is: to claim your action as called out by your genius you must be comprehensible as serving the poor; the action must weigh itself at every moment against the visible suffering of the world. These seem to me principles on which I would be happy to see those in political power over us act upon.

Do I press Emerson's meaning further than his words warrant? Updike says that Emerson's discourse is disconnected and that his affrontive assertions mark "the creation of a new religion"; and Bloom's calling Self-Reliance Emerson's American religion says of him that "by no means the greatest American writer, perhaps more an interior orator than a writer, he is the inescapable theorist of virtually all subsequent American writing." But Bloom, for all the magnificence he allows Emerson's achievement, leaves the achievement incomprehensible by the implicit denial that Emerson is capable of comprehending his own writing, I mean accounting for it philosophically. My insistence that Emerson's achievement is essentially a philosophical one concentrates a number of claims. (1) His language has that accuracy, that commitment to subject every word of itself to criticism, endlessly, with nothing held safe, that is the blessing or the curse of philosophy—it is not a commitment religion may make, sometimes to its credit, sometimes not. (2) "Self-Reliance" in particular constitutes a theory of writing and reading whose evidence its own writing fully provides, before its role in subsequent American writing, and without which its role is incredible, as for many people it must always be; it before all describes its own prose, asserts itself as the foundation of its own existence, as Descartes had asserted *his* argument for self-reliance, his *cogito ergo sum*, as his foundation for his existence, hence as the basis of his philosophy. Emerson broadly alludes to Descartes's *cogito* argument, virtually repeats it—"I think," "I am" Emerson says in "Self-Reliance," or rather rebukes us for failing to say—another fact unnoticed, I believe, because of the endlessly repeated rumor that Emerson was not much of a thinker. (How *eager* his culture has

been, top to bottom, to nourish this rumor! What's in it?) (3) The relation of Emerson's writing (the expression of his self-reliance) to his society (the realm of what he calls conformity) is one, as "Self-Reliance" puts it, of mutual aversion: "Self-reliance is the aversion of conformity." Naturally Emerson's critics take this to mean roughly that he is disgusted with society and wants no more to do with it. But "Self-reliance is the aversion of conformity" figures each side in terms of the other, declares the issue between them as always joined, never settled. But then this is to say that Emerson's writing and his society are in an unending argument with one another— that is to say, he writes in such a way as to place his writing in his unending argument (such is his loyal opposition)—an unending turning away from one another, but for that exact reason a constant keeping in mind of one another, hence endlessly a turning toward one another. So that Emerson's aversion is like, and unlike, religious conversion. (4) His prose not alone takes sides in this aversive conversation, but it also enacts the conversation, continuously creating readings of individual assertion that mutually turn from and toward one another (for example, the poor as rejected, his poor as embraced; the writing of Whim as the decision between life and death; the preaching of aversion as what Kant called a trustworthy demonstration of our concern for community and truth). This is perhaps what most immediately gives to Emerson's prose its sometimes maddening quality of seeming never to come to a point. It is one of Updike's chief complaints about the prose; Bloom forgives Emerson for it. But for me Emerson's prose enacts in this way the state of democracy—not because it praises the democratic condition we have so far achieved but because its aversive stance toward our condition only makes sense on the assumption of democracy as our life and our aspiration. Only within such a life and aspiration is a continuity of dialogue with one another, and with those in power over us, a possibility, and duty. What could it mean to find in Emerson our founding thinker and not find in him this founding aspiration?

When Emerson teaches that actions we take to define our lives, on which we stake the life and death of our families and our societies, should be taken in hope and on such claim to authority as only we alone, in our uncertainty, can bring to it, he is teaching what Kant called practical wisdom. It gives me hope—if small in our dangerous world, still concrete, clear, persistent, as large as my difficult sensibility can absorb. He tells me that those who have power over us, who do not communicate to us their persistent hope of peace, are despairing of peace, and are placing what they call their hope in a favorable roll of scientific or magic dice. This is no more genuine hope than praying for such a favorable outcome is genuine prayer. They are caught by their power, by their images of themselves, by what they believe to be their public's expectations of them, our expectations. We must help to teach them otherwise, teach them hope, and first one another.

Appendix B
A COVER LETTER

To members of the Jerusalem workshop on Institutions of Interpretation.
A cover letter from Stanley Cavell. May 15, 1988.

If "institution" speaks of the setting (up) of something; and "interpretation" speaks of ways of taking something already set; then "institutions of interpretation" speaks of ways of placing what is placed. And it asks immediately whether our ways of placing are themselves already setups.

The text I am submitting as my contribution to our discussions at this stage is a version of the first of three lectures (circling Emerson) delivered to the American Philosophical Association earlier this spring. Writing my lectures also in anticipation of our Jerusalem meetings, I imagined that some brief words of placement would prepare the material for our purposes. Now I find otherwise, but it is too late to do more than hope for the best.

What I might call the given rhetorical situation of my lectures for the association was my odds with the profession of philosophy, expressed by some roughly public sense of my stance as questioning the institutionalization of the study of philosophy (in American universities), and, specifically, by my roughly private sense of this institutionalization as, on the whole, taking Wittgenstein and Heidegger to be more or less incapable of interpreting themselves philosophically—and, a fortiori, incapable of interpreting philosophy for its profession (in America?). Take this as saying that even for those who regard Wittgenstein and Heidegger as useful or interesting writers or thinkers, even of genius, they would not, on the whole, be taken as paradigmatic of what serious philosophy should look and sound like. My suggestion to the association that Emerson can be taken to lie back of both writers would fashion—to the extent it is picked up—the given rhetorical situation into a choice of interpretations: either an intensified institutional refusal of philosophical authority (or paradigmatic status) to Wittgenstein and to Heidegger, or a warranting of a certain institutionalization of Emerson as a philosopher. Would I dream that the institutions of the institution of philosophy (its self-differentiations from other disciplines of scholarship, communication, publication, lecturing, credentialing) would hence be forced or enticed to question themselves?

Within the American institution of philosophy, dominant strains in the investigations, both of the idea of interpretation and of the idea of institutions, oddly share a common site—the idea of a rule. (Perhaps this expresses the legalism of American culture.) John Rawls's *A Theory of Justice*, which has, for two decades, dominated the English-speaking contribution to

political and moral philosophy, is worked out on the basis of a conception of institutions as defined by rules (before all, in my view, on a view of promising as such an institution); and Saul Kripke's *Wittgenstein on Rules and Private Language* takes Wittgenstein's *Investigations* to be based on a skeptical idea that rules are infinitely interpretable, hence that anything that happens can be made to accord with or to conflict with a prospective rule. The second and third of my Carus lectures focus, respectively, on these texts of Kripke and of Rawls, in each case finding them to accept or to reject, let us say, a foundational role of rules that fatefully shapes the outcome of their views of language and of just human relations, and which both (though Rawls less directly) associate with Wittgenstein's teaching (a view of Wittgenstein that denies, to my mind, his most fervent demotion of rules, but which seems to be the price of taking him with institutional seriousness, say of disciplining him).

How Wittgenstein sees rules (in particular the question whether "every action according to the rule is an interpretation" [*Investigations*, sec. 201]) will have, I imagine, to be put in conjunction with Wittgenstein's controversial and difficult study of "seeing as" in part 2 of the *Investigations*, which he identifies as a study of interpretation: "But we can also see the illustration now as one thing now as another.—So we interpret it, and see it as we interpret it" (p. 193). This identification is in turn to be put in conjunction with Heidegger's perception that "the 'as' makes up the structure of the explicitness of something that is understood. It constitutes the interpretation" (*Being and Time*, p. 189). The issue is, for both Wittgenstein and for Heidegger, however differently, to elicit the conditions under which "interpretation" is a possible and necessary interpretation of what knowing (or truth) is.

A particular point of interest for us, concerning this shared "as" of interpretation, comes out if we think of Wittgenstein's too-famous example of the duck-rabbit. Of the seven features of this figure I verify in *The Claim of Reason* (p. 354), I note these: that one interpretation exists in opposition to another; the shift from one perspective or standpoint to the other is subject to our will, although what we see from each standpoint is not; that the opposition is total, that one interpretation *eclipses* another, annihilates it—until it returns with its own annihilative power (or weakness). One of Emerson's images for interpretation is that of a circle around which another can be drawn. The interpretation of interpretation as an eclipsing, total choice (say of a point of centering, as if marking out sacred ground) is as a choice between the most intimate of contested grounds, as between brothers. This interprets interpretation as a claim to inheritance, to a birthright. In view of Wittgenstein's puzzling over whether "I really see something different each time or only interpret what I see in a different way" (*Investigations*, p. 212), it may be worth noting that "interpretation" and "experience" share a root in the idea of going or passing or leading (per-

ilously) toward, through, or over. (This shared root leads toward, or from, my approach to Emerson's "Experience" in *This New Yet Unapproachable America*. Parenthesis added 1990.)

I spoke of my fantasy that a few preparatory words (about Emerson) would establish the pertinence, even usefulness, of my contribution to our proceedings. They would have begun with Emerson's identification of his writing (among his caduceus-helix of other identifications) as his "constitution," the task of which (for his America) is to transfigure institutions of conformity, from what is called America into an America as unapproachable, or forbidding, as the human form of life called thinking. But the words of preparation quickly ran out of sight; the story proved to be no more to be hurried than it is to be anticipated. For what has to be told about Emerson's placing of our places, of our placing what is placing us—the recounting of our accounts, the transforming or deconforming of our conformities— (now just confining ourselves to passages of "Self-Reliance" on the way from "The American Scholar" to "Experience") can be put in two stages:

1. Emerson's question is: After our destitution from the prostitution of our constitution by the substitution for it of these institutions, what restitution?

2. Emerson's answer is: Understanding our substance in its circumstance acknowledges a partiality for standing upright with our hands with opposable thumbs placing a standard whose measure draws us to a standpoint from which to recount or to retake our stance, to inscribe a new circle around every circle we stand in and stand for; as if we are already free, outside each enclosure (but not therefore outside every enclosure).

I would not, I think, place things this way before the association to which I initially delivered the Carus lectures. Is this because I would not dare to, or because I would not see the point of doing so—would not, that is, believe the association would take the point, so placed? Then is the way I wound up placing things in those lectures meant as a preparation for approaching what I just now called Emerson's question and answer?—as if the prose of those lectures was a burden I accept (as of trials or dues) in order to have the right to be heard? But to whom would I address such a query? On whom do I confer the right to answer my question of right, to whom shall I defer my right? To one who recognizes how institutions are burdens, or to one who does not? Who is one? Then perhaps, to which institution do I address my query about, let us say, the institutions of queries and of trials and of permissions and of dues? There are no tales out of school. So how do we imagine otherwise?

BIBLIOGRAPHY

Aiken, Henry David. *Reason and Conduct: New Bearings in Moral Philosophy.* New York: Knopf, 1962.

Aristotle. *Nicomachean Ethics.* Translated by Terence Irwin. Indianapolis, Ind.: Hackett Publishing, 1985.

Arnold, Matthew. *Culture and Anarchy.* Edited and with an introduction by J. Dover Wilson. Cambridge: Cambridge University Press, 1986.

————. "Dover Beach." In *Dover Beach.* Edited by Jonathan Middlebrook. Columbus, Ohio: Charles E. Merrill, 1970.

Augustine. *The Confessions of St. Augustine.* Translated by E. B. Pusey, with a foreword by A. H. Armstrong. New York: Dutton, 1970.

Austin, J. L. *How to Do Things with Words,* 2d ed. Edited by J. O. Urmson and Marina Sbisa. Cambridge, Mass.: Harvard University Press, 1975.

————. "Ifs and Cans." In *Philosophical Papers.*

————. "Other Minds." In *Philosophical Papers.*

————. *Philosophical Papers,* 3d ed. Edited by J. O. Urmson and G. J. Warnock. Oxford: Oxford University Press, 1979.

————. "A Plea for Excuses." In *Philosophical Papers.*

————. *Sense and Sensibilia.* Reconstructed from the manuscript notes by G. J. Warnock. Oxford: Oxford University Press, 1962.

Baier, Annette. *Postures of the Mind.* Minneapolis: University of Minnesota Press, 1985.

Bankei. *The Unborn: The Life and Teachings of Zen Master Bankei.* Translated and with an introduction by Norman Wandell. Berkeley, Calif.: North Point Press, 1984.

Beckett, Samuel. *Endgame.* New York: Grove Press, 1958.

Bloch, Ernst. *The Utopian Function of Art and Literature.* Translated by Jack Zipes and Frank Mecklenberg. Cambridge, Mass.: MIT Press, 1988.

Bloom, Allan. *The Closing of the American Mind.* New York: Simon and Schuster, 1987.

Bloom, Harold. "Mr. America." In *The New York Review of Books,* November 22, 1984.

Cavell, Stanley. "The Availability of Wittgenstein's Later Philosophy." In *Must We Mean What We Say?*

————. "Being Odd, Getting Even." In *In Quest of the Ordinary.*

————. *The Claim of Reason: Wittgenstein, Skepticism, Morality and Tragedy.* Oxford: Oxford University Press, 1979.

————. "Declining Decline: Wittgenstein as a Philosopher of Culture." In *This New Yet Unapproachable America.*

143

————. *Disowning Knowledge: In Six Plays of Shakespeare.* Cambridge: Cambridge University Press, 1987.

————. "Emerson, Coleridge, Kant." In *In Quest of the Ordinary.*

————. "Ending the Waiting Game: A Reading of Beckett's *Endgame.*" In *Must We Mean What We Say?*

————. "Finding As Founding." In *This New Yet Unapproachable America.*

————. *In Quest of The Ordinary: Lines of Skepticism and Romanticism.* Chicago: University of Chicago Press, 1988.

————. *Must We Mean What We Say?* Cambridge: Cambridge University Press, 1976.

————. "Must We Mean What We Say?" In *Must We Mean What We Say?*

————. *This New Yet Unapproachable America: Lectures after Emerson after Wittgenstein.* Albuquerque, N.M.: Living Batch Press, 1989.

————. "The Politics of Interpretation (Politics as Opposed to What?)" In *Themes out of School.*

————. "Psychoanalysis and Cinema: The Melodrama of the Unknown Woman." In *The Trial(s) of Psychoanalysis.* Edited by Francoise Meltzer. Chicago: University of Chicago, 1988.

————. *Pursuits of Happiness: The Hollywood Comedy of Remarriage.* Cambridge, Mass.: Harvard University Press, 1981.

————. "Recounting Gains, Showing Losses: Reading *The Winter's Tale.*" In *Disowning Knowledge.*

————. *The Senses of Walden.* San Francisco: North Point Press, 1981.

————. *Themes out of School: Effects and Causes.* San Francisco: North Point Press, 1984.

————. "Thinking of Emerson." In *The Senses of Walden.*

————. "Who Disappoints Whom?" [A response to Allan Bloom's *The Closing of the American Mind.*] *Critical Inquiry* 15 (spring 1989): 606–10.

Chekhov, Anton. *Chekhov: The Major Plays.* Translated by Ann Dunnigan. New York: New American Library, 1964.

Coleridge, Samuel Taylor. *Biographia Literaria.* Edited by J. Shawcross. Oxford: Oxford University Press, 1949.

————. "The Rime of the Ancient Mariner." In *The Portable Coleridge,* edited by I. A. Richards. New York: Penguin Books, 1978.

Dante Alighieri. *The Divine Comedy.* Translated by John Ciardi. New York: New American Library, 1954–61.

Derrida, Jacques. "Geschlecht II: Heidegger's Hand." In *Deconstruction and Philosophy: The Texts of Jacques Derrida.* Edited by John Sallis. Chicago: University of Chicago Press, 1987.

Descartes, René. *Meditations on First Philosophy.* In *The Philosophical Works of Descartes,* vol. 1.

_____. *The Philosophical Works of Descartes*. 2 vols. Translated and edited by Elizabeth S. Haldane and G. R. T. Ross. Cambridge: Cambridge University Press, 1911.

_____. "Third Set of Objections with Author's Reply." In *The Philosophical Works of Descartes*, vol. 2.

Dewey, John. *Art as Experience*. New York: Minton, Balch, 1934.

_____. "Emerson: The Philosopher of Democracy." In *Essays on the New Empiricism, 1903–1906*. Vol. 3 of *The Middle Works of John Dewey, 1899–1924*. Edited by Jo Ann Boydston and Patricia R. Baysinger, with an introduction by Darnell R. Rucker. Carbondale and Edwardsville: Southern Illinois University Press, 1977.

_____. *Experience and Nature*. Chicago: Open Court, 1971.

_____. *The Quest for Certainty: A Study of the Relation of Knowledge and Action*. New York: G. P. Putnam's Sons, Perigee Books, 1980.

_____. *Theory of Valuation*. International Encyclopedia of Unified Science, vol. 2, no. 4. Chicago: University of Chicago Press, 1939.

Dickens, Charles. *Great Expectations*. Edited by Angus Calder. New York: Penguin, 1965.

_____. *Hard Times*. Edited by George Ford and Sylvère Monod. New York: W. W. Norton Co., 1966.

Dostoevsky, Fyodor. *The Idiot*. Translated by Constance Garnett. London: Heinemann, 1969.

Emerson, Ralph Waldo. "The American Scholar." In *Selections from Ralph Waldo Emerson*.

_____. "Considerations by the Way." In *The Conduct of Life*, in *Essays and Lectures*.

_____. "Divinity School Address." In *Selections from Ralph Waldo Emerson*.

_____. *Essays and Lectures*. Edited by Joel Porte. New York: Library of America, 1983.

_____. "Experience." In *Selections from Ralph Waldo Emerson*.

_____. "History." From *Essays: First Series*, in *Essays and Lectures*.

_____. "Manners." From *Essays: Second Series*, in *Essays and Lectures*.

_____. "The Poet." In *Selections from Ralph Waldo Emerson*.

_____. *Selections from Ralph Waldo Emerson*. Edited by Stephen E. Whicher. Boston: Houghton Mifflin, 1957.

_____. "Self-Reliance." In *Selections from Ralph Waldo Emerson*.

Frege, Gottlob. "Preface to the *Begriffsschrift*." In *From Frege to Goedel: A Sourcebook in Mathematical Logic, 1879–1931*. Edited by Jean van Heijenoort. Cambridge, Mass.: Harvard University, 1967.

Freud, Sigmund. *Civilization and Its Discontents*. In *Standard Edition*, vol. 21, pp. 59–145.

_____. "Delusions and Dreams in Jensen's *Gradiva*." In *Standard Edition*, vol. 9, pp. 7–95.

————. "Inhibition, Symptom and Anxiety." In *Standard Edition*, vol. 20, pp. 75–156.

————. *The Interpretation of Dreams*. In *Standard Edition*, vols. 4 and 5.

————. *The Standard Edition of the Complete Psychological Works of Sigmund Freud*. 24 vols. Edited and translated by James Strachey in collaboration with Anna Freud. London: Hogarth Press, 1966.

Goethe, Johann Wolfgang von. *Faust*. Translated by Alice Pearl Raphael. New York: Rinehart, 1955.

————. *Wilhelm Meister*. New York: E. P. Dutton, 1912.

Hegel, G. W. F. *Phenomenology of the Spirit*. Translated by A. V. Miller, with an analysis of the text and foreword by J. N. Findlay. Oxford: Clarendon Press, 1977.

Hegel, G. W. F. and F. W. J. Schelling. "The Critical Journal, Introduction: On the Essence of Philosophical Criticism Generally, and Its Relationship to the Present State of Philosophy." Translation and notes by H. S. Harris. In *Between Kant and Hegel: Texts in the Development of Post-Kantian Idealism*. Translated and annotated by George di Giovanni and H. S. Harris. Albany: State University of New York, 1985.

Heidegger, Martin. *Being and Time*. Translated by J. Macquarrie and E. Robinson. New York: Harper Books, 1962.

————. "Building, Dwelling, Thinking." In *Poetry, Language, Thought*.

————. "The Origin of the Work of Art." In *Poetry, Language, Thought*.

————. *Parmenides*. In *Gesamtausgabe*, vol. 54. Frankfurt am Main: Klosterman, 1976.

————. *Poetry, Language, Thought*. Translated by Albert Hofstadter. New York: Harper and Row, 1971.

————. *What Is Called Thinking?* Translated by J. Glenn Gray. New York: Harper and Row, 1968.

Hertz, Neil. *The End of the Line*. New York: Columbia University Press, 1985.

Hobbes, Thomas. *Leviathan*. Edited and introduced by C. B. MacPherson. New York: Penguin, 1982.

Hollingdale, R. J. *Nietzsche*. London: Routledge and Kegan Paul, 1973.

————. *Nietzsche*. Boston: ARK Paperbacks, 1985. (This is a revised edition of the book in the following entry.)

————. *Nietzsche: The Man and His Philosophy*. Baton Rouge: Louisiana State University Press, 1965.

Hume, David. "Of the Original Contract." From *Essays, Moral and Political*, in *Hume's Moral and Political Philosophy*. Edited by H. D. Aiken. New York: Hafner Library Classics, 1948.

————. *A Treatise of Human Nature*. Second edition. Edited by L. A. Selby-Bigge and P. H. Nidditch. Oxford: Clarendon Press, 1978.

Hurka, Thomas. "The Well-Rounded Life." *The Journal of Philosophy* 84 (December 1987): 727–46.

Ibsen, Henrik. "A Doll's House." In *The Complete Major Prose Plays.*
Translated and introduced by Rolf Fjelde. New York: New American Library, 1965.

_____. "Hedda Gabler." In *The Complete Major Prose Plays.*

James, Henry. "The Beast in the Jungle." In *The Great Short Novels of Henry James.* Edited and with an introduction by Philip Rahv. New York: Dial Press, 1944.

James, William. *The Varieties of Religious Experience.* In *The Works of William James.* Edited by Frederick H. Burkhardt, et al. Cambridge, Mass.: Harvard University Press, 1985.

Jaspers, Karl. *Nietzsche: An Introduction to the Understanding of His Philosophical Activity.* Translated by Charles F. Wallraff and Frederick J. Schmitz. 1935. Chicago: Henry Regnery, 1965.

Kant, Immanuel. "Conjectural Beginning of Human History." Translated by Emil Fackenheim. In *Kant: On History.*

_____. *The Critique of Judgment.* Translated by James C. Meredith. Oxford: Oxford University Press, 1911.

_____. *The Critique of Pure Reason.* Translated by Norman Kemp Smith. New York: St. Martin's Press, 1965.

_____. "The End of All Things." Translated by Robert E. Anchor. In *Kant: On History.*

_____. *Foundations of the Metaphysics of Morals.* Translated and with an introduction by Lewis White Beck. Indianapolis, Ind.: Bobbs-Merrill, 1978.

_____. *Kant: On History.* Edited and with an introduction by Lewis White Beck. Indianapolis, Ind.: Bobbs-Merrill, 1981.

_____. *Religion within the Limits of Reason Alone.* Translated and with an introduction and notes by Theodore M. Green and Hoyt H. Hudson. New York: Harper and Row, 1960.

_____. "What Is Enlightenment?" Translated by Lewis White Beck. In *Kant: On History.*

Kaplan, Abraham. *The New World of Philosophy.* New York: Random House, 1961.

Kierkegaard, Soren. *Concluding Unscientific Postscipt.* Translated by Walter Lowrie and David Swenson. Princeton, N.J.: Princeton University Press, 1970.

_____. *Philosophical Fragments.* Translated, with introduction and notes by David Swenson. Princeton, N.J.: Princeton University Press, 1936.

_____. *Repetition.* Translated by Walter Lowrie. Princeton, N.J.: Princeton University Press, 1941.

Kleist, Heinrich von. *An Abyss Deep Enough: Letters of Heinrich von Kleist.* Edited and introduced by Philip B. Miller. New York: Dutton, 1982.

_____. *The Marquise von O____.* In *The Marquise von O and Other Sto-*

ries. Translated and with an introduction by Martin Greenberg. New York: Criterion Books, 1960.

————. "On the Marionette Theater." In *German Romantic Criticism.* Edited by A. Leslie Willson. New York: Continuum, 1982.

Kripke, Saul. *Wittgenstein on Rules and Private Language.* Cambridge: Cambridge University Press, 1982.

Laplanche, Jean. *Life and Death in Psychoanalysis.* Translated by Jeffrey Mehlman. Baltimore: Johns Hopkins University Press, 1985.

Lawrence, D. H. *Women in Love.* Edited by David Farmer, Lindeth Vasey, and John Worthem. Cambridge: Cambridge University Press, 1987.

Lévi-Strauss, Claude. *Elementary Structures of Kinship.* Rev. ed. Translated by James Bell, John Richard von Sturmer, and Rodney Needham, editor. Boston: Beacon Press, 1969.

Lewis, C. I. "The Individual and the Social Order." In *The Collected Papers of C. I. Lewis,* edited by John D. Goheen and John L. Mothershead, Jr. Stanford, Calif.: Stanford University Press, 1970.

Locke, John. *An Essay Concerning Human Understanding.* Edited with an introduction by P. H. Nidditch. Oxford: Clarendon Press, 1975.

————. *The Second Treatise of Government.* In John Locke, *Two Treatises of Government.* 2d ed. Edited by Peter Laslett. Cambridge: Cambridge University Press, 1970.

Marshall, David. *The Figure of Theater.* New York: Columbia University Press, 1987.

————. *The Surprising Effects of Sympathy: Marivaux, Diderot, Rousseau, and Mary Shelley.* Chicago: University of Chicago Press, 1988.

Marx, Karl. "Towards a Critique of Hegel's *Philosophy of Right:* Introduction." In *Karl Marx: Selected Writings.* Edited by David McLellan. Oxford: Oxford University Press, 1977.

Mates, Benson. "On the Verification of Statements about Ordinary Language." In *Ordinary Language,* edited by V. C. Chappell. Englewood Cliffs, N.J.: Prentice Hall, 1964.

Melville, Herman. *Pierre.* Edited and with an introduction by Henry A. Murray. New York: Farrar Straus Press, 1949.

Mill, John Stuart. *On Liberty.* Edited by Elizabeth Rapaport. Indianapolis, Ind.: Hackett, 1978.

————. *On the Subjection of Women.* Introduction by Wendell Robert Carr. Cambridge, Mass.: MIT Press, 1970.

————. *Utilitarianism.* Edited by Oskar Priest. Indianapolis, Ind.: Bobbs-Merrill, 1957.

Milton, John. *The Doctrine and Discipline of Divorce.* In *The Complete Prose Works of John Milton.* General Editor, Don M. Wolfe. New Haven, Conn.: Yale University Press, 1980.

————. *Paradise Lost.* In *The Portable Milton.* Edited with an introduction by Douglas Bush. New York: Viking Press, 1949.

Molière [Jean Baptiste Poquelin]. *Misanthrope: A Comedy in Five Acts.* Translated by Richard Wilbur. New York: Harcourt, Brace, 1955.

Montaigne. *Essays.* In *The Complete Works of Montaigne.* Translated and edited by Donald W. Frame. Stanford, Calif.: Stanford University Press, 1965.

Murdoch, Iris. *The Sovereignty of Good.* London: ARK Paperback, 1986.

Nelson, Robert J. *Pascal, Adversary and Advocate.* Cambridge, Mass.: Harvard University Press, 1981.

Nietzsche, Friedrich. *Ecce Homo.* Translated by Walter Kaufmann and R. J. Hollingdale. New York: Vintage Press, 1969.

_____. *On the Genealogy of Morals.* Translated by Walter Kaufmann and R. J. Hollingdale. New York: Vintage Press, 1969.

_____. *Schopenhauer as Educator.* In *Untimely Meditations.* Translated by R. J. Hollingdale with an introduction by J. P. Stern. Cambridge: Cambridge University Press, 1983.

_____. *Schopenhauer as Educator.* Translated by James Hillesheim and Malcolm Simpson. South Bend, Indiana: Regnery/Gateway, 1965.

_____. *Thus Spoke Zarathustra.* Translated by Walter Kaufmann. New York: Penguin Books, 1978.

Ovid. *Metamorphoses.* Translated by A. D. Melville with an introduction and notes by E. J. Kenney. Oxford: Oxford University Press, 1986.

Pascal, Blaise. *Pensées.* Translated by H. F. Stewart. New York: Atheneum, 1950.

Pater, Walter. *The Renaissance: Studies in Art and Poetry.* Edited by Donald L. Hill. Berkeley and Los Angeles: University of California Press, 1980.

Plato. *The Republic.* Translated by G. M. A. Grube. Indianapolis, Ind.: Hackett Publishing 1974.

_____. *Symposium.* Translated by Michael Joyce. In *The Dialogues of Plato.* Edited by Edith Hamilton and Huntington Cairns. New York: Pantheon Books, 1961.

Rawls, John. *A Theory of Justice.* Cambridge, Mass.: Harvard University Press, Belknap Press, 1971.

_____. "Two Concepts of Rules," *The Philosophical Review* 64 (January 1965): 3–32.

Raz, Joseph. *The Morality of Freedom.* Oxford: Clarendon Press, 1986.

Rorty, Richard. *Consequences of Pragmatism.* Minneapolis: University of Minnesota Press, 1982.

_____. *Philosophy and the Mirror of Nature.* Princeton, N.J.: Princeton University Press, 1979.

Rousseau, Jean-Jacques. *Emile, or On Education.* Translated and with an introduction and notes by Allan Bloom. New York: Basic Books, 1979.

_____. "Letter to D'Alembert on the Theater." In *Politics and the Arts.*

Translated with an introduction by Allan Bloom. Ithaca, N.Y.: Cornell University Press, 1960.

———. *On the Social Contract*. Translated by Judith R. Masters and edited by Roy D. Masters. New York: St. Martin's Press, 1978.

———. *The Reveries of the Solitary Walker*. Translated, with preface, notes, and an interpretive essay by Charles E. Butterworth. New York: New York University Press, 1979.

Russell, Bertrand. *Our Knowledge of the External World*. Chicago: Open Court, 1914.

Santayana, George. "Emerson." In *Interpretations of Poetry and Religion*. New York: Harper Torchbooks, 1957.

———. "The Genteel Tradition in American Philosophy." In *The Genteel Tradition in American Philosophy: Nine Essays by George Santayana*. Edited by Douglas L. Wilson. Cambridge, Mass.: Harvard University Press, 1967.

Schiller, Friedrich. *On the Aesthetic Education of Man: In a Series of Letters*. Edited, translated, and introduced by Elizabeth Wilkinson and L. A. Willoughby. Oxford: Clarendon Press, 1982.

Schlegel, Friedrich. *Athenaeum Fragments*. In *Friedrich Schlegel's "Lucinde" and the "Fragments."* Translated and with an introduction by Peter Firchow. Minneapolis: University of Minnesota Press, 1971.

———. "On Incomprehensibility." In *Friedrich Schlegel's "Lucinde" and the "Fragments."*

Shaftesbury, Earl of (Anthony Ashley Cooper). *Characteristics of Men, Manners, Opinions, Times, etc.* Edited by John M. Robertson. Gloucester, Mass.: Peter Smith, 1963.

Shakespeare, William. *Coriolanus*. Edited by Philip Brockbank. London: Methuen, the Arden Shakespeare, 1976.

———. *Hamlet*. Edited by Harold Jenkins. London: Methuen, the Arden Shakespeare, 1982.

———. *The Tempest*. 5th ed. Edited by Frank Kermode. Cambridge, Mass.: Harvard University Press, the Arden Shakespeare, 1954.

———. *The Winter's Tale*. Edited by J. H. P. Pafford. Cambridge, Mass.: Harvard University Press, the Arden Shakespeare, 1963.

Shaw, George Bernard. *Pygmalion*. New York: Penguin Books, 1951.

Sidgwick, Henry. "The Prophet of Culture." In *Miscellaneous Essays and Addresses*. Edited by E. M. Sidgwick and A. Sidgwick. New York: Macmillan, 1904.

Smith, Joseph H., and William Kerrigan, eds. *Images in Our Souls: Cavell, Psychoanalysis, and Cinema*. Baltimore: Johns Hopkins University Press, 1987.

Spinoza, Benedict de. *Ethics*. In *Ethics and On the Improvement of the Understanding*. Edited with an introduction by James Gutmann. New York: Hafner Publishing, 1949.

Stroud, Barry. "Reasonable Claims: Cavell and the Tradition." *The Journal of Philosophy* 77 (November 1980): 731–44.

Taylor, William R. *Cavalier and Yankee.* New York: Anchor Books, 1963.

Thoreau, Henry David. *Walden.* Annotated by Walter Harding. New York: Washington Square Press, 1963.

Tocqueville, Alexis de. *Democracy in America.* The Henry Reeves translation, as revised by Francis Bowen. Edited and with an historical essay and notes by Phillips Bradley. New York: Vintage, 1945.

Twain, Mark. *The Adventures of Huckleberry Finn.* Edited by Kenneth S. Lynn. New York: Harcourt, Brace and World, 1961.

Updike, John. "Emersonianism." *The New Yorker,* June 4, 1984.

Veblen, Thorstein. *The Theory of the Leisure Class.* New York: A. M. Kelley, 1975.

Weiskell, Thomas. *The Romantic Sublime.* Baltimore: Johns Hopkins University Press, 1986.

White, Morton. *The Origin of Dewey's Instrumentalism.* New York: Columbia University Press, 1943.

———. *Social Thought in America: The Revolt against Formalism.* New York: Oxford University Press, 1976.

Whitman, Walt. *Leaves of Grass.* Introduced by Sculley Bradley. New York: New American Library, 1954.

Wilde, Oscar. *The Artist as Critic: Critical Writings of Oscar Wilde.* Edited by Richard Ellman. Chicago: University of Chicago Press, 1968.

———. "A Chinese Sage." In *The Artist as Critic.*

Wittgenstein, Ludwig. *The Blue and Brown Books.* New York: Harper and Row, 1965.

———. *Philosophical Investigations.* Translated by G. E. M. Anscombe. New York: Macmillan, 1953.

Wordsworth, William. *The Prelude* (text of 1805). Edited by E. de Selincourt. London: Oxford University Press, 1964.